Robin Derrick is creative director of British *Vogue*. An art director and photographer, he started work in 1982 on *I-D* magazine before graduating from St Martin's School of Art in London in 1984. He has served as art director/creative director of many influential magazines, including *The Face*, Italian *Elle*, *Per Lui*, French *Glamour* and *Arena*. In 1999 he was the creative director responsible for the launch of Russian *Vogue*. He has been taking pictures for a decade and divides his time between his role at British *Vogue* and his photographic commissions and exhibitions.

Robin Muir is a writer and curator and a former picture editor of British *Vogue* and the *Sunday Telegraph Magazine*. He is a regular contributor to *The World of Interiors* and *Vogue*. He is the archivist of the Terence Donovan Archive and a contributor to *The New Dictionary of National Biography*. He has published many books on photography and curated exhibitions for the National Portrait Gallery, the Victoria and Albert Museum, the Museum of London and the Yale Center for British Art, New Haven. He is currently researching an exhibition of Scottish painting in the immediate post-war era.

Robin Derrick and Robin Muir are the authors of *Unseen Vogue and People in Vogue*.

D1465342

LITTLE, BROWN

First published in Great Britain in 2007 by Little, Brown
This paperback edition published in 2009 by Little, Brown

Designed by Jaime Perlman
Sub-edited by Stephen Patience
Picture co-ordination by Jennifer Cargey
Endpapers photographed by Steven Fisher

A CIP catalogue record for this book
is available from the British Library.

ISBN 978-1-4087-0213-0

Printed and bound in China

Little, Brown
An imprint of
Little, Brown Book Group
100 Victoria Embankment
London EC4Y 0DY

An Hachette UK Company
www.hachette.co.uk

www.littlebrown.co.uk

VOGUE COVERS

On fashion's front page

EDITED BY ROBIN DERRICK AND ROBIN MUIR

Little, Brown

How to make a Vogue cover
by Robin Derrick

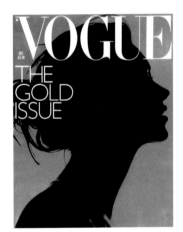

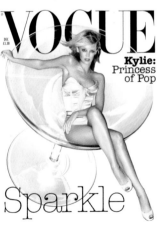

Special issues can provide some of the magazine's most striking covers, as with Kate Moss silhouetted against gold foil (December 2001) and Kylie Minogue in a giant champagne glass (December 2003)

Looking through this anthology of over 90 years of *Vogue* covers, I am struck by the range of imagery that has been put on the front of the magazine. Who would have thought that, along with the beautiful and pretty, *Vogue* would have featured a woman spearing a polar bear in 1917 (see page 11), riding a zebra (page 40) or holding a shotgun (page 88)? The name of the magazine was drawn differently nearly every month, depicted in the most artful of ways — written in pearls, on the wings of aeroplanes or drawn in the sand. The now famous *Vogue* trademark logo was not really adopted until the Fifties.

I joined British *Vogue* in 1993 as art director and currently serve as its creative director, responsible for the way the magazine looks. The newsstand today is a packed and busy place, with many titles fighting for attention; the cover's job is to sell the magazine and carry the image of the brand. Most modern women's magazine covers can basically be described as 'a picture of a girl in a dress', yet for *Vogue* they have to have a special quality. They have to look like '*Vogue* covers', yet be different from each other and from the other magazines on the shelf. This special quality comes from different sources: it could be a particularly amazing model, a celebrity, a beautiful hat, a wink in an eye, a special printing technique, a surprising photograph. The 'story' that each cover tells is different from the one that preceded it.

The seasonal cycle of *Vogue* covers begins with the collections issues, published in March and September. They are the first issues to feature the new-season clothes for spring/summer and autumn/winter respectively. For a collections issue, the cover image always begins with the clothes. This will be an outfit that the editor saw coming down a runway in London, Paris, Milan or New York that not only took her breath away but somehow also encapsulated 'the look' of the coming fashion season.

The next thing to be considered is the type of shot. For example, will this be a glamorous red-lipped studio picture, all flashbulbs and sheen, or a romantic location picture, or a calm interior?

Once the editor has decided on the dress and the look of the cover, we cast the model and the photographer. This is where it starts to get a bit complicated. It's one thing to think up fictional covers with the ideal imagery and cover stars, but on a monthly magazine the 'art' is that of the possible. The photographers and models that *Vogue* works with are the best in the world and, as such, the most in-demand. The logistics of getting the ideal pairing of photographer and model into a studio on the same day are often daunting; then there are the difficulties of getting together hair and make-up teams, who are often even harder to 'get dates on' than the models.

Vogue cover shoots, at a prosaic level are often the simplest photographs that we do for the magazine. Usually they consist of a single model in a studio or on location; the outfit has been chosen and a day is set aside to create the image. A quick look at the 'call sheet' for any modern cover shoot, however, shows that this apparently simple job seems to require a crew of as many as 20 people (and sometimes more): photographer, perhaps three assistants, digital-camera and computer operators (usually two), hairdresser and assistant, make-up artist and assistant, manicurist, stylist and assistant, set designer and assistants, art director, retoucher, and — finally — the model.

The assembly of this team is the most important factor in creating a successful *Vogue* cover. These most carefully contrived of images are the end result

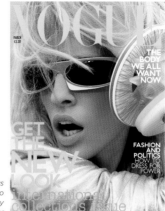

A good cover image should always feature eye contact, according to received wisdom — a 'rule' flouted by this Nick Knight cover

f lots of small decisions. Obviously he dress and the model are vital, but nce everyone is on the shoot it's the micro-decisions (about hair, make-up, whether a shoulder strap is up or down) that make a cover good or bad - *Vogue* or not.

I am an old hand at attending cover shoots, and yet I always make the same basic mistake. I will sit in a meeting in he office looking at pictures of the proposed outfit and girl; I will discuss it great length precisely the colour backdrop we are going to have, whether it will be painted or a built set, nd whether or not the cover might ook good with a foil logo or matt varnish, only for all of these plans to become suddenly irrelevant — I watch Kate Moss's hair being blown back by airdresser Sam McKnight as she moves her body an inch to the right nd it looks incredible. I can plan ut the mundane aspects of the cover o that they work on paper, but it's lways the smallest detail I have not hought of that makes it great.

After the 'fashion' covers have nnounced the new season, the potlight moves on to the magazine's ther concerns — beauty issues, Christmas specials, travel issues and elebrities. The world of celebrity overs is more challenging. When you o to a studio with a model and a antastic team, you can set about reating an image. With a celebrity hey already *have* an image, which you re in some way trying to capture and Vogueify', to use an in-house word. ometimes the 'talent' may play ball vith your vision of them, sometimes ot. Most celebrity cover subjects, specially Hollywood stars, have ublicists and agents who are very een to protect a certain kind of image or their client, and they will often need lacating with various promises: 'Of Course we won't shoot her below the

waist'; 'By all means she can bring her own make-up team'; etc. It can be very frustrating, given that the reason you wanted to shoot the person in question is precisely because you thought they looked great. And, of course, you want them to look even better on the cover of the magazine. These negotiations can become very fraught.

But the thing that depresses me the most about celebrity covers is that their success or failure is completely down to timing. A magazine is on the newsstands for four weeks, and 75 per cent of its sales will be during the first fortnight. That's a two-week period during which people had better be interested in, say, Gwyneth Paltrow or Cate Blanchett.

If a movie is slow to catch on, or a new album is not doing as well as we thought it would, we miss our window and sales suffer. If, as can happen, the cover star is in the news (good or bad), then during those two weeks sales soar. This is regardless of the quality of the image itself. A rather dour cover of Penélope Cruz (February 2002) sold like hot cakes, as it coincided with the news that she was going out with Tom Cruise. An Elizabeth Hurley cover (page 216) soared away, as the issue was on the stands after news broke about her then partner's antics with a prostitute.

In magazine-land there exists a set of rules or perceived wisdoms about covers. They are a strange set of diktats: a cover must have eye contact; be colourful; green logos don't sell; a design with lots of coverlines does sell; still-life covers don't work; blurring is bad. I can find exceptions to all of these in the history of *Vogue*, and some of the exceptions did very well indeed.

The most striking covers are often on special issues of the magazine, where the theme of the issue is worked up into an image. I love doing these — they offer an opportunity to play with the

conventional cover format. Looking back through the archive, I see that previous art directors have also revelled in these chances to think outside the box — the blue-sky cover at the end of World War II (page 116) and the rich purple for the death of George V (page 87) are among my favourites. I produced a silver-mirrored *Vogue* cover to celebrate the turn of the millennium in December 1999, and a silhouette on a gold-foil background the following year (page 221). These special issues (now quite expensive on eBay) were instant hits. Such covers have a winning quality to them, an appeal that seems to reach out from the page.

There exists an elusive set of images that have an appeal to both high and low taste: images that are not arch or difficult, but that charm and seduce. My favourite part of the job is dreaming up and producing these covers. 'Let's put Kylie Minogue in a champagne glass,' someone must have said in about August 2003 (page 230). 'Let's do Kate Moss with an *Aladdin Sane* stripe,' the editor said — a great idea (page 228) that was not, sadly, a huge seller. The more offbeat the concept, the harder it is to predict whether it will sell. But when they work, they can be hugely successful.

As I write this, we are currently planning our December cover. It will be a special issue. I've got an idea about fashion and global warming . . . perhaps we should do Kate Moss spearing a polar bear.

Putting the folly into fashion:
Condé Nast and the rise of the modern magazine
by Robin Muir

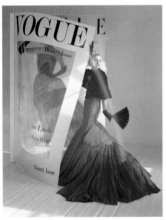

Top: a 1950 cover by Irving Penn forms the basis of a Tim Walker shoot for Italian Vogue. *Above: a 1951* Vogue — *the cover is by Clifford Coffin — is dextrously balanced en plein air*

In 1909, after four years of overtures and rebuttals, Condé Nast, a young and energetic publishing executive from St Louis, bought the weekly society gazette *Vogue*. His new acquisition was an ailing large-format New York magazine, already an institution only a decade and a half into its existence (it was founded in 1892) but in poor financial shape. It billed itself as 'the dignified authentic journal of society, fashion and the ceremonial side of life, mainly pictorial', but it had a decelerating circulation of 14,000 and a diminishing advertising revenue. Yet, while it foundered in deep water, it possessed something — 'the magnet that drew out the gold', as Nast put it — that kept its rivals back in the shallows tentatively dipping their toes: a devoted core readership of Manhattan's social elite.

Nast set about expanding this eager readership. From a weekly publication he made it a fortnightly; he increased the cover price from 10 to 25 cents; he substantially increased the advertising pages (and the page rates); he augmented the society pages to include fashion and the 'fashionable life one leads'; he acquired the best-quality paper and married it to up-to-date printing facilities. But most strikingly of all, he made the most obvious, glaring and brilliant change he could, the one thing guaranteed to get *Vogue* noticed immediately, which would cut it adrift from its previous incarnation and its rivals and stamp Nast's imprimatur upon it for ever. He replaced its over-decorated, unfailingly monochromatic front page with full-colour covers, as blazing as state-of-the art printing could make them. His contributors were no longer unnamed journeyman illustrators, but fully accredited artists.

The perfunctory yielded to the meticulous. Nast understood what succeeding generations of proprietors came to regard as inherent common sense: that new readers would not buy the product if not first intrigued enough to reach for it. The cover had to seduce the purchaser at the first point of contac (expected to be the newsstand in *Vogue*'s case). Here, Nast experimented with every stylistic trick: Art Nouveau curlicues, Impressionistic colour washes, and the exuberant, decorative flourishes of the Wiener Werkstätte.

Nast intuited well the modern woman of taste and means, mainly because she lived life at his side. Nast's parties (in a 30-room Park Avenue apartment) were fabled for their sumptuousness: actresses, dancers, socialites and fellow tycoons flocked there in droves — and found themselves written up in *Vogue*'s pages. Fashion (and the fashionable life) was the key to the magazine's early success, and this was replicated across the Atlantic.

By now, *Vogue*'s covers were at the vanguard of contemporary aesthetic taste, so idiosyncratic and distinctive tha an Easter ball at the Waldorf-Astoria in 1914 saw partygoers disport themselves in a series of *tableaux vivants* inspired by recent issues of the magazine. In a simila vein, *Vogue* covers now adorned the walls of fashionable New York restaurant and in 1918 were briefly available on paper bags sold to benefit the Red Cross

Nast's next venture, British *Vogue*, was born in 1916, in the middle of the Great War, when the threat to shipping halted imports of US *Vogue* to these shores. Women readers weren't exactly thronging the quays baying for quality fashion magazines, but the novelty of thi American import had created something of a stir, with its clear typefaces, its witty headings and, above all, its clearly discernible photographs of beautiful people and their clothes. Add to that a British predilection for the unaffordable (air travel, transatlantic liner crossings, white velveteen skating dresses trimmed with rabbit fur) as well

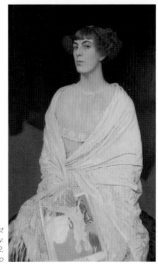

Alan Beeton's 'Isabella Holding Vogue*', first
exhibited in 1928 at the Royal Academy.
Isabella holds an issue from October 1922,
with a cover by Eduardo Benito*

s the unobtainable (new Ford cars,
ckets to the Ballets Russes) and you
ad an unstoppable force. The first issue,
rumpeting a 'Forecast of Autumn
ashions', appeared in late September
916 with a cover illustration by Helen
hurlow (page 8). Her tableau of female
marionettes representing the four
easons (Autumn has cut the strings of
er rivals) was unostentatious, being
mostly a symphony of low-key colours
gainst a drab grey backdrop. This set
he tone for the magazine's first few
ssues — unsurprisingly, perhaps, as the
arger backdrop in which *Vogue* was set
vas the carnage of the Western Front.

British *Vogue* often ran covers that
ad previously appeared on its
American sister publication, not least
because it was more cost-effective to
orrow rather than to originate.
Occasionally, Britain was allowed
diosyncratic flourishes, notably designs
y Helen Thurlow and Porter Woodruff,
mong others, but the far better
nown post-Great War covers by
Georges Lepape and George Plank, and
he triumphs of Art Deco graphics by
Benito, Bolin, Mourgue and Marty
manated from New York.

A landmark for *Vogue* occurred in
uly 1932 with the appearance of its first
photographic cover (page 76), born of
printing processes that allowed four-
olour separations. Against a wider
ackdrop of financial turmoil, Nast had
nvested heavily in new technology at his
printing works in Connecticut, and
eaped the benefits. This development
atapulted the magazine far above its
ivals, who stubbornly faced the world in
lack-and-white — mainly because they
ad no choice. Starting with Steichen's
weeping, linear beach scene, *Vogue's*
overs were all but unbeatable.

Despite such advances, the magazine's
ditors were well aware of Nast's guiding
rinciple. 'It is the avowed mission of
Vogue,' he had stated, 'to appeal not

merely to women of great wealth but
more fundamentally to women of great
taste . . . ' And taste for Nast was
inextricably bound to the fine arts, not
technological advances in the applied.
The advent of photographic covers did
not immediately spell the ruin of the
graphic. Nast had acquired the
extravagantly illustrated French
magazine *La Gazette du Bon Ton*, which
he continued, uncharacteristically, as a
loss-making indulgence until 1925.
Principal *Bon Ton* artists Pierre Brissaud,
Georges Lepape and André Marty were
co-opted to *Vogue*. Each possessed
a distinctive style — cursory, linear,
meticulous, angular — but their
openness to the prevailing nuances of
European art, whether the Cubism of
Braque or the etiolated figures of
Modigliani, left a clear mark on *Vogue*
well into the late Forties.

'While the camera maintains its
conquering but boring supremacy,'
wrote Harry Yoxall, who oversaw British
Vogue from the Twenties till the Sixties,
'we won't see their peers again'. He
wrote this in 1966, mourning the
end of a golden era for fashion
illustration, which *Vogue* had mined
almost to extinction. Figures like
Eric (Carl Erickson), René Bouché
and René Bouët-Willaumez, with their
sketchboards and stock-still mannequins
draped in couture, were anachronistic
even by the Forties, quirky Proustian
creatures with foibles as amusing or
irritating as any star photographer today.
(Eric's bowler hat, extravagant
buttonholes and gargantuan breakfasts
placed him somewhere nearer the fin-
de-siècle of Toulouse-Lautrec.)

Photographic covers introduced
readers to the great names of a new
and far-reaching discipline: fashion
photography. At once, the machine age
rendered the exotic more attainable
and made it, by the camera's very
nature, far more 'real' than the drawn

image ever could. Illustrated covers
were mostly conceptual, from the
creative imagination of artists;
photography all but destroyed this.
A new constant emerged: it was clear
to whom *Vogue* spoke because she
appeared on its cover, and it was
clear how she was expected to appear
to the world because *Vogue* arranged
her appearance.

Shortly after the first photographic
cover ran, Nast wrote that he had been
'determined to bait the editorial pages in
such a way as to lift out of all the millions
of Americans just the 100,000 cultivated
people . . . ' What he left to be declared
by commentators much later on was
that his intuitive good taste gave birth to
the strangest of notions: that something
as frivolous and insubstantial as a
magazine could elevate American and
European tastes in fashion, art, literature,
photography, cuisine, the stage, interior
design, music and more.

VOGUE

This number a

Forecast
of
Autumn Fashions

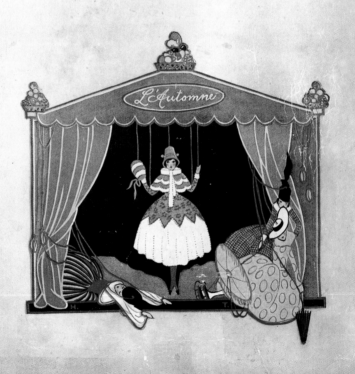

L'Automne

epte ber 15th CONDÉ NAST & CO. One Shilling Net. Fortnight
LONDON

15 SEPTEMBER 1916 Forecast of Autumn Fashions

The British edition of *Vogue* was launched mainly because Condé Nast, the proprietor of American *Vogue*, saw an opportunity. Americans had fallen for smart British style and the modes and manners of the aristocracy, while the British were in thrall to American motor transport, moneyed opulence and music. (For the remainder of the century, things rarely changed.) A more prosaic reason was that the threat of submarine attack at the height of war restricted all but essential shipping, and imported American magazines we suddenly unobtainable. Helen Thurlow's illustration for the first British cov was effective, if a mostly grey affair. In her puppet display, Autumn triumph over Spring, Summer and Winter, as befitted the season of launch.

Illustration by Helen Thurlo

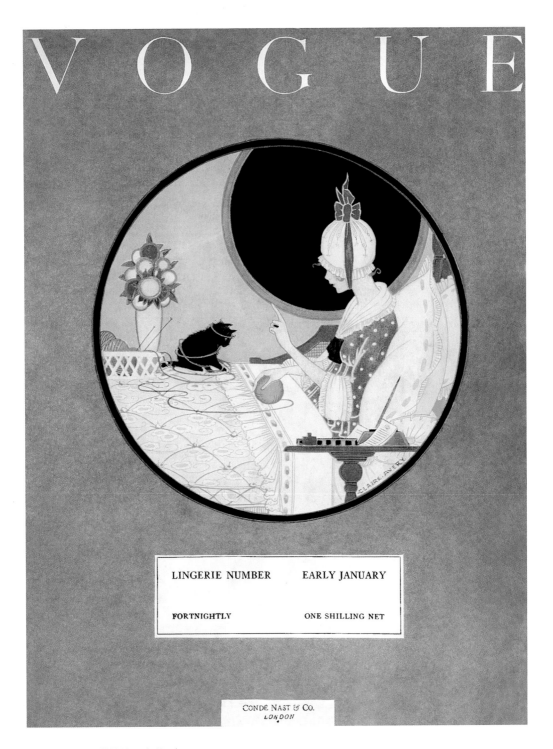

VOGUE

LINGERIE NUMBER EARLY JANUARY

FORTNIGHTLY ONE SHILLING NET

CONDÉ NAST & CO.
LONDON

EARLY JANUARY 1917 Lingerie Number

Early *Vogue* covers tended to bear little relation to the central themes they promised. This roundel of a naughty kitten and its indulgent owner was no exception. The minimal use of coverlines showed due reverence to the illustrator's art.

Illustration by Claire Avery

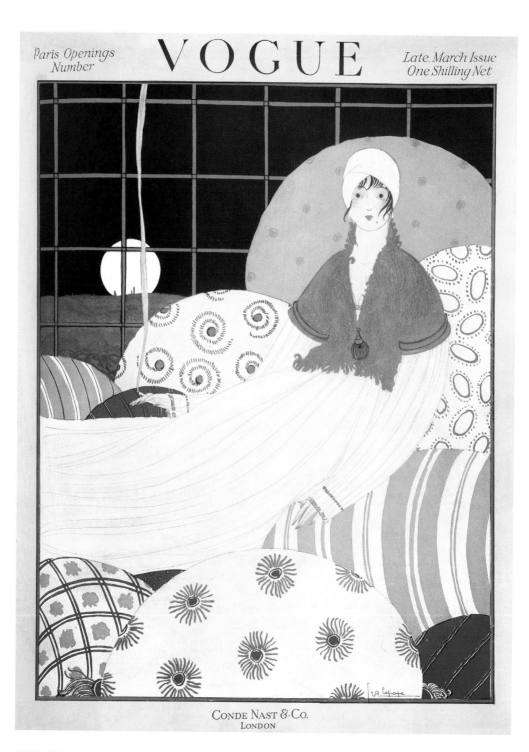

CONDE NAST & CO.
LONDON

LATE MARCH 1917 Paris Openings Number

Despite the richly patterned home comforts, *Vogue*'s cover heroine is, to judge from her purple-rimmed eyes, clearly an insomniac. Perhaps she is simply keyed up by the impending collections and — as *Vogue* put it — 'just waits impatiently for her silhouette to come to her from the deep secrecy of the Paris ateliers . . . It is so exciting to be kept in suspense as to what one is really going to look like.'

Illustration by Georges Lepape

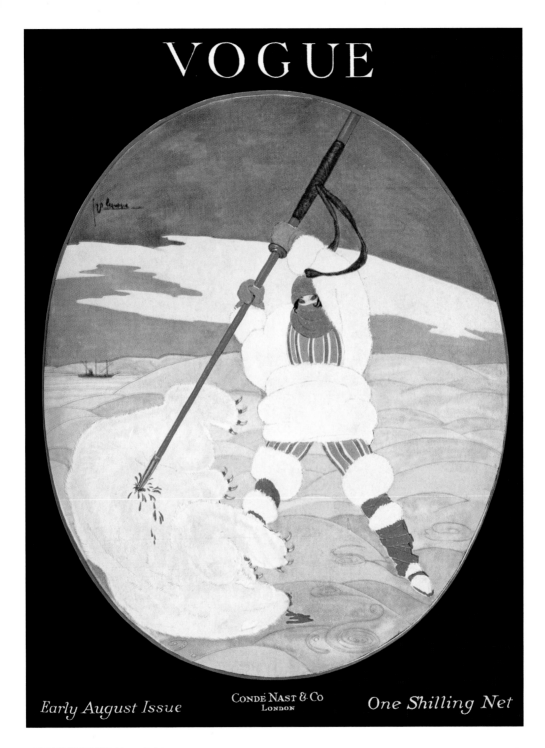

EARLY AUGUST 1917 Vogue Points

This cover may have seemed startling for all kinds of reasons, not least because the vignette from the icy wastes came out in August. The central theme — the spearing to death of polar bears — was not one that was pursued further by *Vogue*.

Illustration by Georges Lepape

VOGUE

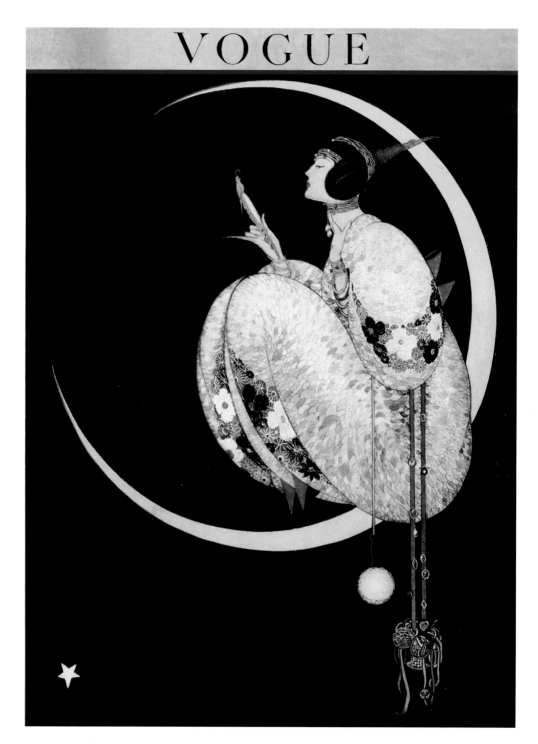

EARLY DECEMBER 1917 Winter Number

George Wolfe Plank's odalisque, admiring herself on a crescent moon, was keenly aware of the season's drop in temperature. Hence the all-enveloping, padded outfit, which owed a debt to the prevailing fashion for chinoiserie. Such motifs, from hairstyle to chrysanthemum pattern, found favour well into the Twenties. Plank learned his craft at *La Gazette du Bon Ton* in Paris alongside artists such as Lepape, André-Edouard Marty and Eduardo Benito, none of whom was unaware of this oriental bias in art. The designs of Erté and Léon Bakst for the Ballets Russes were most influential of all. *Vogue* was never able to secure the services of Erté or Bakst, but its artists knew a good idea when they saw one.

Illustration by George Wolfe Plank

VOGUE

Early January 1918 CONDÉ NAST & CO
LONDON *One Shilling Net*

EARLY JANUARY 1918 Greater than the Whole

Art historian William Packer wrote that by early 1918 the Great War in *Vogue* was 'honoured in silence and by implication rather than by open report', and this subtle cover illustrates this perfectly. Our two fashionably cropped heroines study, a little wistfully, a globe. As twilight descends on their clifftop retreat, they have allowed themselves — perhaps as wives of serving husbands — a moment to reflect on the course of the war. Lepape's subtle suggestions extend to a manicured hand's gesture towards the mid-Atlantic and a steamer setting out over the water. The United States was, of course, the new ally. As winter turned to spring, *Vogue*'s war reporting became more rooted in reality.

Illustration by Georges Lepape

·VOGUE·

Late January 1918

CONDÉ NAST & CO
LONDON

One Shilling Net

LATE JANUARY 1918 Lingerie Number

Only the contents page revealed the special theme to this month's issue, though perhaps one might suppose something from Alice de Warenne Little's tenebrous, boudoir-oriented cover illustration. 'Vogue knows that woman's heart leaps at the magic words "Paris Lingerie"; that she is desirous of hearing the last word uttered by the Paris artists on the daintiest of personal apparel.'

Illustration by Alice de Warenne Little

VOGUE

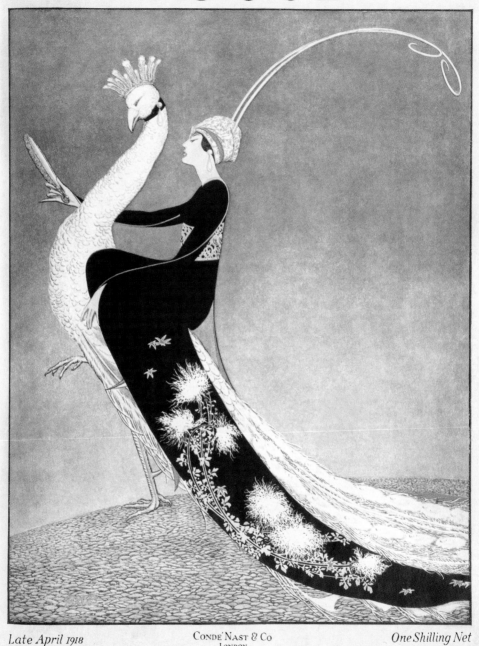

Late April 1918 CONDÉ NAST & CO
LONDON One Shilling Net

LATE APRIL 1918 Dressing on a War Income

The motif of a peacock on *Vogue*'s cover — whether subtly placed or, as here, more obviously rendered — was surprisingly prevalent in the magazine's early years. Or perhaps not, when one considers the fine array of feathers the proud bird habitually displays. As a cipher for elegance, it was unbeatable. In 1909, the year Condé Nast acquired US *Vogue*, two covers featured peacocks. Plank's fine illustration was the apotheosis of the peacock: American *Vogue* ran it in the same month (April 1918), and had previously published it in 1911 — it was the only cover to be given such a second life.

Illustration by George Wolfe Plank

15

VOGUE

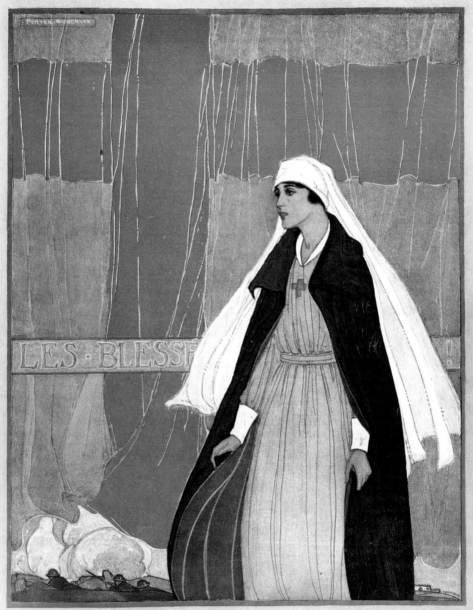

Late May 1918 CONDÉ NAST & CO One Shilling Net

LATE MAY 1918 Les Blessés

Although British *Vogue* was conceived and born at the height of war — and could not ignore it — the magazine initially tended to fight shy of graphic coverage in text or pictures. This ended in mid-1918 after the carnage of the Western Front could no longer be cast aside and the Allies were on the home straight to victory. *Vogue*'s careworn nurse stood for all that women had achieved during wartime. Behind a blood-red cross (more of a crucifix than a banner of safe deliverance, echoed at her breast and on the ambulance to the right of her) the trench warfare continued unabated. Our heroine partially obscures an exhortation she had clearly heeded: to aid *les blessés*, the wounded and dying.

Illustration by Porter Woodruff

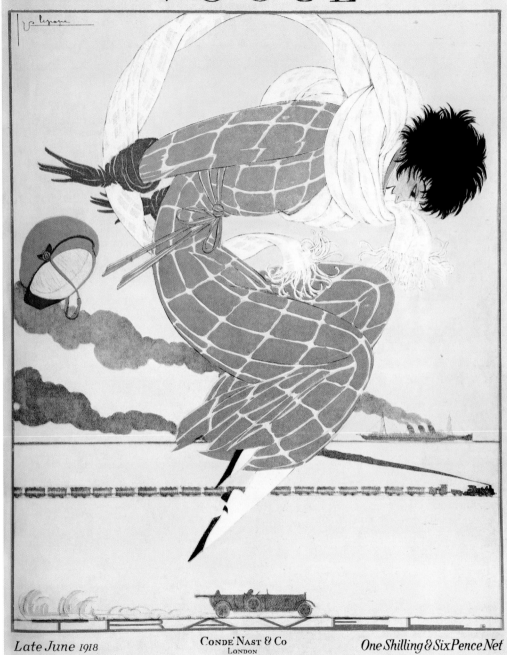

VOGUE

Late June 1918

CONDÉ NAST & CO
LONDON

One Shilling & Six Pence Net

LATE JUNE 1918 Summer Fashions Number

Georges Lepape's traveller, a little over-swathed for the summer months, is overcome by the choices open to her: ocean liner, railway and road. It was optimistic of her in the last year of the war, as the first was perilous (the U-boat threat), the second unreliable (timetables were in disarray) and the third unlikely (fuel was in short supply) — but *Vogue* was not necessarily, then as later, in the business of reflecting reality.

Illustration by Georges Lepape

VOGUE

LATE DECEMBER 1918 Christmas and After

Though the Armistice was signed in November 1918, *Vogue*'s festivities — due perhaps to production deadlines set long in advance — could not start until the Christmas number. Helen Dryden's celebratory cover focused on the deliverance of France, where so many Britons had fallen, and whose ragged tricolour reminded readers that victory came at a price. Of course, few serving men made it home in time for Christmas. In an article entitled 'The Strolling Players of the Trenches', the magazine reported on the drama companies and concert parties that had been dispatched to France to keep morale high.

Illustration by Helen Dryden

VOGUE

Early February 1919 CONDE NAST & CO.

EARLY FEBRUARY 1919 Early Signs and Portents

An often reproduced cover, one of Lepape's finest, particularly in the
skilful depiction of gently falling snow and the almost imperceptibly
shifting tones of grey. Lepape would become the greatest of *Vogue*'s
Art Deco stylists, and was the most prolific cover artist of its early
years. Between 1920 and 1930, he produced over 70 covers. His last
appeared in 1939, just as war broke out for a second time.

Illustration by Georges Lepape

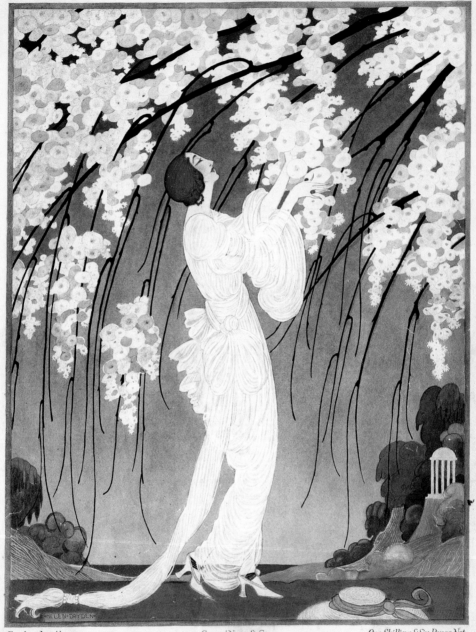

VOGUE

Early April 1919

CONDÉ NAST & Co
LONDON

One Shilling & Six Pence Net

EARLY APRIL 1919 Fashion for Light Hearts

The American artist Helen Dryden was one of *Vogue*'s longest-serving cover illustrators, her first appearing in 1912 and the last in 1923, when her naturalistic style gave way to the cleaner, more geometric lines of Art Deco. Here, her carefree, optimistic cover reflected the early years of peace — 'daffodils have more than begun to peer and every day brings us nearer to the light-heartedness of summer frocks and frivolities'.

Illustration by Helen Dryden

VOGUE

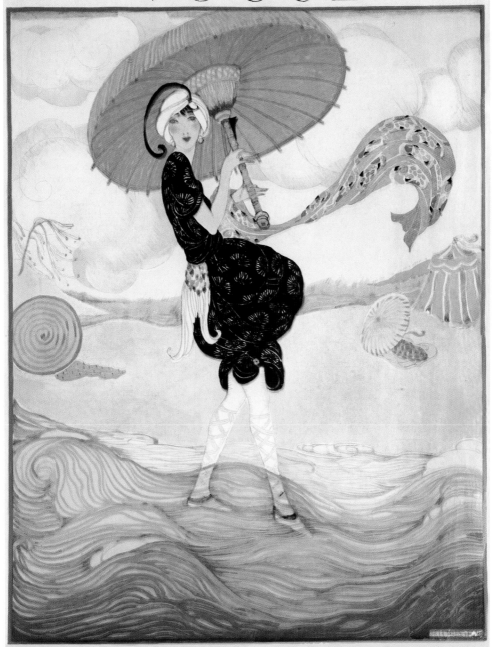

LATE JULY 1919 Summer Frocks of Silk

Dryden's languid style, always cheerfully coloured, owed much to the movements of a previous era — Art Nouveau in particular, and the fin-de-siècle enthusiasm for *japonisme*. To Condé Nast, she was vital in realising the visual tone that his modern magazine aimed to achieve. As Packer put it, 'She was evidently always aware of developments abroad and, rather more than that, quite prepared to demonstrate openly her sympathetic interest. No other of Nast's Americans was like her . . .' In 1914, recognising her poster-like style, the Café Moderne at New York's Majestic Hotel hung its walls with reproductions of her covers (with those of George Wolfe Plank and Frank Leyendecker).

Illustration by Helen Dryden

VOGUE

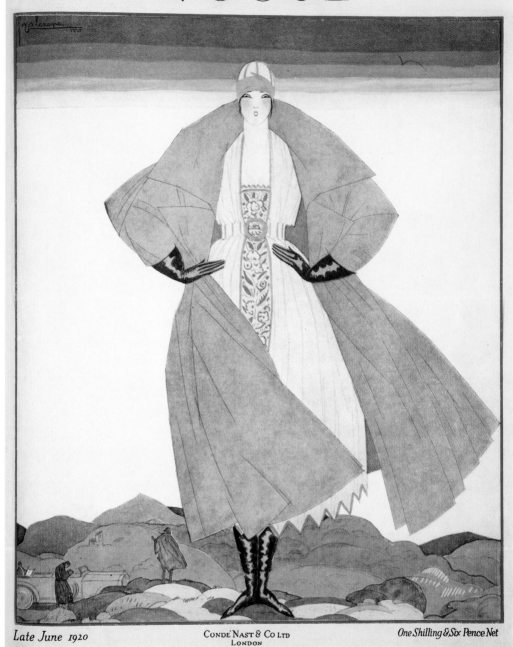

Late June 1920

CONDÉ NAST & CO LTD
LONDON

One Shilling & Six Pence Net

LATE JUNE 1920 Motoring from Silver Coast to Blue

The best of Lepape's covers spun some sort of quirky narrative in one self-contained illustration. This cover girl's expression reveals petulance or exasperation as, clearly on an inclement day, her conveyance has broken down or her fellow travellers have failed properly to consult their map.

Illustration by Georges Lepape

VOGUE

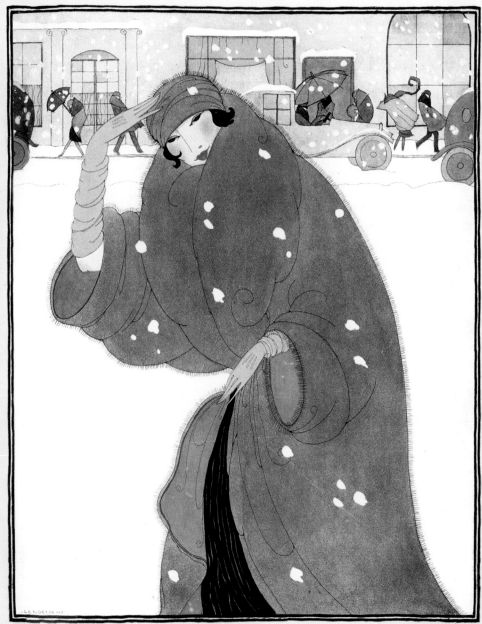

Early November 1920

CONDE NAST & CO LTD
LONDON

One Shilling & Six Pence Net

EARLY NOVEMBER 1920 Winter Fashions Number

This was a prolific year for Dryden, in which she produced perhaps her most famous cover. She was everything *Vogue* could wish for in a cover artist. She could change her style — one moment over-ornate, the next decorative, but always informative. Moreover, she was adept at showing what was on the fashion horizon (in this case the voluminous sleeve) and placing it firmly in an appropriate *mise-en-scène*.

Illustration by Helen Dryden

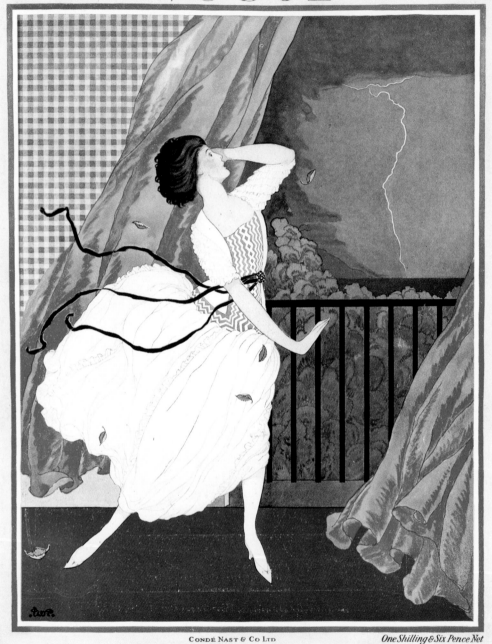

LATE JUNE 1921 Holiday Number

Plank's summer cover was one of his most dramatic — and startlingly expressive. The vertical jaggedness of the lightning outdoors mirrors the scene unfolding inside, with ribbons streaming horizontally from the unfortunate girl's waist. For a tableau that does not rely on intricacy for its impact, it is surprisingly full of well-observed detail, from the striations caused by the howling wind to the leaves fluttering slowly downwards.

Illustration by George Wolfe Plank

VOGUE

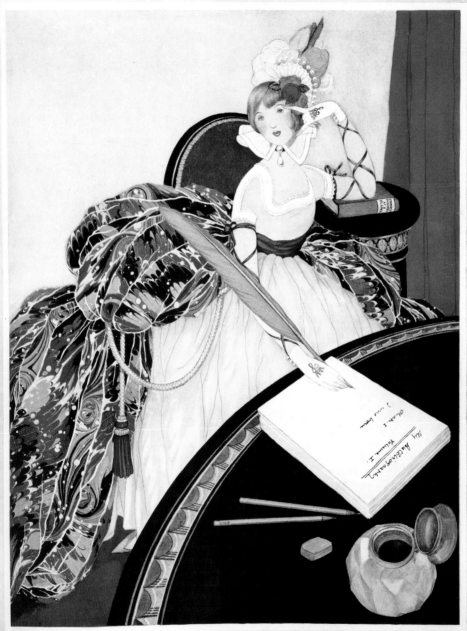

Early August 1921 CONDÉ NAST & CO LTD
 LONDON One Shilling & Six Pence Net

EARLY AUGUST 1921 Interior Decoration Number

An elaborately attired authoress *manquée* (of high birth, judging by the monogram on her gloved hands) finds it difficult, as so many do, to begin the story of her life. The French phrasebook may yet help the tenor of that first sentence. Plank's customary humour extends to the richly detailed pattern of her overskirts, replicating the marbled endpapers of many contemporary hardback books.

Illustration by George Wolfe Plank

VOGUE

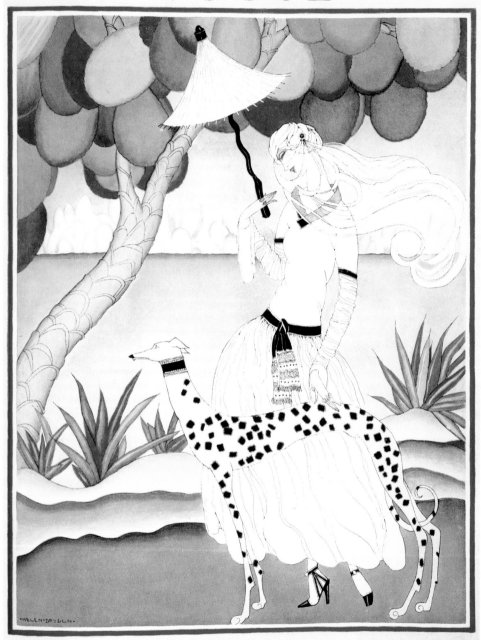

Late January 1922 CONDÉ NAST & CO. LTD One Shilling & Six Pence Net
LONDON

LATE JANUARY 1922 Riviera Number

Dryden's monochromatic dog and its matching *soignée* keeper make a striking partnership amid colourful, almost tropical, foliage. Oddly, where animals were concerned, on covers as well as on fashion plates, *Vogue*'s artists tended to strive for a degree of accuracy. This seems an exception: for a greyhound/Dalmatian cross to yield almost rhomboid markings (no doubt to harmonise with its owner) is highly unusual . . .

Illustration by Helen Dryden

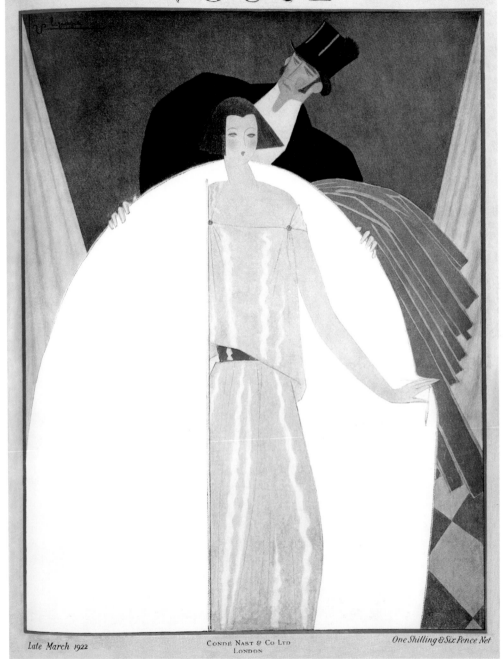

VOGUE

Late March 1922

CONDÉ NAST & CO LTD
LONDON

One Shilling & Six Pence Net

LATE MARCH 1922 Smart Spring Fashions

An uncluttered Modernist cover in which the shimmering gown of a geometrically hairstyled partygoer is revealed by social nicety on the part of her angular companion. 'Vogue knows what the new silhouette will be, the exact length of skirts, the favourite sleeves, the correct colours, the trimmings, the collars, the girdles — in fact, there is nothing Vogue does not know about the new mode . . .'

Illustration by Georges Lepape

VOGUE

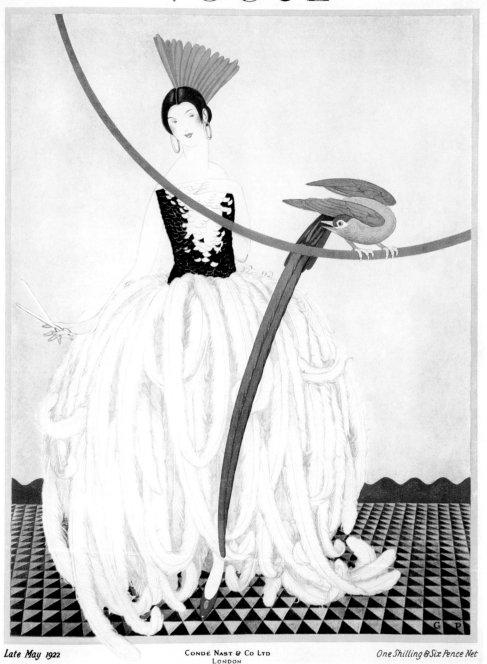

Late May 1922 CONDÉ NAST & CO LTD
LONDON *One Shilling & Six Pence Net*

LATE MAY 1922 Ascot Number

Despite the bloodletting on the cover of Early August 1917 (page 11), *Vogue* covers were not in the business of endorsing gratuitous animal harm. Nor did they necessarily mean to promote a cruel sense of impending dread. This gaily coloured cover possesses a strong atmosphere of foreboding (which the intuitive bird of paradise is not slow to notice), but the accent is firmly tongue-in-cheek. We think.

Illustration by George Wolfe Plank

VOGUE

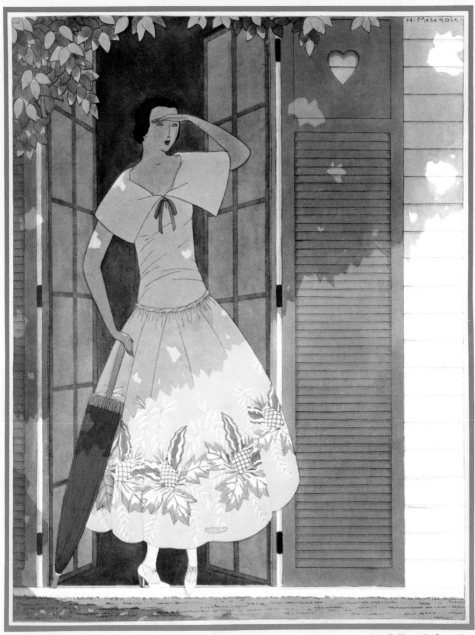

Early June 1922 CONDE NAST & CO LTD One Shilling & Six Pence Net
LONDON

EARLY JUNE 1922 Summer Fashions Number

'June, the month of roses and romance, is the time of all others for the delicate frocks and the gayest of colours.' Harriet Meserole's vignette of an early summer's morning is unusual for its chiaroscuro. Most *Vogue* covers tended to be bathed entirely in light.

Illustration by Harriet Meserole

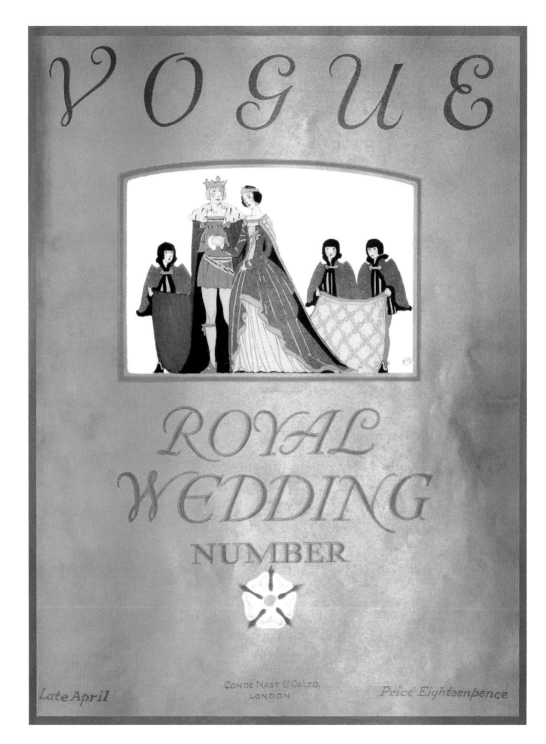

LATE APRIL 1923 Royal Wedding Number

A vignette in faux-medieval style celebrates the wedding of the future
George VI to Elizabeth Bowes-Lyon. Royal weddings, though infrequent,
were much anticipated by *Vogue*. The first covered was that of Princess
Mary, George V's only daughter, to Viscount Lascelles. It marked the start
of a particularly British style of breathless reportage: 'It was indeed a
Fairy Princess with Youth, Beauty and Happiness as her attendants . . .'

Illustration by Frederick T. Chapman

LATE SEPTEMBER 1923 Forecast of Autumn Fashions

When a magazine reduces its price, you can be sure something behind the scenes has gone horribly wrong. This is it: in 1922 *Vogue*'s editor, Elspeth Champcommunal, was fired, replaced by the literary intellectual Dorothy Todd. For those who loved the arts, Todd's tenure was a golden age — Aldous Huxley reviewed books, Gertrude Stein and Edith Sitwell contributed poems, and Virginia Woolf wrote perceptive commentaries. The fashion pages, however, were all but neglected. For the first time *Vogue* began to lose money, and advertisers deserted the magazine. Condé Nast seriously considered pulling out of Britain; only the memory of its extraordinary success during the war halted him.

Illustration by Georges Lepape

31

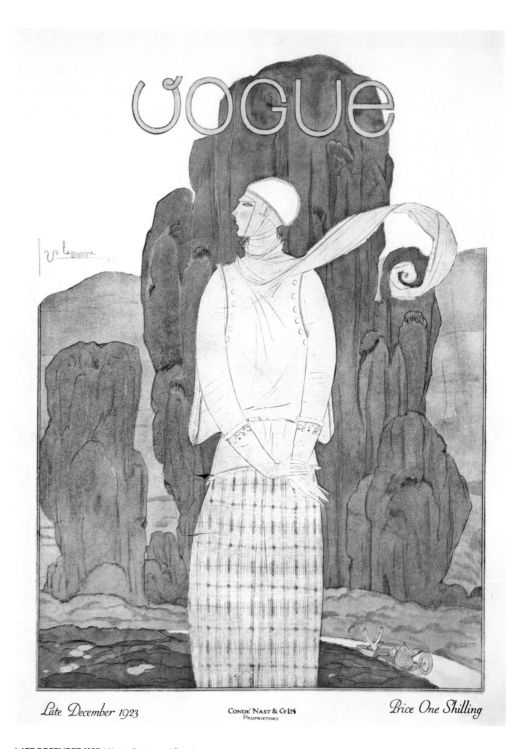

LATE DECEMBER 1923 Winter Sports and Travel

When *Vogue* celebrated its golden jubilee in 1966, it used this cover to sum up the Twenties and offered this tribute to its creator, Lepape (the greatest, it considered, of *Vogue* cover artists in an era when the art of fashion illustration was at its zenith): 'It was he who took fashion drawing out of a vacuum and put it into context. His backgrounds were dramatic, and perfect for the mood of his model.'

Illustration by Georges Lepape

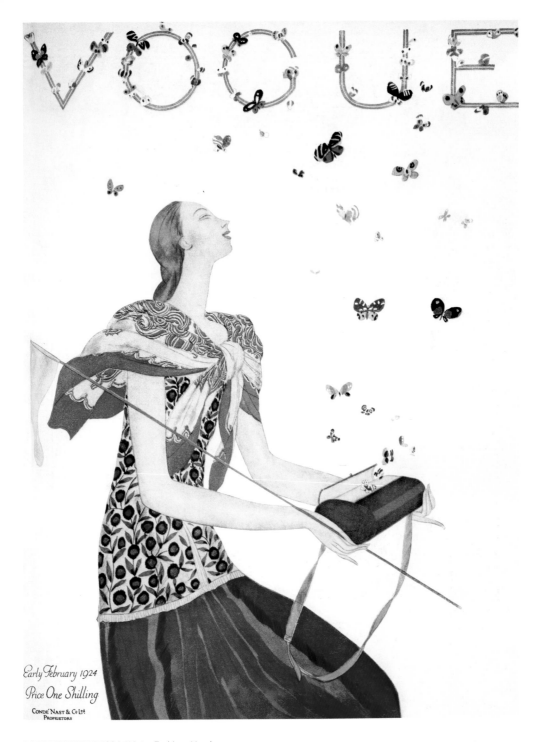

EARLY FEBRUARY 1924 Winter Fashions Number

Eduardo Benito's tally of 144 covers for US *Vogue* (many of which filtered through to the British edition) makes him the most prolific of *Vogue's* cover illustrators. He had started illustrating for the magazine in 1921, but it would be several more years until he got into his stride. He is best known for his drawings of Brancusi-like heads, but this pretty confection was typical of his early style, which owed much to his colleague Lepape.

Illustration by Eduardo Benito

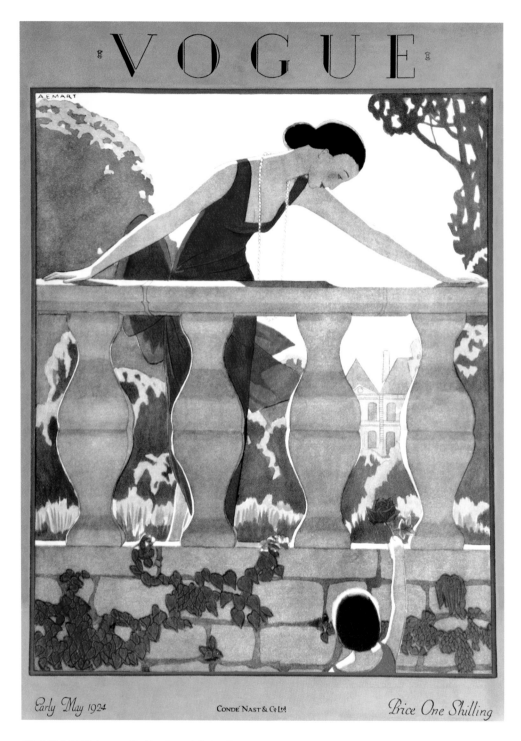

EARLY MAY 1924 Summer Fashion Steps Gaily into Print

André-Edouard Marty had first worked for *La Gazette du Bon Ton*, the exquisite and influential magazine devoted to fashion (and fashion illustration) founded in 1911 by Lucien Vogel and Michel de Brunhoff. *Bon Ton*'s influence on Condé Nast's vision of *Vogue* was considerable and its artists — chiefly Marty, Pierre Brissaud and Lepape — would become his stars when *Bon Ton* was forced to close during World War I.

It reopened in 1920, but by 1921 Nast had bought it, thereby bringing Eduardo Benito and Pierre Mourgue to *Vogue*. *Bon Ton* continued in fits and starts until 1925, when Nast closed its doors for ever.

Illustration by André-Edouard Marty

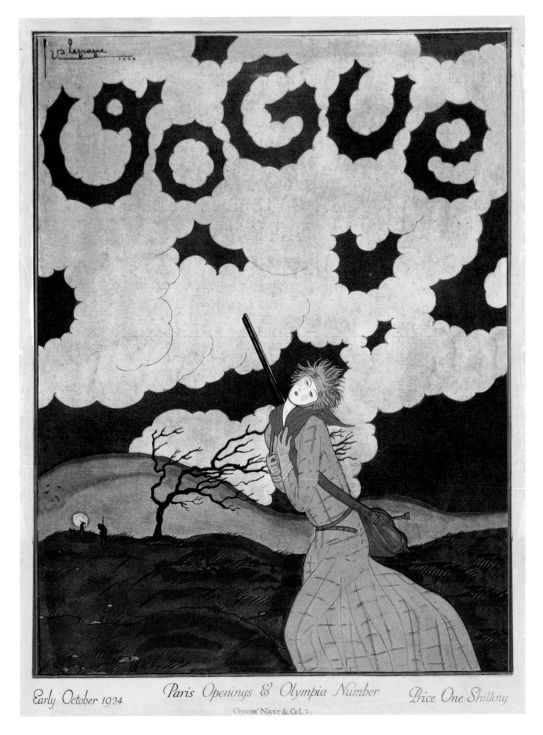

EARLY OCTOBER 1924 Paris Openings and Olympia Number

An alarming, crepuscular cover by Georges Lepape shows the shooting season in full swing. The clouds descending on a bleak, wind-blasted landscape, while reassuringly spelling out the familiar logo, threaten to engulf *Vogue*'s lady gun. Her colleagues — still loading in the background, almost by the light of the moon — may yet discern her from afar by the vividness of her orange tweeds. Field sports were not, it seems, the only pastime currently *à la mode*. This issue dedicated a double-page spread to 'Outstanding Figures in British Golf'. Another feature, 'Life out of Town Offers a Variety of Entertainment', concentrated on precisely two: hunting with the Bicester and horse racing in Scotland.

Illustration by Georges Lepape

35

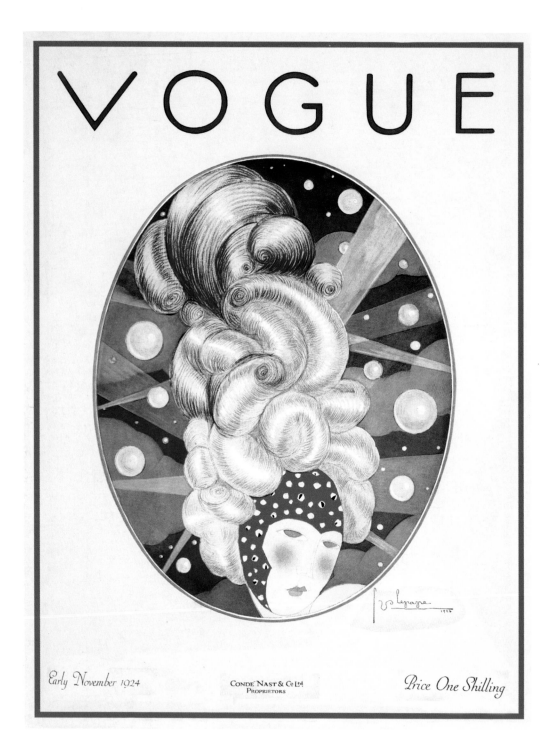

VOGUE

Early November 1924

CONDE NAST & Co Ltd
PROPRIETORS

Price One Shilling

EARLY NOVEMBER 1924 Winter Sports and Travel Number

A futuristic vignette from the imagination of Lepape. The colossal plumed headdress atop a close-fitting helmet was impractical for any pedestrian travel plans, let alone a galactic voyage. And strange new worlds were not what *Vogue* had in mind when it suggested that London 'numbers among its fascinations that of being charmingly easy to get away from'. It was thinking of something nearer: 'the sunlit snows of Switzerland'.

Illustration by Georges Lepape

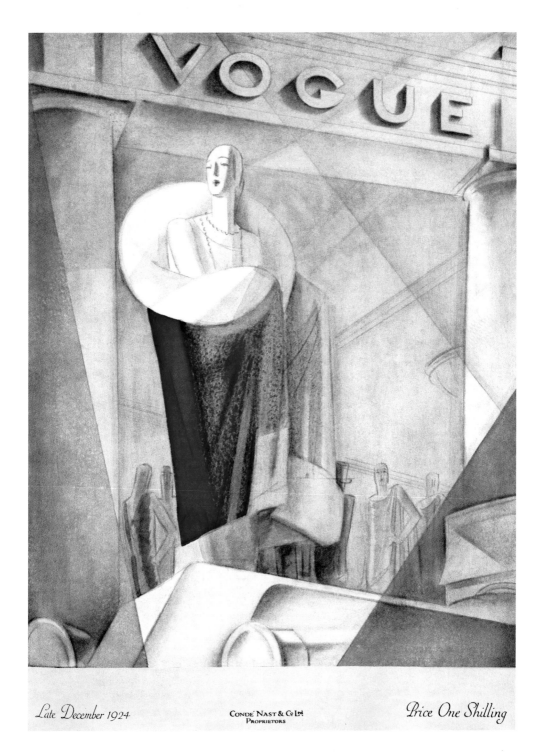

Late December 1924

Condé Nast & Co Ltd
PROPRIETORS

Price One Shilling

LATE DECEMBER 1924 In the Name of Vanity

Benito's style shifts towards Art Deco, the newest movement. Influenced, he claimed, by the sharp lines that only machinery could make, this heralds a new era for *Vogue*'s covers. Geometrics fought to replace the highly decorative, and occasionally, as here, won out.

Illustration by Eduardo Benito

VOGUE

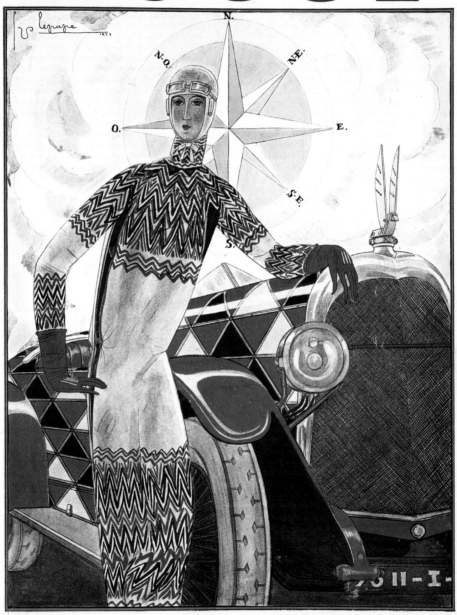

LATE JANUARY 1925 Speed, the New Vice

For *Vogue*, Modernism was at its most expressive when allied to ease of travel. 'Speed is not a disorder,' it warned readers, 'but a new order to which it will be necessary to adjust.' And nothing could make a more alluring cover than a fashionable androgyne in driving gauntlets, set fair for all points of the compass. The exaggerated zigzags of her shift, mirrored in the car's bodywork, are recurring motifs of Art Deco.

Illustration by Georges Lepape

VOGUE

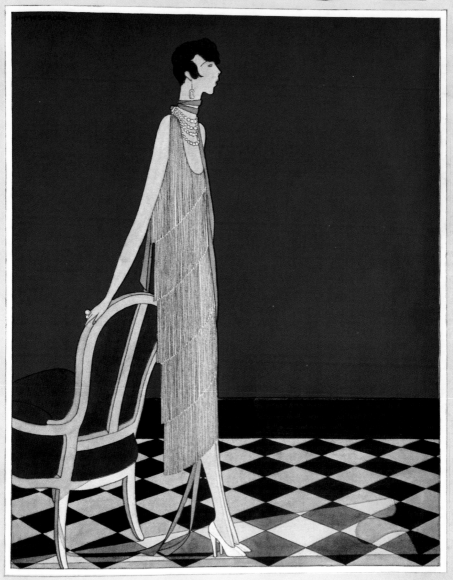

Early September 1925 Condé Nast & Co. Ltd. Proprietors Price One Shilling

EARLY SEPTEMBER 1925 The New Silhouette

By now, *Vogue* covers began to reflect fashion as it might be seen (albeit in certain rarefied drawing rooms across the land). Still a little stylised, Meserole's illustration presents — in tiered and shimmering tea-frock, and with hair neatly shingled — the spirit of the age.

Illustration by Harriet Meserole

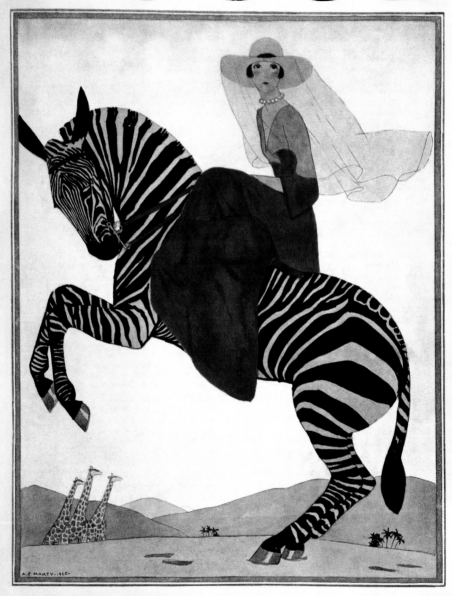

VOGUE

Late January 1926 Condé Nast & Co Ltd Proprietors Price One Shilling

LATE JANUARY 1926 Spring Fabrics and Original Vogue Designs

A celebrated cover that put Marty firmly on the map — and into the papers. *Vogue* was thrilled with this meditation from the *New York Herald Tribune*: 'On the cover of one of those delightful magazines by which Mr Condé Nast almost persuades us that style is an American invention, a lady recently rode a prancing steed. She sat side-saddle, clad in a habit of Victorian length, and cast upon the reader a glance of intense modesty. Nothing could have been more prim and conventional, save that the mount was a zebra . . . We [ought to] know at a glance the ancient and inevitable meaning of a zebra thus accoutred. But we suspect that Mr Nast can take his symbols and leave them alone.'

Illustration by André-Edouard Marty

VOGUE

Early February 1926 CONDÉ NAST & CO LTD PROPRIETORS Price One Shilling

EARLY FEBRUARY 1926 Spring Fashion Forecast

Vogue's forecast included this classic tea-gown with billowing scarf tied under the collar. The pretty chiffon ruffle-cuffed blouse was mirrored in a fashion fable drawn for this issue by Marty's colleague Eduardo Benito: 'Sophie Discovers Herself'.

Illustration by André-Edouard Marty

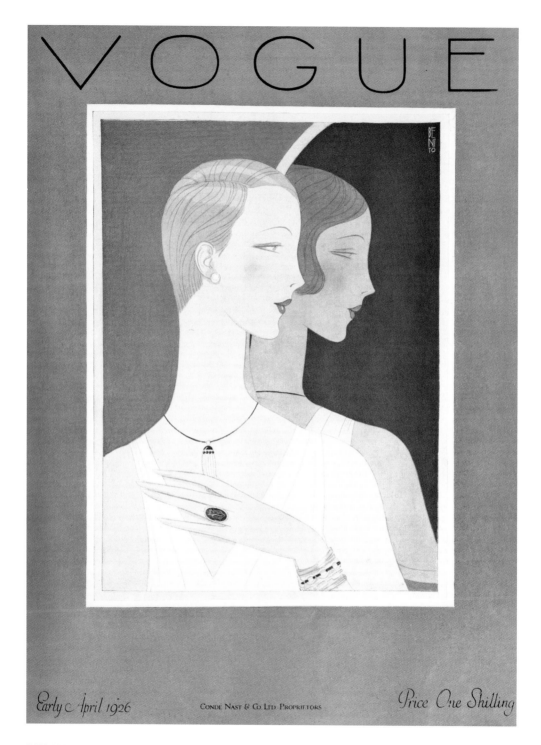

VOGUE

Early April 1926

CONDÉ NAST & CO. LTD. PROPRIETORS

Price One Shilling

EARLY APRIL 1926 Those Personal Touches

Unusually, author Aldous Huxley supplied text for the Paris collections coverage — a series of well-observed *aperçus*. Benito, meanwhile, was contributing much besides the cover. 'A Few Important Stages in a Prima Donna's Development' showcased his fashion illustration.

Illustration by Eduardo Benito

EARLY MAY 1926 Smart Fashions at Moderate Cost

This is Benito at his apogee. As William Packer notes: 'Through the summer and autumn months, he produces a spectacular series of images that quite literally overwhelm anything else. [This] is certainly one of the very best of all *Vogue* covers, the archetypal Deco image that burst upon an unsuspecting world on May Day. She is quite magnificent; her white Brancusi head is set alight by scarlet lips and golden pendants and the whole vision is thrown forward by the scarlet, black and golden rays of what might just as well be an enormous collar as a mirror.' Or a telltale V for *Vogue* in the prevailing style.

Illustration by Eduardo Benito

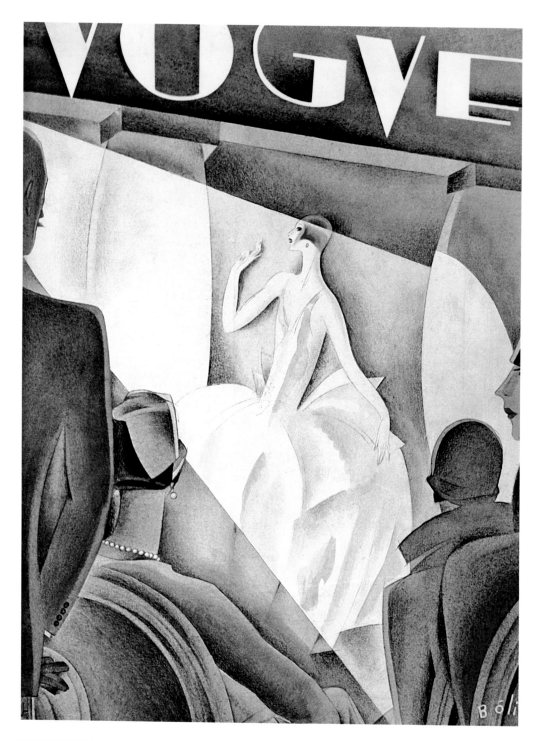

EARLY JUNE 1926 Summer Holidays and Travel

A masterpiece in miniature of Twenties style by Guillermo Bolin, an illustrator who all but outdid Benito in angularity and Deco geometry. This vignette is almost filmic in its crafted use of light and shade.

Illustration by Guillermo Bolin

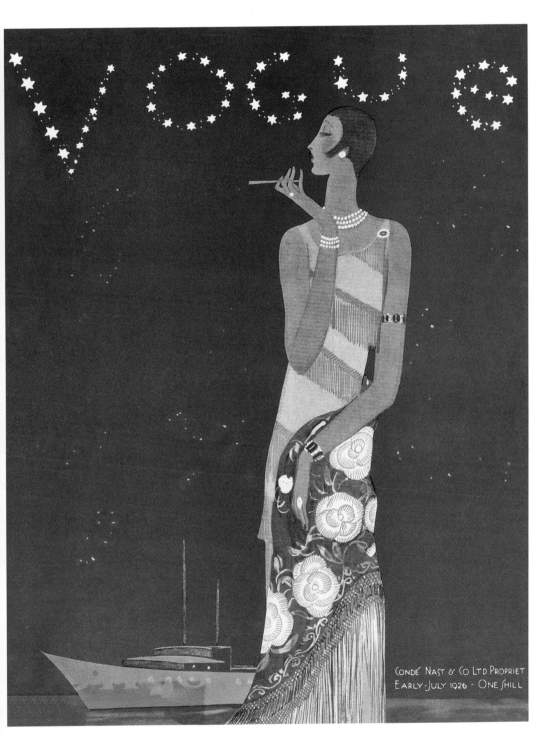

EARLY JULY 1926 Vogue Constellation

Although the location is more likely to be the French Riviera than the English (for *Vogue* readers, Cannes would always win over Torquay), this is a fine example of Benito's mastery. He was adroit at incorporating the *Vogue* logo into the whole of a design, and in this instance the stars spell out the name in the still cool of the evening. His attention to detail was impressive, too. Here he reminds *Vogue*'s readers that evening temperatures drop even in sultry, romantic settings, and so he has included the season's must-have: a silk shawl with heavy fringing and embroidered with peonies. Such oriental motifs found great favour in the mid-Twenties.

Illustration by Eduardo Benito

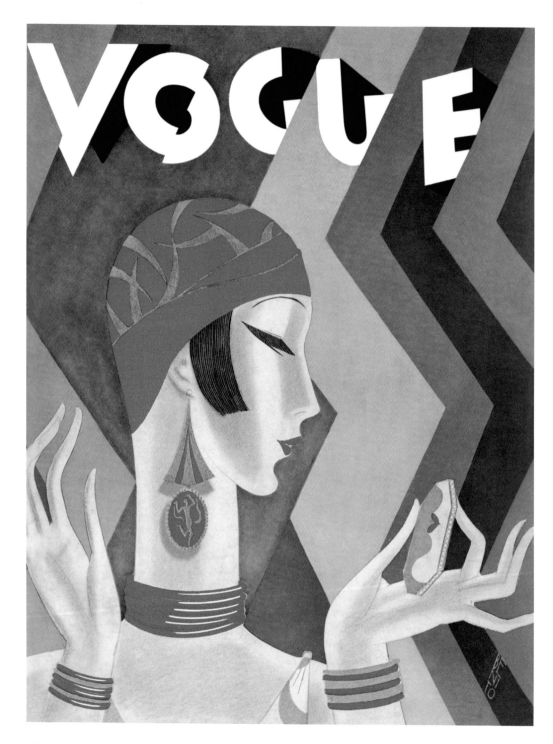

LATE JULY 1926 Hot Weather Fashions

The theme of the mirror and its qualities of reflection and distortion are brought home in this single cover. The individual letters of *Vogue*'s logo begin to slip as Benito's subject examines her compact.

Illustration by Eduardo Benito

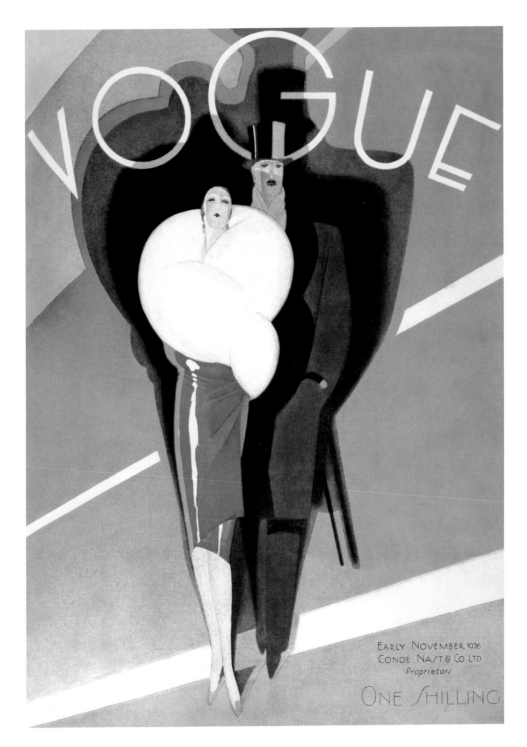

EARLY NOVEMBER 1926 The Evening Mode

Bolin's *soigné* couple are caught in the glare of a frontal spotlight
that casts a great shadow in their wake. That their silhouette almost
forms a V-shape is a fortuitous side effect.

Illustration by Guillermo Bolin

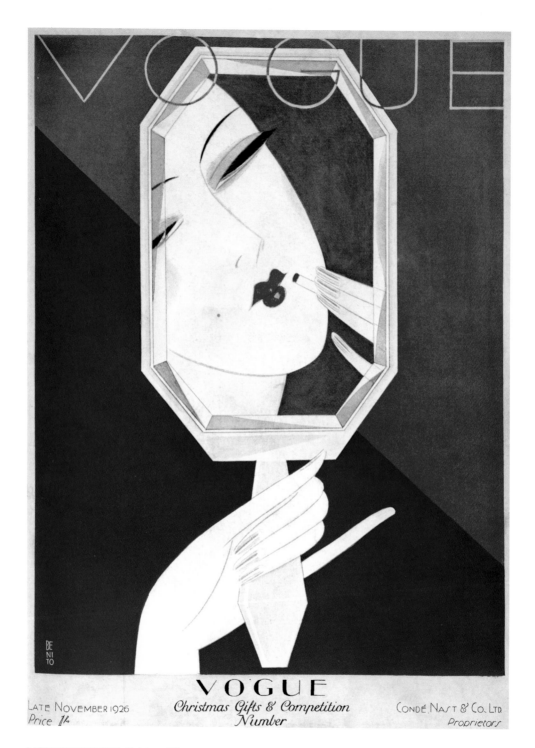

LATE NOVEMBER 1926 Christmas Gifts

Beauty reflected in a hand-mirror was not a novel concept for a *Vogue* cover, but rarely was it so supremely rendered as here, by Benito. The face in the glass owes much to a by-then-unfashionable enthusiasm for the Japanese woodcuts of Utamaro.

Illustration by Eduardo Benito

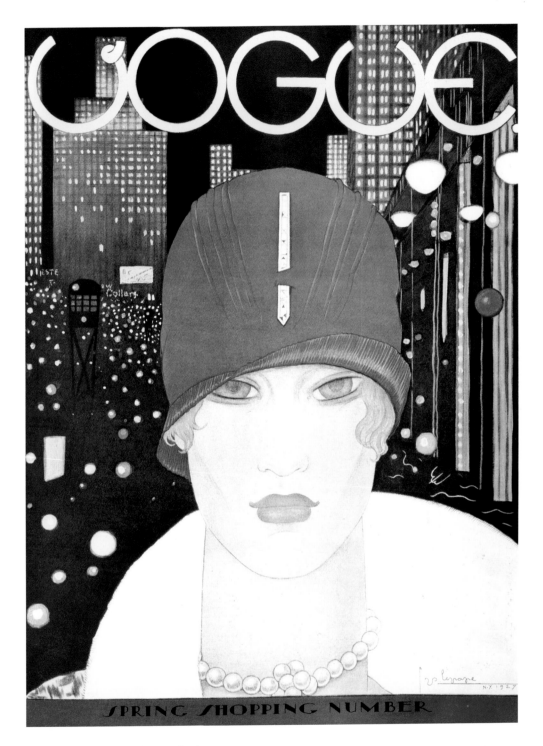

LATE MARCH 1927 Spring Shopping Number

The model and photographer Lee Miller's introduction to *Vogue* was as unconventional as anything in her extraordinary life. Years before her unexpected war dispatches to *Vogue*, she slipped off a Manhattan sidewalk and into the path of an oncoming car. She was dragged back to safety by the magazine's proprietor, Condé Nast, who was enchanted enough to offer her modelling assignments. She was an instant success

— her first appearance was on this cover by Lepape, the diamanté pin of her cloche reflecting the lights of Manhattan. Though her features are rather severely rendered, the eyes that struck Nast are unmistakable.

Illustration by Georges Lepape. Model: Lee Miller

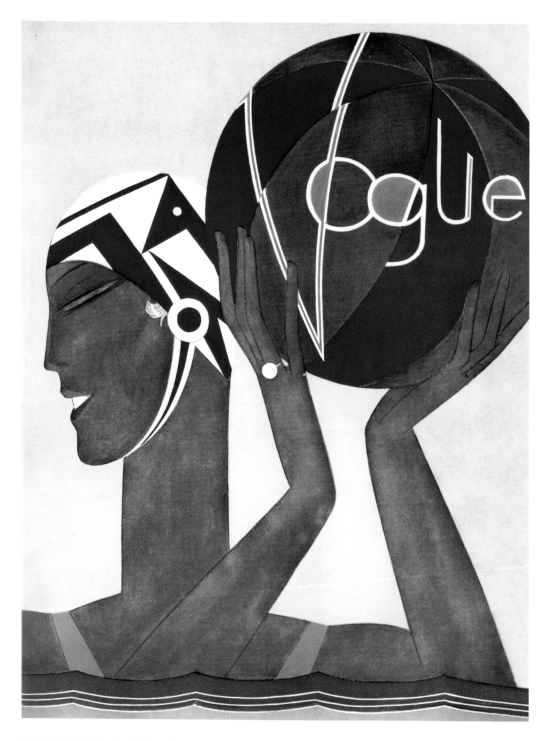

EARLY JULY 1927 The New Bathing Costume

Pierre Brissaud's angular beach cover would find an unconscious parallel in *Vogue*'s first photographic cover, published five years later (see page 76). As well as his eye-catching fashion drawings, Brissaud had a parallel career as an illustrator of advertisements for Peugeot, which have now become collectors' items. He was also a prolific illustrator of classic French novels, such as *Madame Bovary* and the works of Anatole France.

Illustration by Pierre Brissaud

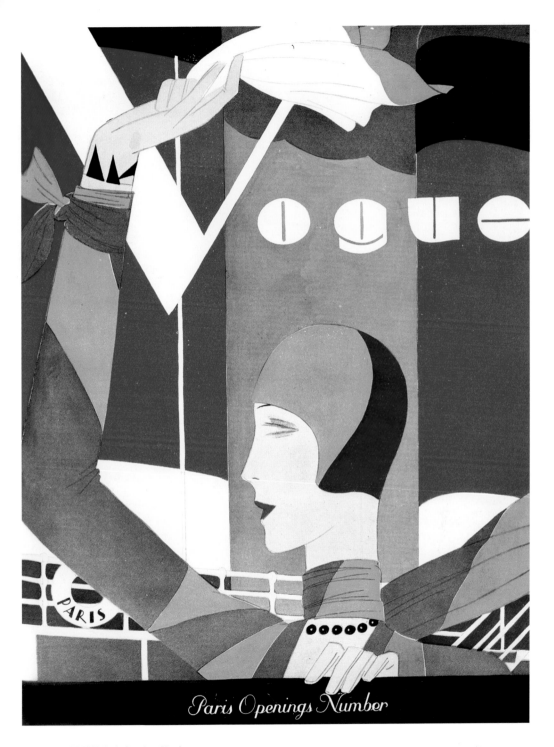

Paris Openings Number

21 SEPTEMBER 1927 Paris Openings Number

Another Art Deco profile by Benito extols the art of travel in a linear series of panels, while admitting, on a lifebelt, this issue's central message: the news from Paris. The arm of *Vogue*'s transatlantic traveller is artificially elongated to fit in with the harmonious series of verticals; her patterned wardrobe dovetails with the prevailing shapes of the oceanic backdrop. A valedictory handkerchief stands in for the smoke of the funnel behind her. (This month *Vogue* changed the bi-monthly dates of issue, as shown on the cover, from 'Early' and 'Late' to two distinct calendar dates. This would continue throughout the next decade until the outbreak of war in 1939, when the magazine became, for the first time, a monthly.)

Illustration by Eduardo Benito

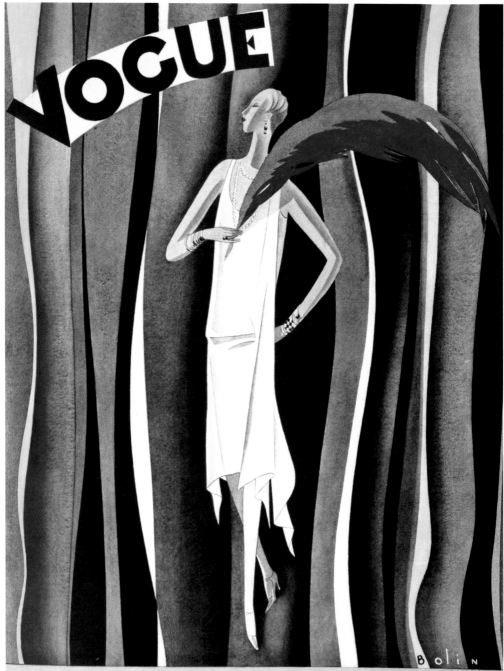

19 OCTOBER 1927 Smart Fashions for Limited Incomes

Bolin's cover sets a handkerchief-hemlined gown against a forbidding, arboreal backdrop. His cover girl — walking, it seems, on air — appears to brush off the hint of all-enveloping darkness with nonchalance and a large russet ostrich feather. This issue's features included 'Morning Hours of the Younger Generation'. Perhaps this was Bolin's account of how, for the party-going young, those wee hours were sometimes spent . . .

Illustration by Guillermo Bolin

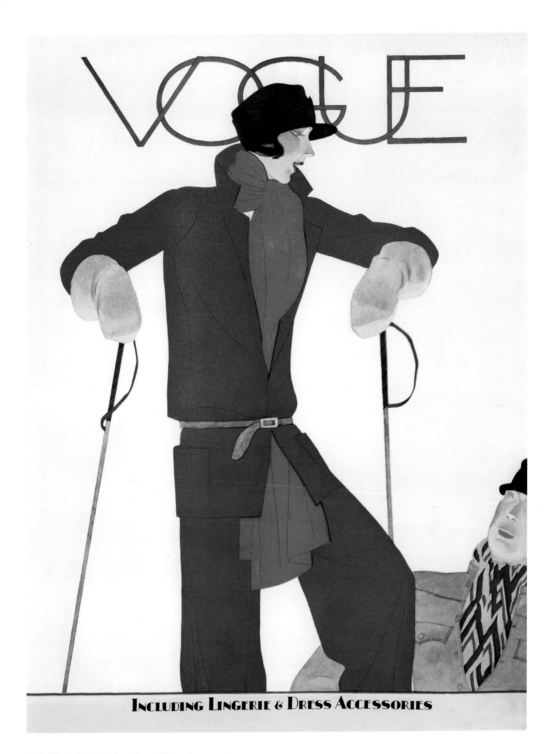

14 DECEMBER 1927 Lingerie and Dress Accessories

Vogue's editorial ignored this month's themes in favour of something more pressing than underwear and shoes: 'And here we can make an important announcement. One of *Vogue*'s special plans for the coming year is a series of articles by Augustus John on the works of other artists. These articles will constitute Mr. John's first published art criticisms and are a matter of unique interest.'

Illustration by Pierre Mourgue

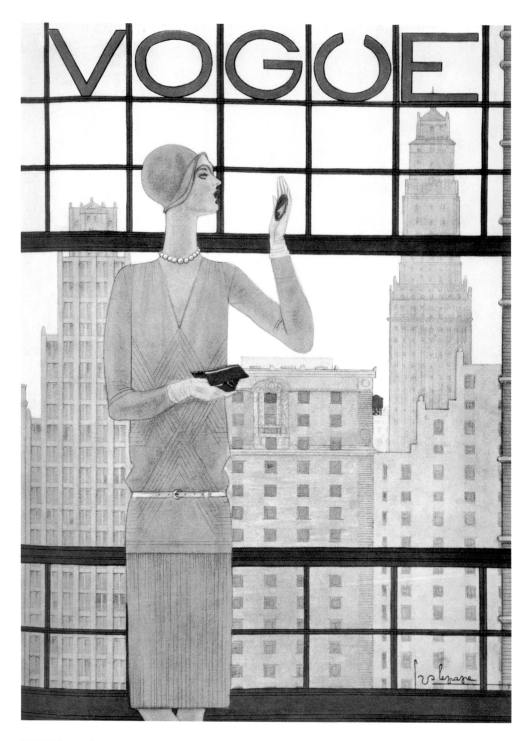

2 MAY 1928 London Season Number

The motif of the Manhattan skyline observed through the tall window of a towering apartment block was a theme that recurred in *Vogue*'s covers, twice in 1928 alone. Pierre Mourgue's — from exactly the same vantage point — predated this more elegant Lepape cover by just over a fortnight. Lepape's exaggeratedly elongated model wears the dropped-waist silhouette popularised first by Chéruit and then by Chanel. That she is adroit is irrefutable (few finessed make-up with gloved hands); that she is also audacious is borne out by the plunging V-line of her *décolleté*, unthinkable in *Vogue* even a few years earlier.

Illustration by Georges Lepape

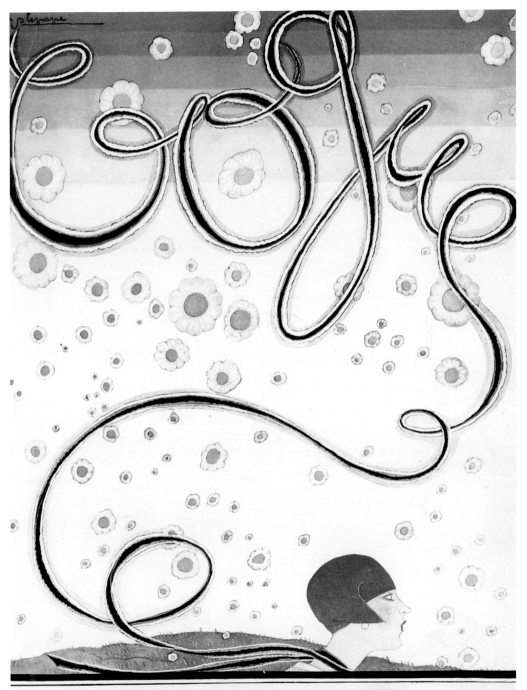

Paris Forecast & Clothes for Scotland

25 JULY 1928 Paris Forecast and Clothes for Scotland

The proliferation of storm-tossed heroines in high summer downpours showed that *Vogue* had no illusions about the British climate, as well as a keen sense of humour. Here Lepape is at his most mischievous (and his most typographically witty). Lepape's bright-eyed *chauffeuse* speeds across the Scots 'braes' in a close-fitting cloche hat, trailing her up-to-the-minute scarf in the fresh northern winds. Beautiful, certainly, and fashionable, but long trailing scarves came with a caveat. Less than a year earlier, in September 1927, the dancer Isadora Duncan had met a dramatic end. Her scarf, long and trailing, wrapped itself around the rear wheel of a convertible roadster. The car moved off and she was strangled.

Illustration by Georges Lepape

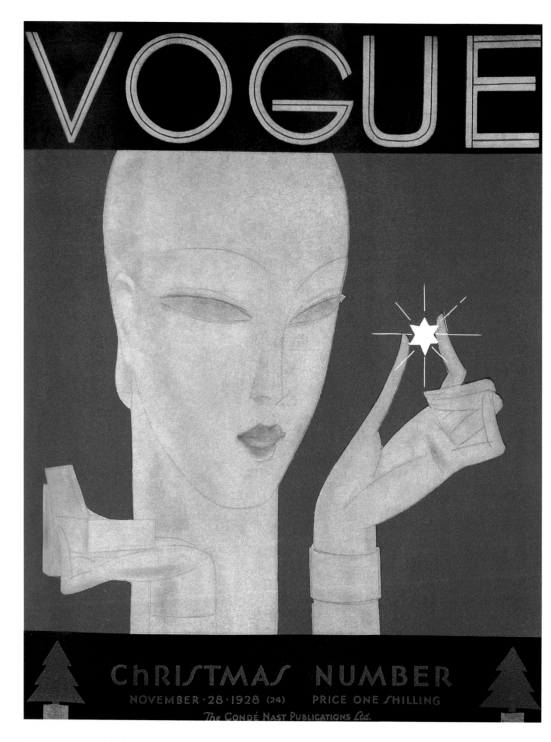

28 NOVEMBER 1928 Christmas Number

A sculptural head admires something seasonal plucked, it seems, from the firmament: a sparkling jewel or a Christmas star. A pertinent question regarding gift-giving was raised by *Vogue*'s leading article in this celebratory issue: 'Are Our Friends Worthy of It?'

Illustration by Eduardo Benito

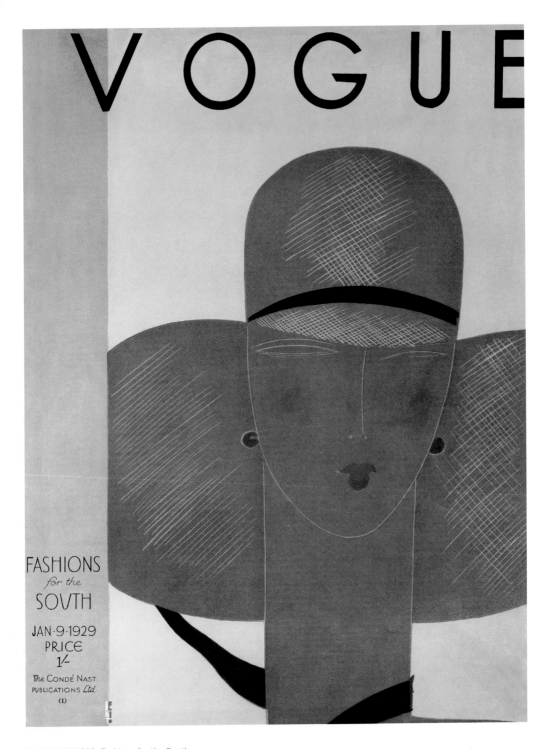

9 JANUARY 1929 Fashions for the South

Apart from spearheading new directions for the graphic arts, Benito's covers often reflected social changes and influences at play. A touch of Brancusi or Modigliani is evident in this sparsely drawn head with cross-hatched summer hat. Though this reflects the flat tones of the period, as the Thirties dawned, Benito's girls became leaner and more bronzed, as for the first time pale-skinned beauty began to look somewhat *démodée*.

Illustration by Eduardo Benito

6 FEBRUARY 1929 Spring Fabrics and Vogue Patterns

Of *Vogue*'s 24 covers this year, Lepape and Benito account for 10 each. This is Lepape's first, reprising the typographic effect of his swirling scarf from the previous July (see page 55). This time his model stands on tiptoe to achieve her irresistible objective: some graffiti on a blank wall.

Illustration by Georges Lepape

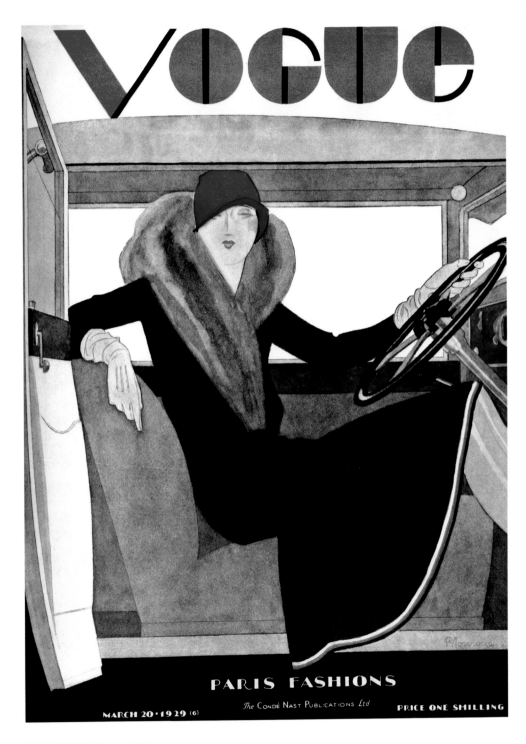

VOGUE

PARIS FASHIONS

The CONDÉ NAST PUBLICATIONS *Ltd*

MARCH 20·1929 (6)

PRICE ONE SHILLING

20 MARCH 1929 Paris Fashions

Another refugee from *La Gazette du Bon Ton*, Pierre Mourgue travelled
regularly to New York to absorb its modes and manners. His illustrations,
however, were keenly sought for his innate Parisian wit and flair. This
was the embodiment of what *Vogue* called 'smartness' — 'a quality and
a word that especially fits the needs of a rapid action and an existence
as swift, as highly geared and as brightly coloured as a racing car'.

Illustration by Pierre Mourgue

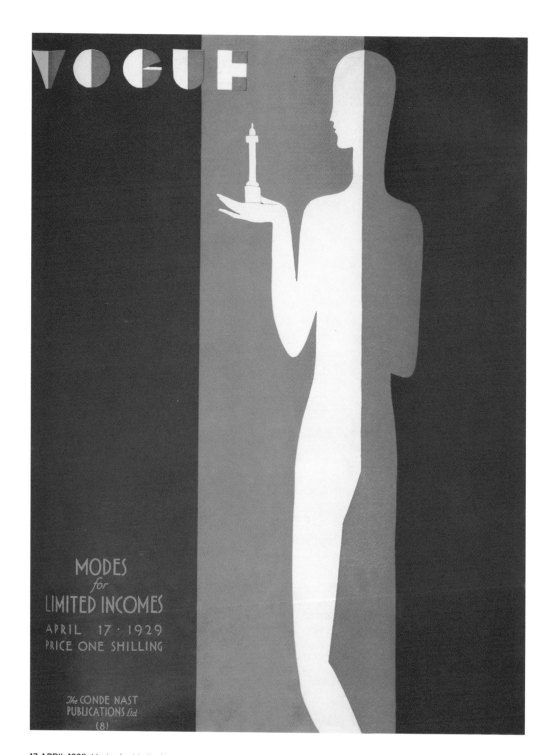

17 APRIL 1929 Modes for Limited Incomes

One of Benito's starkest covers, in three panels. So prolific was Benito and so utter his understanding of Condé Nast's vision for the magazine, that in 1927 he was offered the art directorship of *Vogue*. He turned the opportunity down, saying: 'I don't want to go into the office every day.' Instead the post went to a fearsomely intellectual doctor of political science. Dr Mehemed Fehmy Agha was Turkish and trained in graphic design at the Bauhaus; it was observed of him that he was 'a man who knew too much ever to like anything'. Clearly what he *did* like was the Bauhaus ethos of 'form follows function'; it is most manifest here in the typography of the *Vogue* logo, in which each letter is a sparse cipher.

Illustration by Eduardo Benito

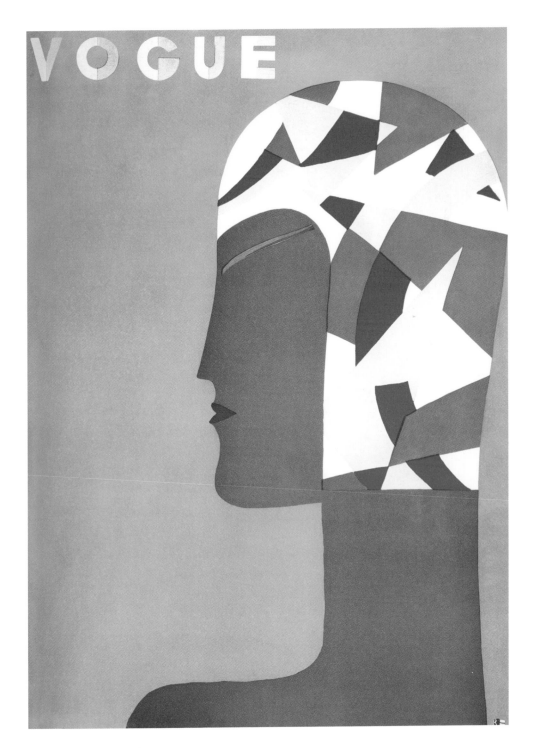

10 JULY 1929 Midsummer Fashions

In a memo to Condé Nast, Benito outlined — in a futuristic typeface — his thoughts on magazine design in the age of the machine: 'Let us realise that we are living at a time when for the first time, thanks to machinery, we are living in an effective collaboration with the pure geometric forms . . . Modern aesthetics can be explained in one word: machinery. Machinery is geometry in action . . . The setting up of a magazine page is a form of architecture, it must be simple, pure, clear, legible like a modern architect's plan, and as we do a modern magazine we must do it like modern architecture.'

Illustration by Eduardo Benito

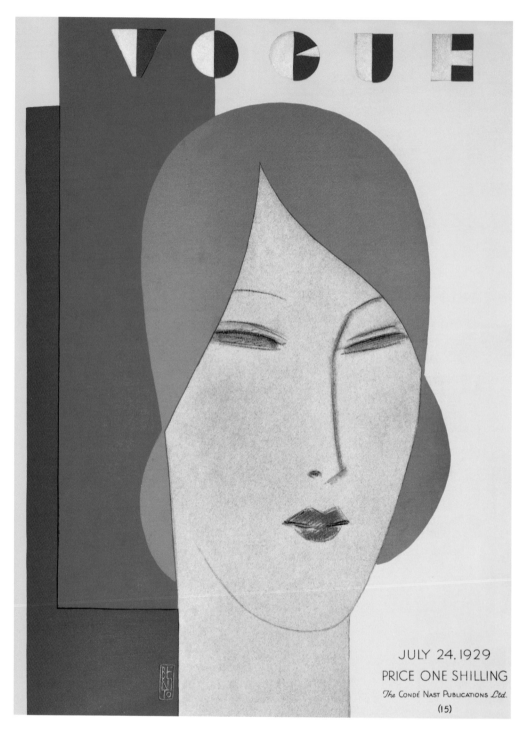

24 JULY 1929 Autumn Forecast

Benito's signature here is encased in a cartouche, echoing the hieroglyphs of Ancient Egypt. The discovery of Tutankhamen's tomb in 1922 led to a fascination with Egypt which lasted for the rest of the decade.

Illustration by Eduardo Benito

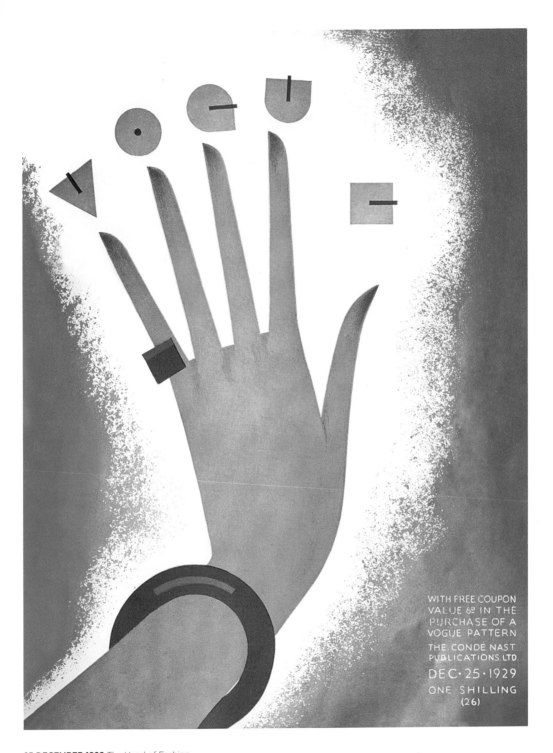

WITH FREE COUPON
VALUE 6ᴰ IN THE
PURCHASE OF A
VOGUE PATTERN
THE CONDÉ NAST
PUBLICATIONS LTD
DEC·25·1929
ONE SHILLING
(26)

25 DECEMBER 1929 The Hand of Fashion

'The hand of fashion [with *Vogue* at its fingertips] is reaching for beauty this season as never before. No longer does the smart woman wear jewellery of a few seasons past. Stones are larger, more beautifully cut, and settings are intricate and strikingly modern.'

Illustration by Guillermo Bolin

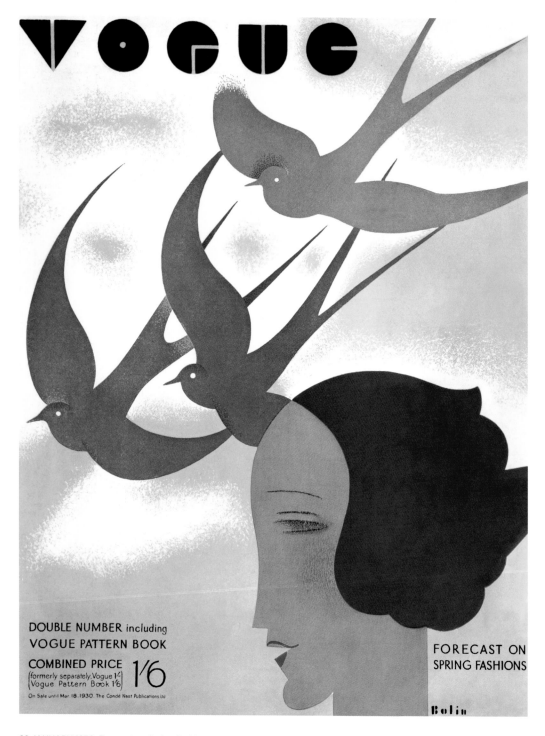

22 JANUARY 1930 Forecast on Spring Fashions

Bolin's forecast for spring makes a central theme of three swallows, although these are traditionally harbingers of summer. Bolin was picked out — along with Jean Pagès, André-Edouard Marty and others — in a memorandum that outlined the aesthetic inclination of the proprietor. '*Vogue*'s desire,' wrote Condé Nast, 'is to promote all that is new in art (so long as it is inherently good and has the intangible quality of chic that characterises all the material in the magazine), regardless of whether it belongs to the literal school of art or to the imaginative school — a school that cannot be explained accurately through the medium of words.'

Illustration by Guillermo Bolin

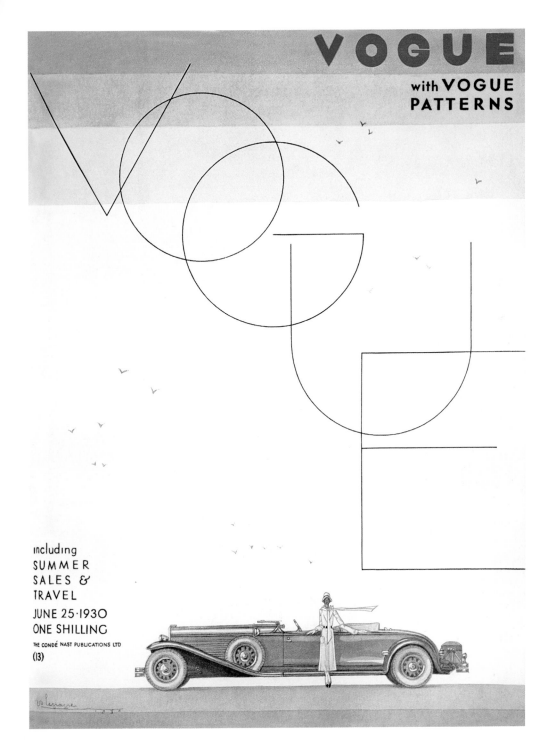

VOGUE

with **VOGUE PATTERNS**

including
**SUMMER
SALES &
TRAVEL**

JUNE 25·1930
ONE SHILLING

THE CONDÉ NAST PUBLICATIONS LTD
(13)

25 JUNE 1930 Summer Sales and Travel

The fascination with speed and travel continues with Lepape's elongated convertible. *Vogue*'s guide to the best destinations included Le Touquet ('all the smart people are to be seen there'), Scotland ('you must think of your tweeds and teagowns') and 'a golfing motor tour' of England.

Illustration by Georges Lepape

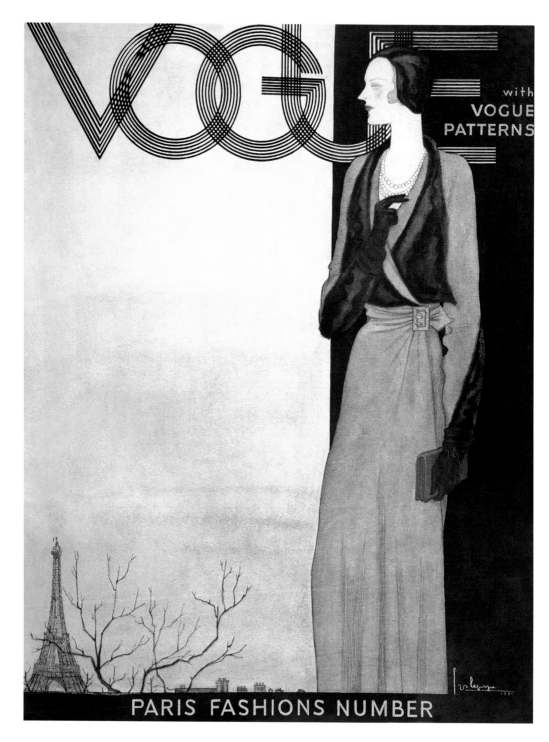

1 OCTOBER 1930 Paris Fashions Numberr

In profile and at twilight, a chic Parisienne gazes over to one of her city's landmarks before stepping out for the evening. Inside, *Vogue* reminded readers that 'the frocks and wraps of this winter are emphatically clothes that demand an appropriately luxurious car. You can't scuttle into a taxi in Chanel's ruby-red velvet wrap that sweeps in magnificence to the ground . . . ' The previous year, the comedy actress and woman-about-town

Gertrude Lawrence had worn Chanel's three-piece 'sports costume'. Her instinctive sense of style was much copied and a leaner, boyish silhouette began to find admirers in and out of *Vogue*.

Illustration by Georges Lepape

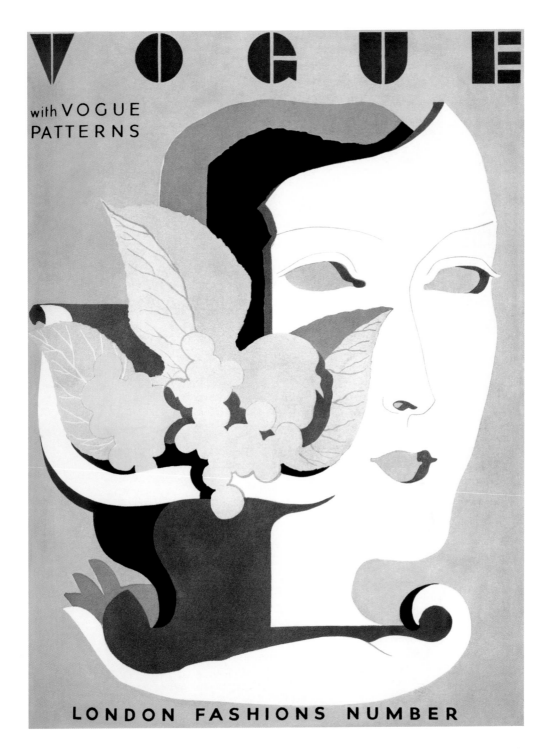

29 OCTOBER 1930 London Fashions Number

This Cubist-inspired still life with mask is the first cover by Alix Zeilinger. He was not a prolific contributor — 'comparatively insignificant', according to one commentator — but his covers, though few, were memorable.

Illustration by Alix Zeilinger

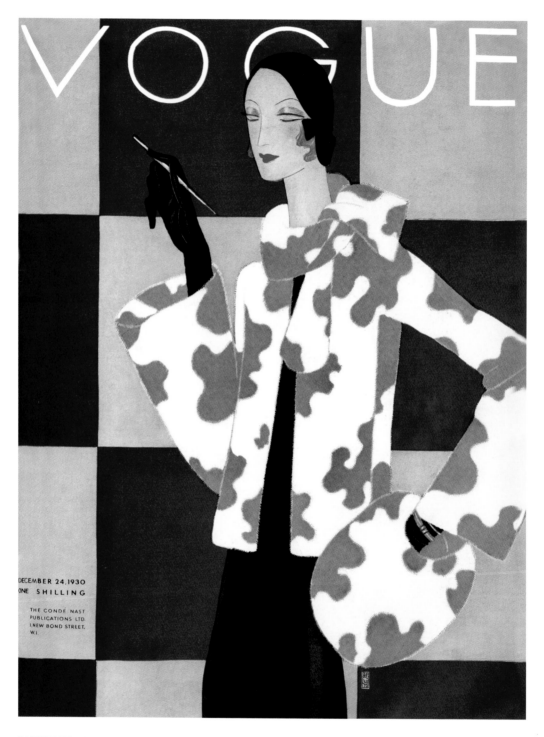

24 DECEMBER 1930 Essays in Modernity

The jigsaw-patterned animal print of the coat, scarf and muffler make a striking contrast with the regularity of the pink and brown backdrop. This issue of *Vogue* drew the reader's attention to the virtues of 'modernity'. Its editorial promised an aesthetic revelation (and showed there was more to its appreciation of art than fashion illustrators): 'Take a dress of the year 1930, a perfect period frock in satin and fur with a particularly lovely swirl to its lines which is an invention of our own day, take, in fact, a Patou of this winter and imagine it as seen through the eyes of half a dozen celebrated artists of our day — say Picasso, Matisse, Modigliani, Van Dongen, Foujita and Marie Laurencin. This is what *Vogue* has done with a Patou dress . . .'

Illustration by Eduardo Benito

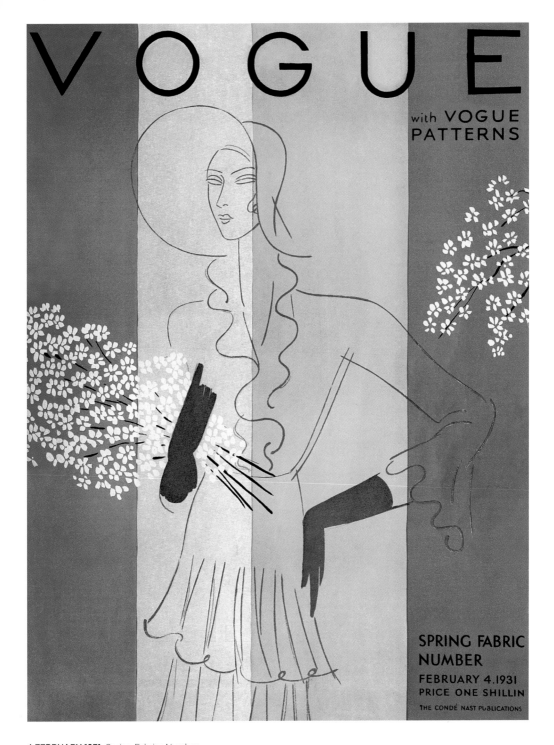

VOGUE

with **VOGUE PATTERNS**

SPRING FABRIC NUMBER
FEBRUARY 4.1931
PRICE ONE SHILLIN
THE CONDÉ NAST PUBLICATIONS

4 FEBRUARY 1931 Spring Fabrics Number

This is something of a stylistic *volte-face*. The almost cursory outline of the female form makes authorship all but unrecognisable. However, a glance at the rendition of the eyes, unmistakably Brancusi-like, betrays it as a Benito. The calligraphic and precise rendering of the flowers owes a little to the chinoiserie which Benito's *Vogue* predecessors had taken as a chief inspiration. *Vogue* had almost impossibly high hopes for hats adorned with real flowers and feathers — '*garnitures* will spread an aura of beauty about that should revive the most wilted morale. A feather may change your luck and the whole course of your life.'

Illustration by Eduardo Benito

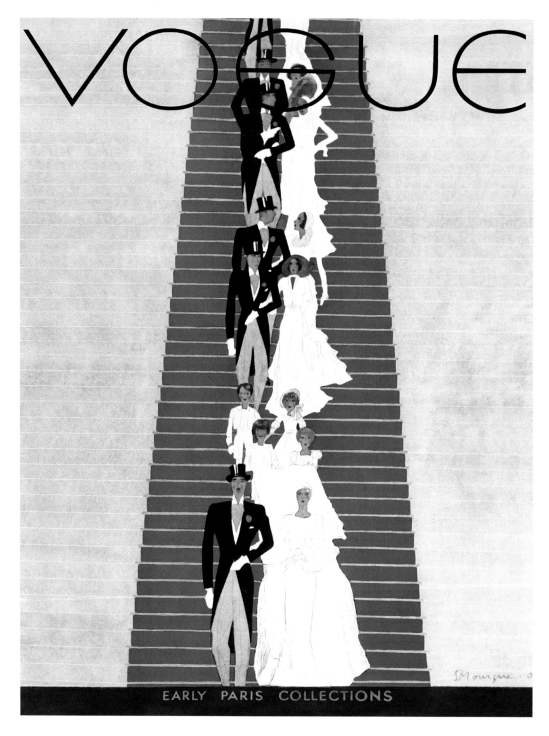

4 MARCH 1931 Early Paris Collections

An unusual cover in many ways, not least the prominence given to men. Previously they were firmly in the background, in supporting roles (reloading shotguns, tethering horses, driving glamorous passengers around Scottish moors). This was also the bridal issue, a fact not identified by coverlines but rather by the whole tenor of the illustration. There was a faint Busby Berkeley quality to the descent of a huge flight of stairs by this horde of couples.

Illustration by Pierre Mourgue

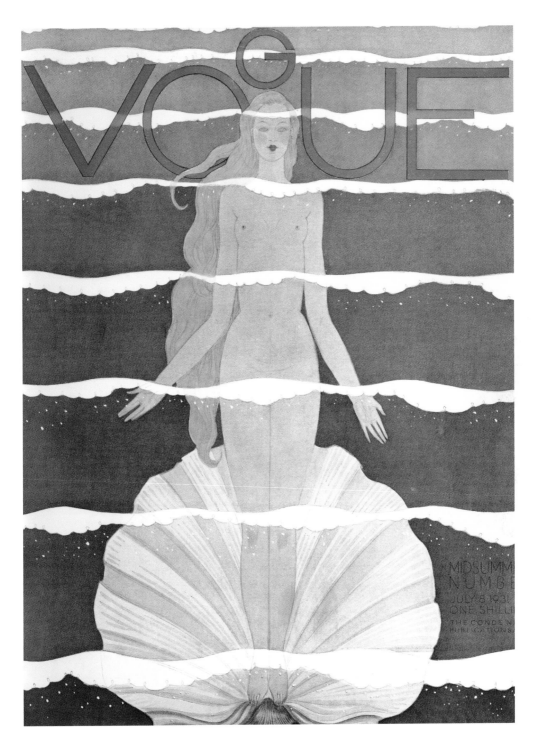

8 JULY 1931 Midsummer Number

Lepape's debt to Botticelli is clear, as well as to the graphic grid made of the *Vogue* page by his colleague Benito. At the time there was no question that the magazine's logo would appear in its entirety and this explains the rather awkward positioning of the G, like a halo. The cover would perhaps be more harmonious without it. Though a cresting wave covers her modesty, Lepape's Venus represents a departure. Nudes were customarily hidden behind foliage, or swathed in towels or sheets as if at bathtime. Despite the allusion to Renaissance art, this was the first time — at least at British *Vogue* — that a nude was encountered frontally, her arms open in a gesture of vulnerability and welcome.

Illustration by Georges Lepape

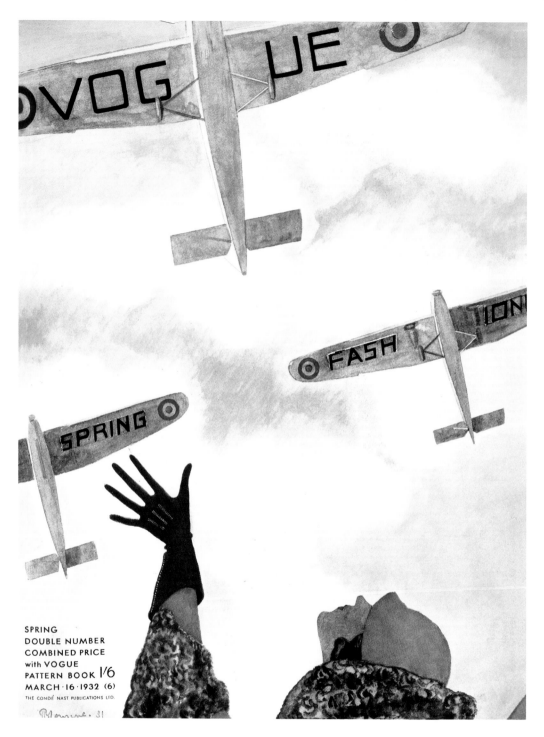

SPRING
DOUBLE NUMBER
COMBINED PRICE
with VOGUE
PATTERN BOOK 1/6
MARCH · 16 · 1932 (6)
THE CONDÉ NAST PUBLICATIONS LTD.

16 MARCH 1932 Spring Fashion

Was Mourgue prescient? Or simply responsive to a brilliant graphic idea? Without the target design, these might simply be light aircraft soaring in the spring sunshine. In 1932 the thought of war was probably only on the minds of Whitehall mandarins or observers of German domestic politics. By this stage, Hitler had not yet been installed as Chancellor, and the Nuremberg Rallies were still more than a year into the future. *Vogue*'s

viewer of this dramatic aerial display, reaching up a gloved hand in appreciation, might not have the vantage point that the reader has. She might not notice that the words 'Spring' and 'Fashion' are rather clumsily tacked on, almost as an afterthought.

Illustration by Pierre Mourgue

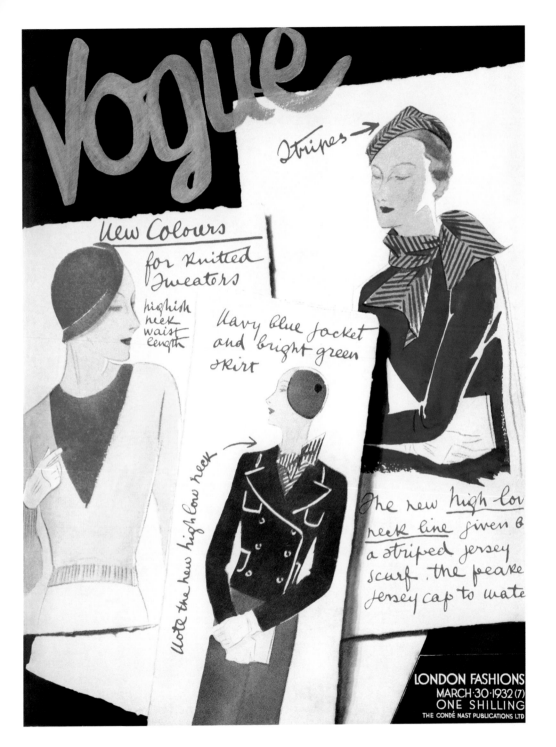

30 MARCH 1932 London Fashions

This cover has the feel of work-in-progress, as if we have glimpsed the ideas board of a fashion designer as he or she reaches the right conclusion about the season's colours and fabrics. Even the *Vogue* logo looks hurriedly and simply drawn, as if up against a deadline. The descriptive coverlines, far more detailed than readers would have expected, were still a novelty — the more so for being in a handwritten scrawl. *Vogue* hinted that this informative and straightforward cover was born out of necessity: 'Today fashion changes so quickly in line and detail that it needs an almost breathless endeavour on the part of fashion experts, artists and photographers to keep up with the stream of All that is Newest.'

Illustration by Guillermo Bolin

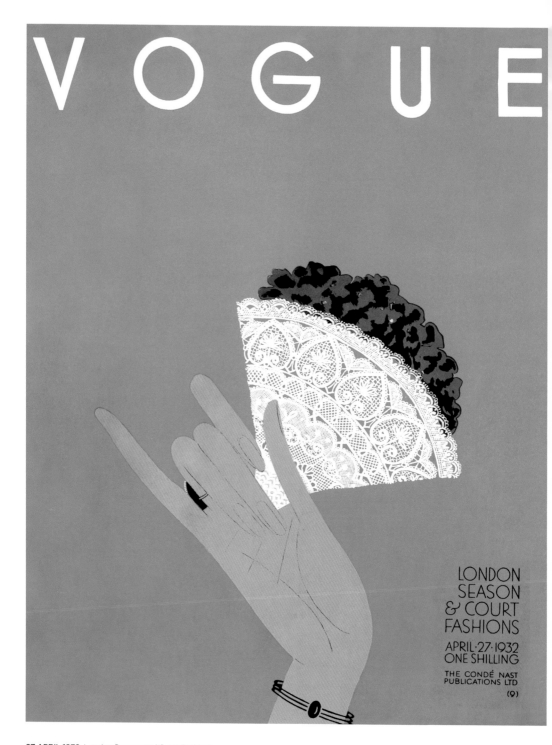

VOGUE

LONDON
SEASON
& COURT
FASHIONS
APRIL·27·1932
ONE SHILLING
THE CONDÉ NAST
PUBLICATIONS LTD
(9)

27 APRIL 1932 London Season and Court Fashions

Was court presentation becoming anachronistic? *Vogue* thought not, though it commissioned from Nancy Mitford a piece that answered a few questions while wryly undermining existing preconceptions. 'A debutante is, of course, a young woman making her first appearance in society. But the word has other implications and for some reason seems to carry us back to the agreeable atmosphere of the Edwardian days, when a girl was kept in the schoolroom until, round about her eighteenth birthday, a ball was given for her somewhere in Belgrave Square, Before this eagerly awaited occasion she met nobody outside her own family; after it she could meet those people selected by her papa and mama and in their presence.'

Illustration by Eduardo Benito

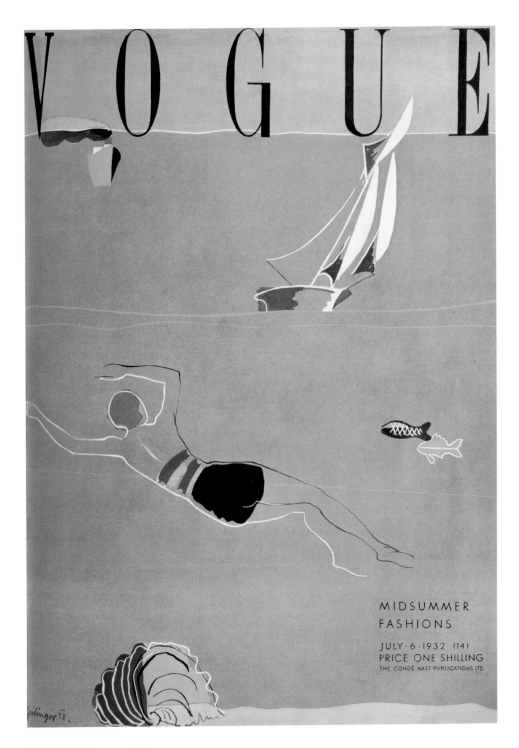

6 JULY 1932 Midsummer Fashions

The delicate, Dufyesque lines of Zeilinger's cover are given extra impact by the blocked-out bands of colour and the distinctive layering of the central nautical theme. It has, perhaps, been overshadowed by its immediate successor — *Vogue*'s first photographic cover.

Illustration by Alix Zeilinger

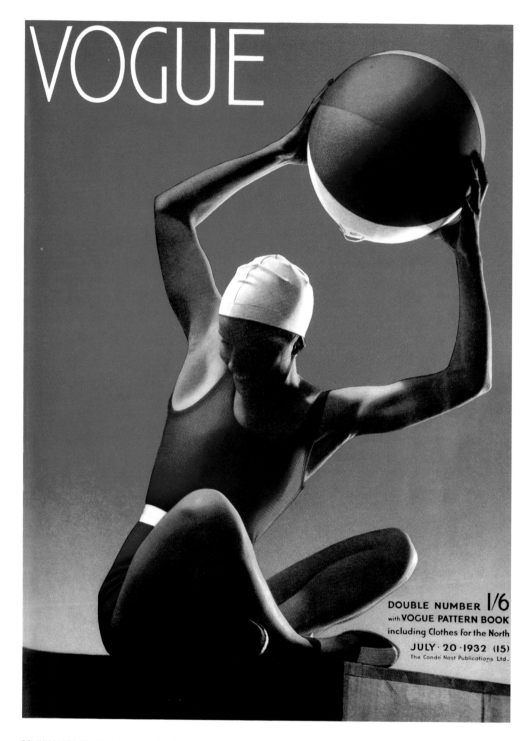

20 JULY 1932 The First Photographic Cover

This linear, Modernist beach scene (taken in the studio) heralded a new era for *Vogue* design. It interrupted a long tradition of illustrated covers, but did not kill them off. Steichen's photograph allowed for the briefest of coverlines; no fashion credits were offered. Instead his model acts as a cipher for a new breed of woman: active, healthy and free to enjoy travel, sports and leisure pursuits. *Vogue* pioneered the use of colour printing in magazines, and Condé Nast's craftsmen were at the forefront of the new four-colour engraving process. Nevertheless, it was a labour-intensive undertaking. Fernand Bourges, the magazine's chief colour technician, had to make 18 plates for any given subject.

Photograph by Edward Steichen

SEPTEMBER·14·1932 (19) **PARIS OPENINGS·DOUBLE NUMBER** with Vogue Pattern Book
THE CONDÉ NAST PUBLICATIONS LTD.

14 SEPTEMBER 1932 Paris Openings

The infinite regress of the cover-within-a-cover is frustrated only by the natural limitations of the illustrator. This was Marty at his simplest, the play of light and shadow clearly provided by the outsized lamp. Long regarded as a favourite of Condé Nast, when he turned his hand to fashion reportage he was a palpable failure. The trouble was, wrote Nast, that Marty and his set were 'chiefly interested in achieving amusing drawings and decorative effects — sometimes Japanese and eighteenth century — but they were bored to death by anything resembling an obligation to report the spirit of contemporary fashion faithfully, let alone put seams and lines where they actually belonged . . . '

Illustration by André-Edouard Marty

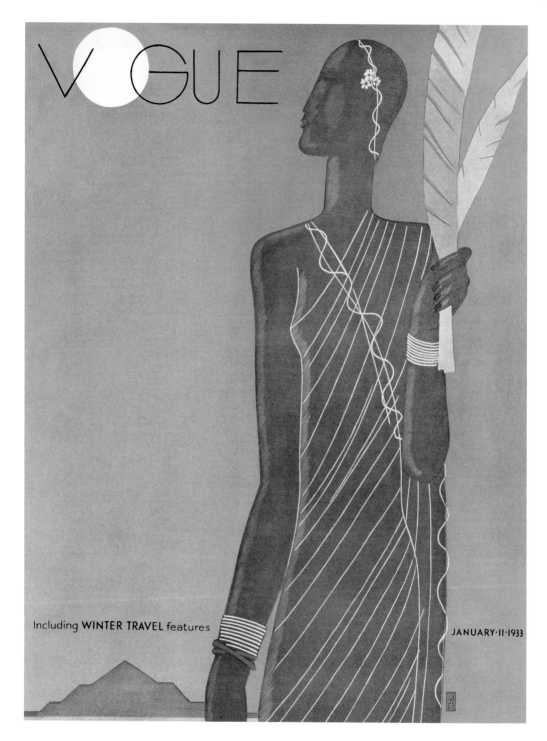

11 JANUARY 1933 Winter Travel

This stylised and etiolated tribeswoman seems to serve purely as a motif for exotic travel rather than a particular inhabitant of a specific land. Her nobility and certain of her jewellery seem to owe much to the Masai, but her nail varnish is distinctly occidental in feel and she appears to have been transported to the pyramids of Egypt. Her headband, adorned with daisies, is particularly inapt. Trips to far-off lands were not easy in the interwar years, and *Vogue* would always be impressed by the spirit of adventure revealed in lone women travellers, the more so if they retained their chic poise in the face of the inhospitable.

Illustration by Eduardo Benito

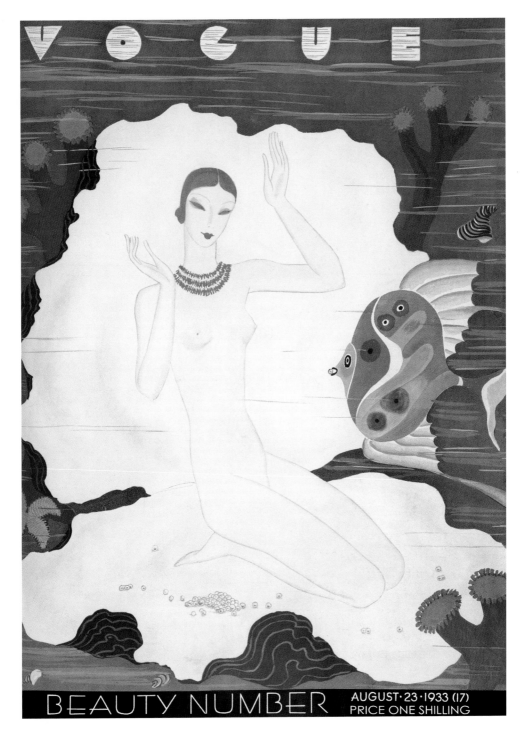

VOGUE

BEAUTY NUMBER AUGUST·23·1933 (17)
 PRICE ONE SHILLING

23 AUGUST 1933 Beauty Number

Not for the first time, Benito pays homage to Lepape, here producing *Vogue*'s second sub-aquatic nude in two years. As the editorial put it: 'Nowadays no one is content to present a dull and plain appearance to the world. If a woman possesses no single one of the attributes that make up what is conventionally thought beautiful, she can still be what the French call *soignée* . . . And as to all the possible defects that can so effectually mar comeliness or pulchritude, no one need sit down and mourn them any more.' However, the magazine rather ruined the heartening tone by offering the *soignée* 'chic forms of knitting'.

Illustration by Eduardo Benito

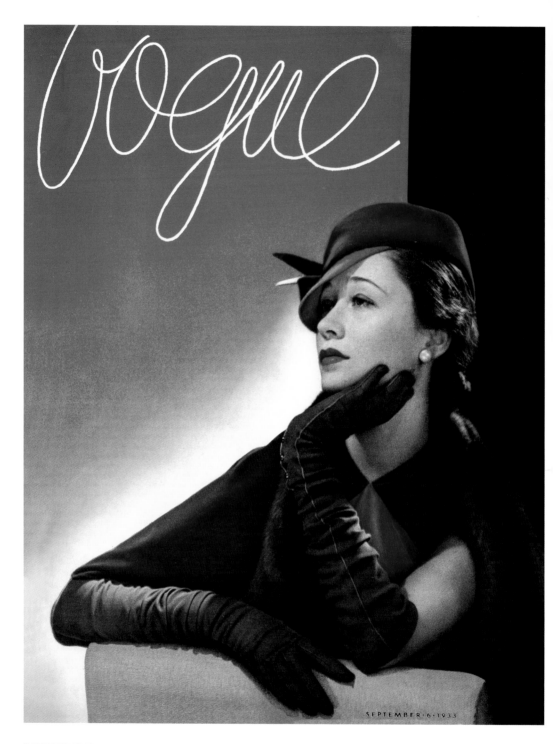

6 SEPTEMBER 1933 Vogue's Eye View of the Mode

The sparse typography accentuates the diagonal line starting from Miss Koopman's elbow up to the tilt of the red velvet 'miner's cap' by Reboux. Of particular interest, however, is Toto Koopman's life, which reads like a fairy story crossed with a thriller. Born in poverty in Holland, she rose to become one of the most glamorous models of the Thirties. During World War II, she risked her life by helping the French Resistance and hiding escaped Allied prisoners. Inevitably, she was betrayed and spent several horrific years in a concentration camp. After the war, in partnership with her lover Erica Brausen, she became an art dealer. Their great discovery: Francis Bacon.

Photograph by George Hoyningen-Huene.
Model: Toto Koopman. Fashion: Reboux

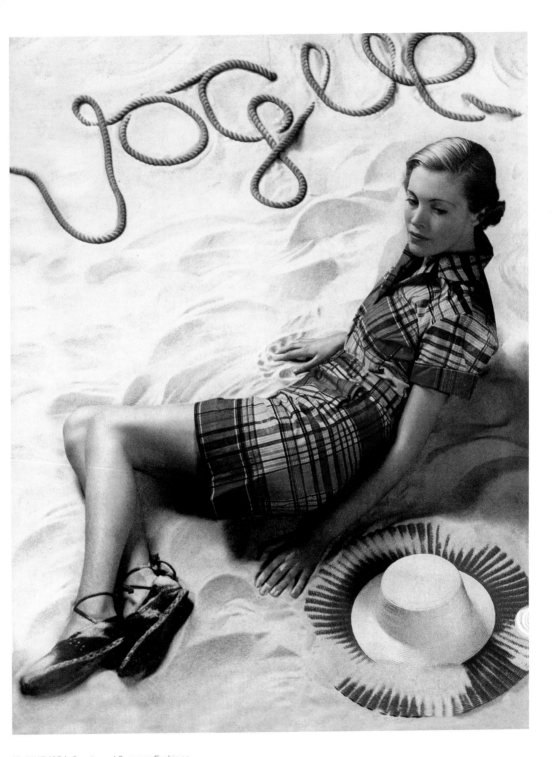

13 JUNE 1934 Sports and Summer Fashions

'If you are going to lie on a beach this summer, acquiring a warm tan like the young woman on our cover, it goes without saying that you'll spend most of your time in shorts.' It also goes without saying that this sunlit tableau was entirely concocted in the studio by *Vogue*'s master engraver, Bourges, and his photographic collaborator, Anton Bruehl. The art director's flourish was the *Vogue* logo looped from old rope. The woman's outfit was by Jaeger.

Photograph by Anton Bruehl and Fernand Bourges. Fashion: Jaeger

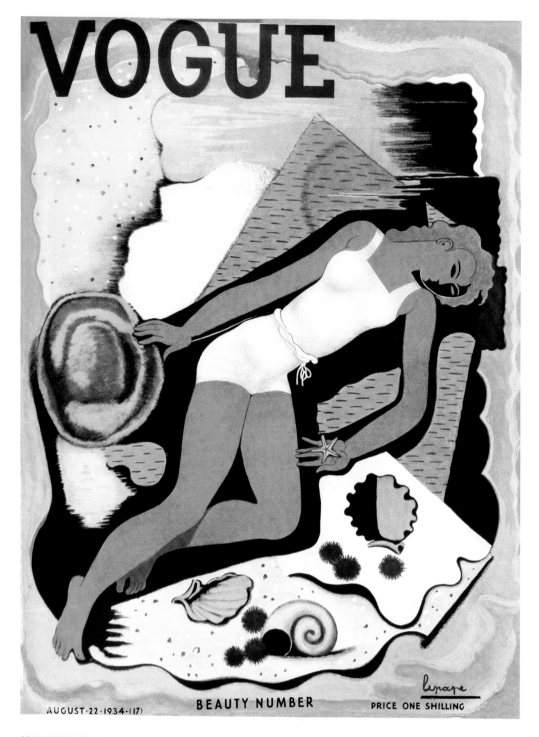

VOGUE

AUGUST·22·1934·(17)

BEAUTY NUMBER

PRICE ONE SHILLING

22 AUGUST 1934 Beauty Number

'A young woman striding off so blithely for holidays,' remarked *Vogue*, 'has obviously thought of everything . . . and the last farewell visit she pays is to that highly important person, the hairdresser.' Her suitcase 'contains all that she needs in the way of beauty preparations' — and presumably a furry beach hat and a piece of straw matting. Lepape's Cubist-inspired cover was one of his oddest and his last for some time. This cover ran simultaneously in the French edition — with one glaring exception. In the Continental edition his sunbathing blonde went completely topless. To appease prim British sensibilities, she was given a white singlet.

Illustration by Georges Lepape

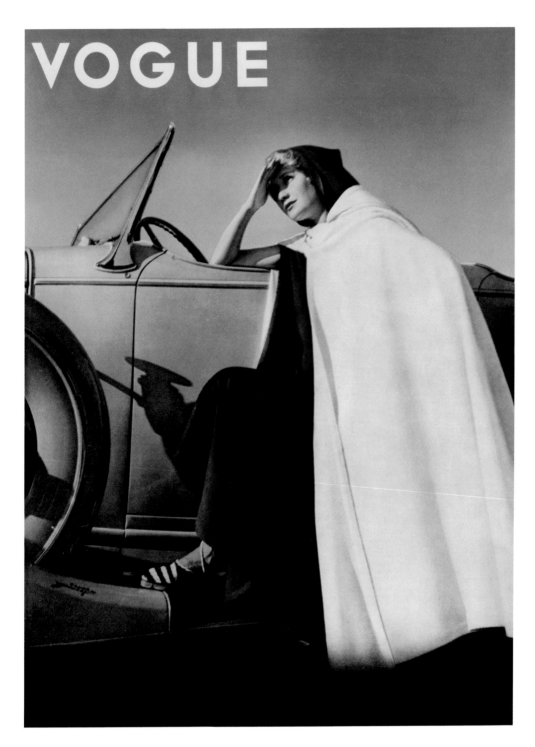

VOGUE

23 JANUARY 1935 Forecast of Spring Fashions

'We gaze ahead at the new mode like a clairvoyant,' explained *Vogue*. Here the new mode is embodied in the person of Miriam Hopkins, who wears a 'pair of enveloping burnouses, perfect for cruising'. This cover photograph started out in black and white; the colour was added by *Vogue*'s photographic laboratory. George Hoyningen-Huene's skill with studio lighting enabled him to imitate daylight and the play of shadow.

Here, for once, he stepped outside its confines to shoot *en plein air*, in California, the sky as seamless as the studio backdrop he favoured.

Photograph by George Hoyningen-Huene.
Model: Miriam Hopkins. Fashion: Travis Banton

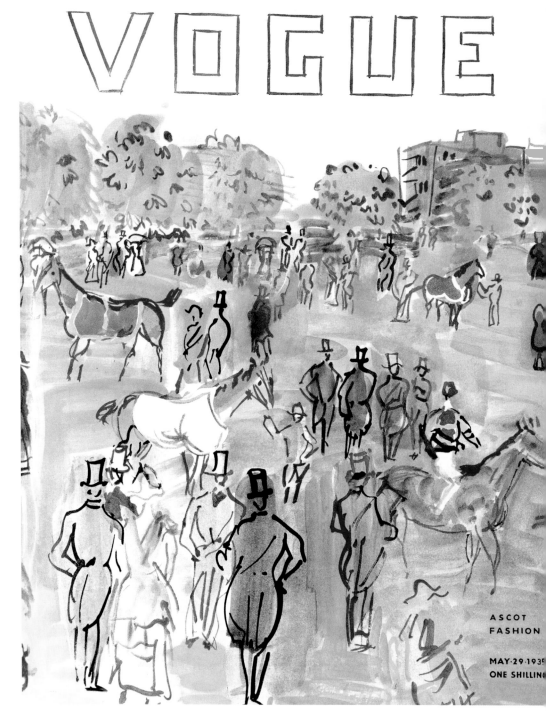

VOGUE

ASCOT
FASHION

MAY·29·1935
ONE SHILLING

29 MAY 1935 Ascot Fashion Number

As indicated by this approximation of what British horse racing might be like (slightly wide of the mark), the Fauvist Raoul Dufy was in many ways the perfect illustrator for *Vogue*, preferring panoramic scenes of fashionable congregations at Biarritz, sparkling social occasions along the Riviera, horse racing at Deauville. He had no qualms in applying his talents to the fashion world and had previously designed fabrics for Paul Poiret as well as rugs, tapestries and designs for ceramics. Illustrative, highly colourful and highly decorative, Dufy's work was much admired at the time, though the narrowness of its range and its lack of concern with more pressing social themes has since given it a lightweight reputation.

Illustration by Raoul Dufy

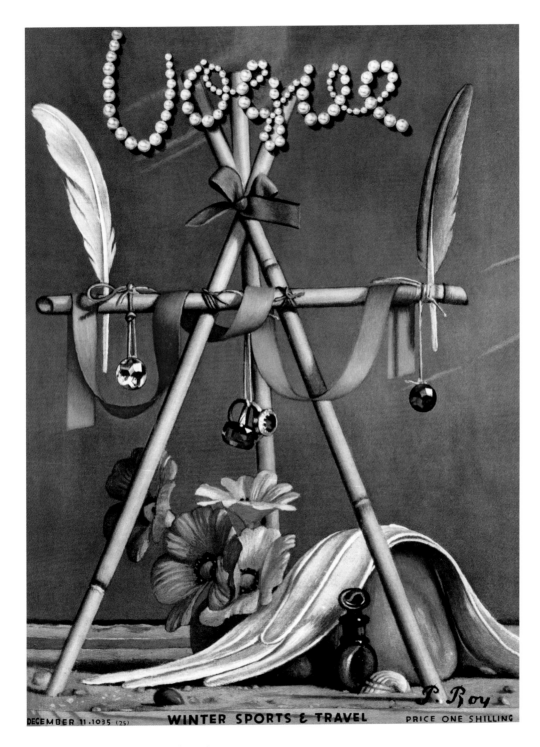

11 DECEMBER 1935 Winter Sports and Travel

Pierre Roy's reputation rests mainly on the careers he encouraged: Paul Eluard, Marcel Duchamp and Man Ray. He made many covers for *Vogue* in the Thirties in the Surrealist style, having helped organise what is considered the first group exhibition of Surrealist painters. His allusive paintings often contained mystical references or featured everyday objects distorted in incongruous and alarming ways. His *Vogue* covers were easier to read, but still relied occasionally on a sense of dissociation and heightened reality for their best effect. This tableau (while having nothing to do with winter sports or travel) is one of the tamer examples. The broken string of pearls as a logo design had been used before.

Illustration by Pierre Roy

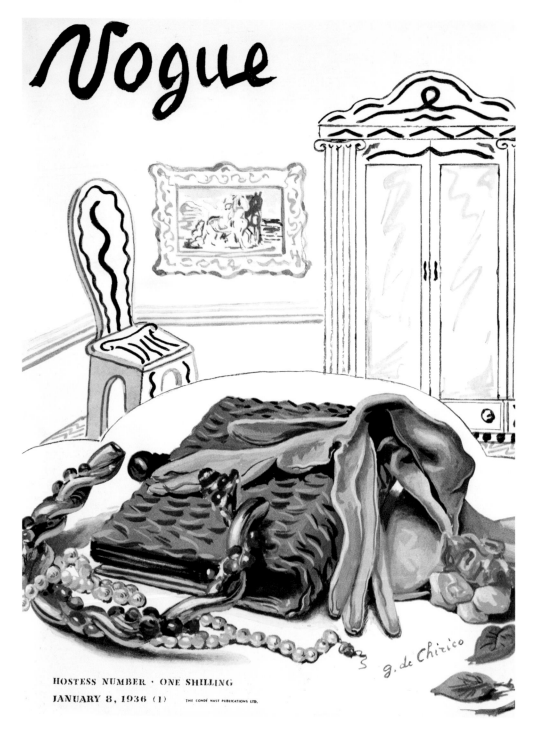

Vogue

HOSTESS NUMBER · ONE SHILLING

JANUARY 8, 1936 (1) THE CONDÉ NAST PUBLICATIONS LTD.

g. de Chirico

8 JANUARY 1936 Hostess Number

Giorgio de Chirico was one of many painters who briefly turned illustrator for *Vogue*. His brooding metaphysical style was ill-suited to fashion magazines, but his quirkier, quasi-Surrealist concoctions were ideal. Many painters used magazine covers to promulgate their own singular artistic visions, while others simply enjoyed the prestige. Certainly *Vogue* relished the association, as such issues became collectors' items.

Illustration by Giorgio de Chirico. Accessories: Chanel

Vogue

FEBRUARY 5 · 1936 (8) PRICE ONE SHILLING

5 FEBRUARY 1936 The Death of George V

'The opening page of *Vogue*, which is accustomed to reflect the events of our own special sphere, must now enlarge its scope to reflect the event which has blotted out all others in any sphere — the death of His Majesty King George.' In an effort to observe decorum while admitting grief, the magazine opted for a simple cover, unadorned except for the date and price and coloured royal purple. (This, the equivalent of *Vogue* flying its flag at half-mast, was repeated in March 1952 for the death of George VI.) While couching its editorial in suitably solemn terms, *Vogue* felt able to inject a note of practical common sense: 'The livelihood of thousands of workers, the well-being of whole districts, depends on the activity of the fashion and printing industries. This is no time for extravagance, but it is certainly no time for thoughtless and unnecessary economy . . . '

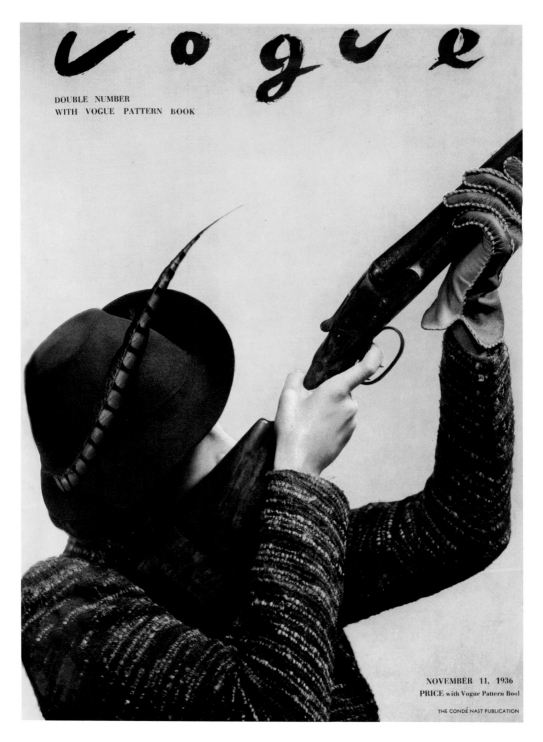

DOUBLE NUMBER
WITH VOGUE PATTERN BOOK

NOVEMBER 11, 1936
PRICE with Vogue Pattern Bool

THE CONDÉ NAST PUBLICATION

11 NOVEMBER 1936 Christmas Gifts

Vogue did not make a habit of featuring field sports on its covers, far less weaponry, but this, which it called rather baldly 'Girl with Gun', heralded the autumn season perfectly. 'Even if you do not shoot you will want to wear a country suit like this one in Rodier's rough blue and brown tweed.' A sweeping pheasant feather decorates the brown felt hat and the calligraphic logo is brushed cursorily on, as if in rifle lubricant.

Photograph by Anton Bruehl and Fernand Bourges. Fashion: Rodier

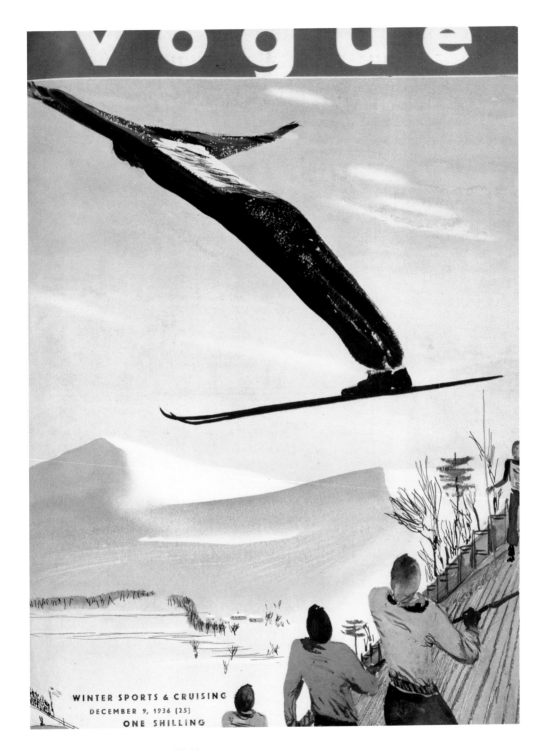

9 DECEMBER 1936 Winter Sports and Cruising

Three vaguely sketched onlookers marvel at the skills of a fourth figure. Perhaps the exuberance was born out of the knowledge that the last barrier to the winter sports holiday had fallen away: the Franc had been devalued. Our enthusiasts' ski break would have cost each around £20 for a fortnight. No wonder *Vogue* was confident in recommending expensive black gaitered 'ski knickers' by Hermès.

Illustrator unknown

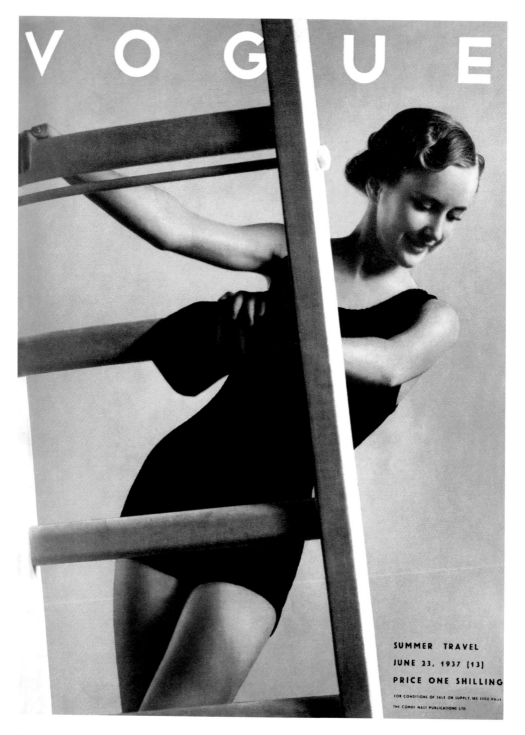

VOGUE

SUMMER TRAVEL
JUNE 23, 1937 (13)
PRICE ONE SHILLING
FOR CONDITIONS OF SALE OR SUPPLY, SEE TITLE PAGE
THE CONDE NAST PUBLICATIONS LTD

23 JUNE 1937 Summer Travel

Like his colleagues George Hoyningen-Huene and Edward Steichen, Bruehl was able to replicate an outdoor scene in the confines of the studio. Here, with a simple metal ladder as a quasi-gymnastic prop, he symbolises summertime and its frequent companions on the *Vogue* cover: health and beauty. The featured swimsuit from Simpson was of a new fabric which rendered the bathing silhouette 'aquatic perfect as a seal's skin'. The suntan was courtesy of Coppertan's Elation Powder and marks an early instance of *Vogue* admitting that the great ideal of the Thirties — the bronzed skintone — could be thus assisted.

Photograph by Anton Bruehl. Fashion: Simpson

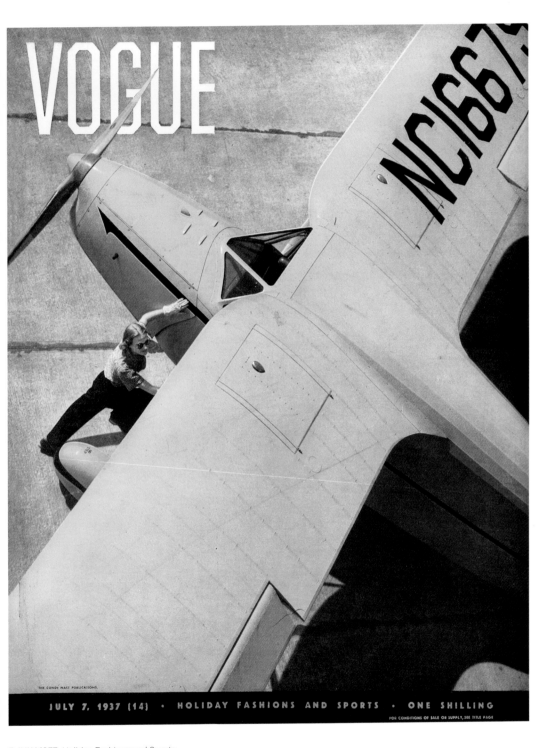

VOGUE

THE CONDÉ NAST PUBLICATIONS.

JULY 7, 1937 (14) • HOLIDAY FASHIONS AND SPORTS • ONE SHILLING

FOR CONDITIONS OF SALE OR SUPPLY, SEE TITLE PAGE

7 JULY 1937 Holiday Fashions and Sports

More than the sleek contours of aeroplanes themselves, what *Vogue* found utterly irresistible throughout the Thirties was aircraft flown by daring, sleek-contoured lady pilots. If they possessed a family title and an ability to metamorphose from intrepid airwoman to chatelaine and hostess, so much the better. *Vogue* marvelled at the twin accomplishments of the Hon Ruth Cokayne, who 'beneath her white flying kit wears a divided-skirt print dress that goes straight from the landing field to lunch', and the Hon Joceyln Hotham, 'who in her B.A. Eagle neither wears nor needs special flying kit. Her grey flannel suit has a divided skirt.'

Photograph by Anton Bruehl

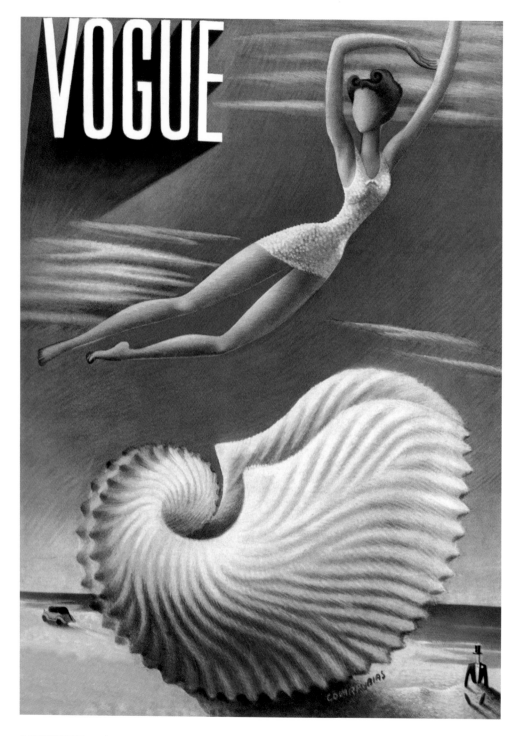

4 AUGUST 1937 London in Summer

Vogue deconstructed its cover of a Surrealist landscape occupied by two faceless inhabitants: 'You yourself might have day-dreamed this painting by Covarrubias on one of those drowsy days on the beach; dreamed of the fluted shell (representing mathematical perfection), of the flat bands of sea and sky. That figure swimming through space is fanciful enough, but the bathing suit is no mere symbol — it's a Sacony suit of white wool jersey . . .' The significance of the motor car is not explained. The Mexican painter Miguel Covarrubias, better known for his caricatures and illustrations for *Vogue*'s sister *Vanity Fair*, had a concomitant career as an anthropological researcher.

Illustration by Miguel Covarrubias

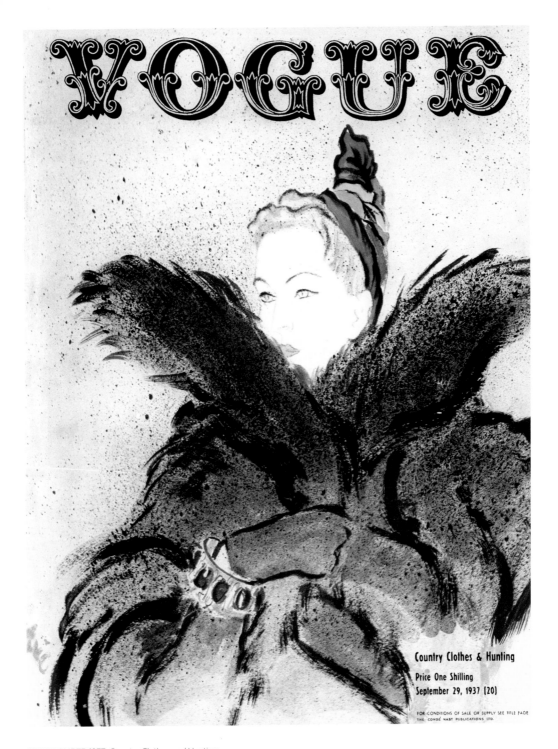

VOGUE

Country Clothes & Hunting
Price One Shilling
September 29, 1937 [20]

FOR CONDITIONS OF SALE OR SUPPLY SEE TITLE PAGE
THE CONDÉ NAST PUBLICATIONS LTD.

29 SEPTEMBER 1937 Country Clothes and Hunting

Schiaparelli's ensemble of fur coat and peaked cap of twisted crêpe in vivid colours was not perhaps the obvious choice for an issue celebrating fieldsports, but there was at least a tangible link with the countryside: the fur coat was of dyed fox. Elsa Schiaparelli's infatuation with Surrealism raised the craft of fashion design beyond mere style and chic into a vital expression of contemporary culture: the Dalí-inspired lobster-print dress; the Man Ray-suggested suede 'human hand' gloves with 'fingernails' of red sharkskin; the shoe hat; the Cocteau line-drawn dinner jacket. In her hands clothes became art objects, fashioned out of 'tree-bark' rayon, spun glass, straw, horsehair upholstery stuffing and scratchy jute sackcloth.

Illustration by Eric (Carl Erickson). Fashion: Schiaparelli

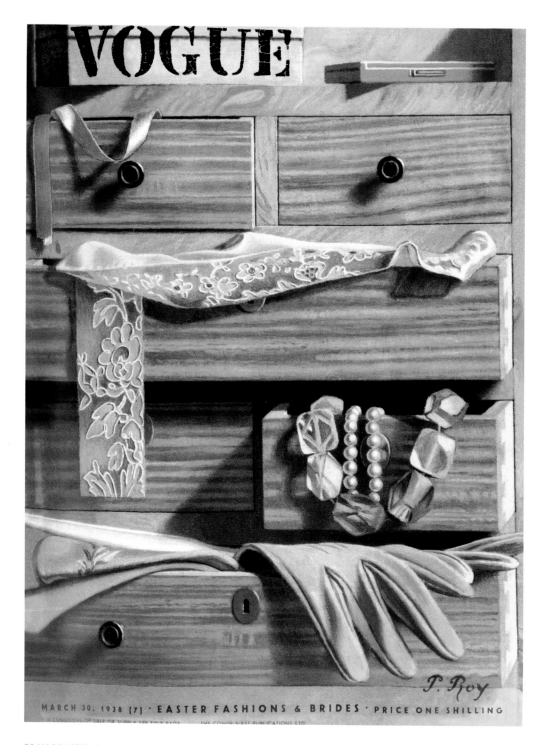

30 MARCH 1938 Easter Fashions and Brides

Another *trompe-l'œil* confection from *Vogue*'s favourite Surrealist, which bore scant regard to the themes of the issue, but which *Vogue*'s editorial valiantly made relevant: 'We guess a careless young bride-to-be as the owner of the wardrobe Pierre Roy painted so faithfully for our cover; for just so would her drawers drip with ribbons, laces, gloves and jewels — a new fashion crop of pastel fripperies, delicate evidences of femininity.'

Illustration by Pierre Roy

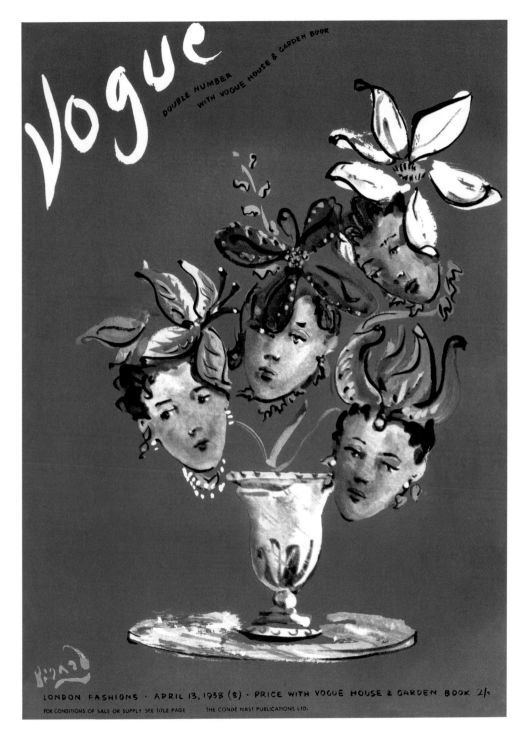

13 APRIL 1938 London Fashions

Christian Bérard was a celebrated stage designer and an ambidextrous illustrator for *Vogue*. Condé Nast loathed his work but retained him because he was sought after by the opposition — *Harper's Bazaar*. Bérard was also the social fulcrum of interwar Paris, despite a lack of social niceties. US *Vogue*'s Edna Woolman Chase remembered him as 'fat, grossly untidy, a victim of drugs and liquor', and the model Bettina introduced him to her parents: 'It was one of his "off" nights ... He stood *au naturel*, complete with greasy suit and *boeuf bourguignon* and bugs in his beards. Mother nearly fainted.' Remarkably prolific, Bérard lasted another 10 years before an opium-induced heart attack killed him.

Illustration by Christian Bérard

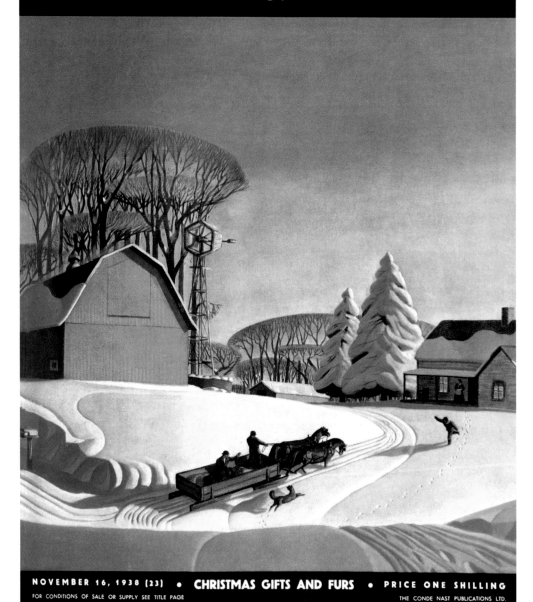

VOGUE

NOVEMBER 16, 1938 (23) • **CHRISTMAS GIFTS AND FURS** • **PRICE ONE SHILLING**

FOR CONDITIONS OF SALE OR SUPPLY SEE TITLE PAGE THE CONDE NAST PUBLICATIONS LTD.

16 NOVEMBER 1938 Christmas Gifts and Furs

At this sentimental winter landscape, painted by Dale Nichols, *Vogue* grew wistful: 'The Christmas scene we all imagine but, alas, too seldom see.' Nichols was a much loved American Regionalist painter, the region being Nebraska, and the best of a limited oeuvre concentrated on slices of rural farming life. He became art director of the *Encyclopaedia Britannica* but kept up his homespun paintings: 'I feel that an artist paints best what he has been exposed to during his youth. I think my memory paintings of my home state may be my only creations that I sign with full confidence.' (This issue, incidentally, was also the first to mention Herr Hitler by name, in an ironical paragraph on the mid-season's hats.)

Illustration by Dale Nichols

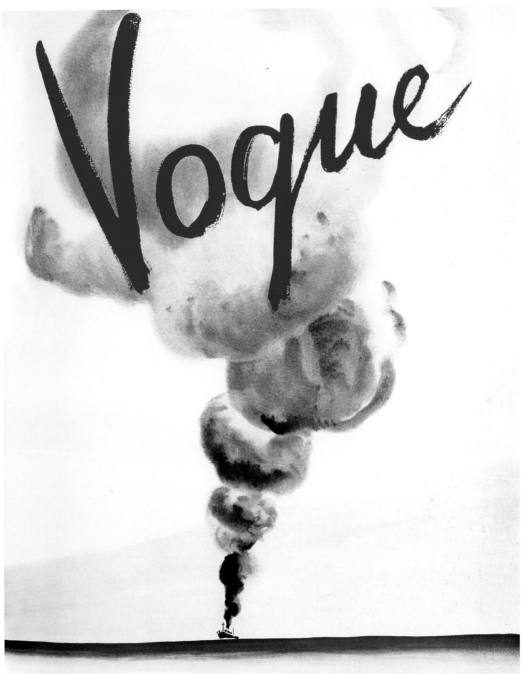

WINTER SPORTS & CRUISING · DECEMBER 14, 1938 (25) · ONE SHILLING J. PAGÈS

FOR CONDITIONS OF SALE OR SUPPLY SEE TITLE PAGE THE CONDÉ NAST PUBLICATIONS LTD.

14 DECEMBER 1938 Winter Sports and Cruising

A prescient and stirringly emotive cover from Jean Pagès heralded the passing of 1938, while looking forward to what would prove to be a darker new year. The liner's passage into the horizon, billowing smoke of a particularly virulent colour and in alarming quantity has, with hindsight, grim impact, as few such ships could make safe passage out in the years to come. In the meantime, *Vogue* was cheered by the thought of seasonal escape:

'Steam's up . . . for channel crossing to winter sports; Atlantic crossing to New York, South America, the West Indies; for cruising right round the world.' For Pagès, a Frenchman, this would prove especially poignant, as he was forced to spend the war years away from home.

Illustration by Jean Pagès

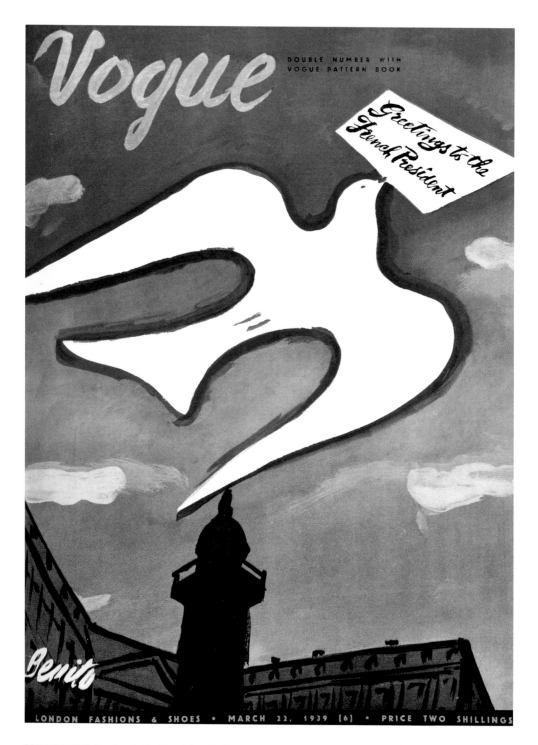

22 MARCH 1939 Greetings to the French President

The dove of peace was ineffectual as the storm clouds of war gathered over Europe. The president to whom *Vogue* sent its best wishes was Albert Lebrun, in London by March 1939 on a state visit. His time in office was cut short by the German invasion and he was forced to sign France's surrender on 10 July 1940 and hand over the reins to Marshal Pétain. The Free French government-in-exile was based in London under General de Gaulle, who assumed power when Paris was liberated in 1944. This dove of peace appeared on the cover of US *Vogue*, too, but in its beak the message was more prosaic: 'The Paris Collections'.

Illustration by Eduardo Benito

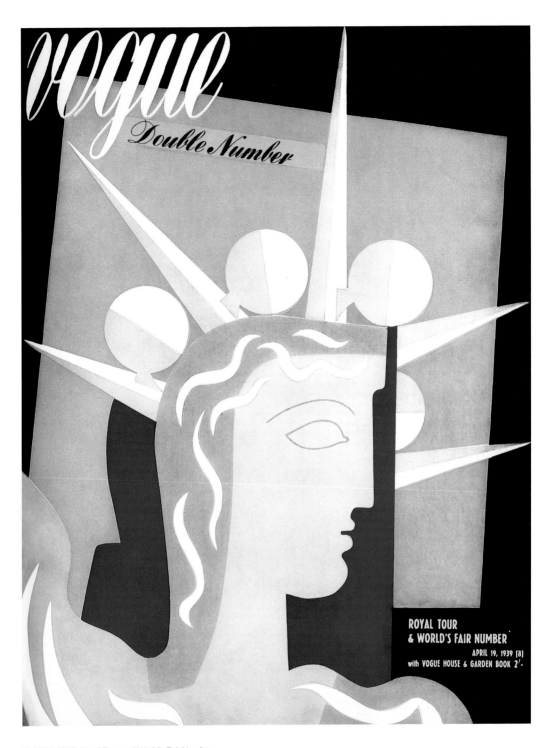

19 APRIL 1939 Royal Tour and World's Fair Number

Some 44 million people visited the 1939 World's Fair in New York; major attractions were the Trylon, a 700ft spire, and the Perisphere, a completely spherical building. The royal tour was one of North America, the first ever undertaken by a reigning British monarch. This cover was drawn by Witold Gordon, who himself made several murals for the fair. His design for Liberty's crown incorporates elements of the Trylon and the Perisphere.

Illustration by Witold Gordon

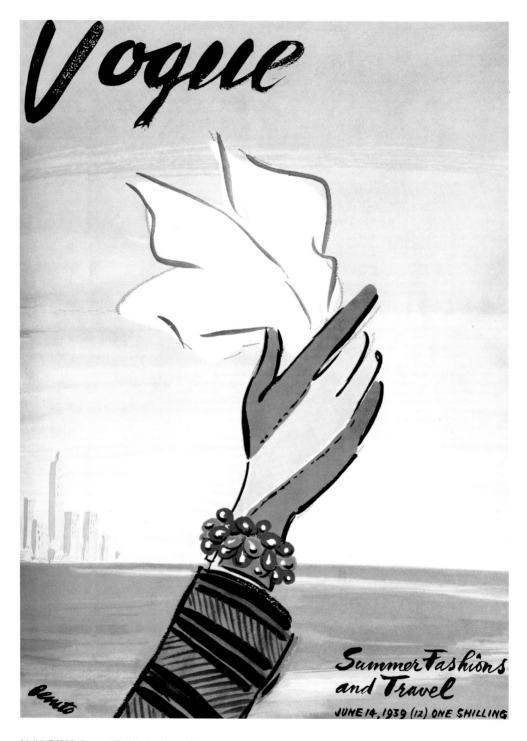

14 JUNE 1939 Summer Fashions and Travel

And still the World's Fair kept *Vogue* enthralled. 'Greeting the New York skyline as thousands will do this summer, this waving World's Fair visitor wears Alexandrine's two-toned suede glove.' The fair's theme was 'The World of Tomorrow', to which end a time capsule was buried, containing, *inter alia*, a packet of Camel cigarettes, an issue of *Life* magazine and the novels of Thomas Mann. A copy of the Magna Carta, which belonged to Lincoln Cathedral and had travelled over to New York specially for the exhibition, was forced to remain there following the outbreak of war in September.

Illustration by Eduardo Benito. Fashion: Alexandrine

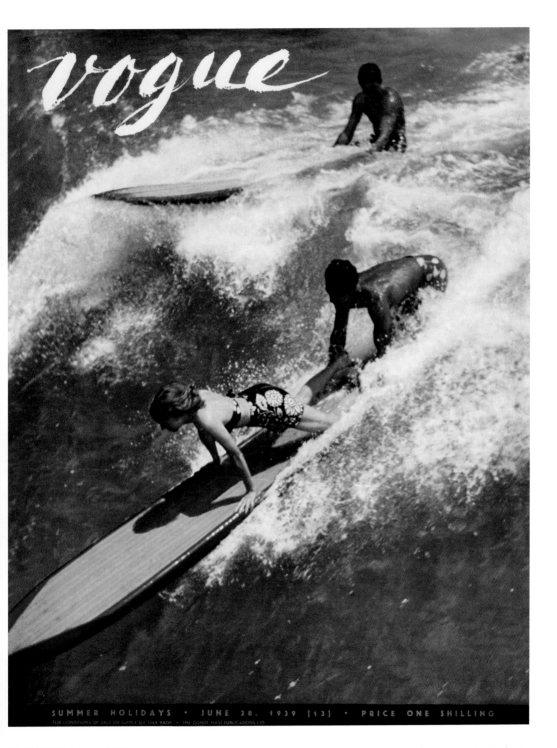

SUMMER HOLIDAYS · JUNE 28, 1939 [13] · PRICE ONE SHILLING
FOR CONDITIONS OF SALE OR SUPPLY SEE TITLE PAGE · THE CONDÉ NAST PUBLICATIONS LTD

28 JUNE 1939 Summer Holidays

This, an unseasonal Christmas cover for US *Vogue* in 1938, became the British edition's summer-holiday one the following year. Not that many sun-seekers would have made it as far as Hawaii, where this exuberant shot was captured. *Vogue* described Frissell's pictures as 'sunlit, windblown records of action outdoors'. The first had appeared in 1932, while Miss Frissell was working as an editorial assistant at the magazine. Her snapshot aesthetic found a willing recipient, and her blue-blood connections gained *Vogue* access to, as it put it, 'the smartest country clubs, race-tracks, swimming-pools, horse shows, golf-links and tennis-courts'.

Photograph by Toni Frissell

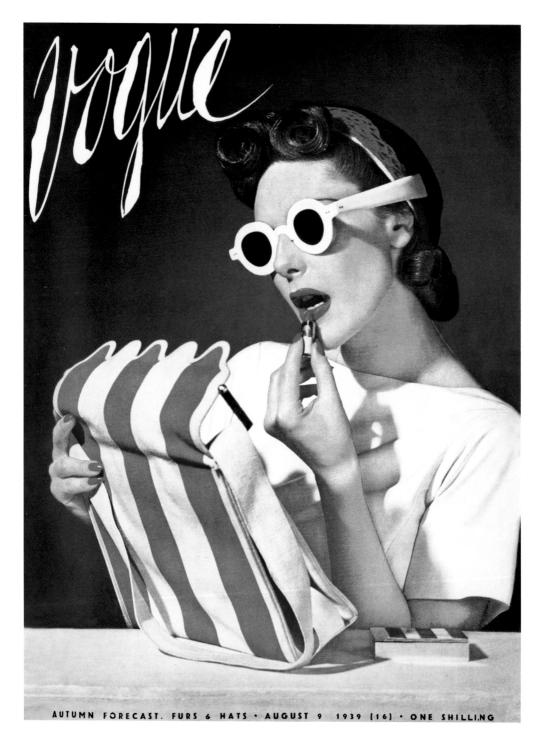

Autumn Forecast. Furs & Hats · August 9 1939 (16) · One Shilling

9 AUGUST 1939 Autumn Forecast, Furs and Hats

There is some dispute as to who took this cover photograph, one of the best known of the period. British *Vogue* credits it with the name 'Hirsch', who was unknown as a photographer beforehand and seems not to have made any other photographs for the magazine, cover shots or otherwise. American *Vogue*, where it first appeared (in the previous month), refused to be drawn over authorship and left it anonymous. A compilation of *Vogue* covers from 1986 favours Hirsch, too, but another book, *In Vogue* (2006), comes down firmly in favour of Horst, whose era this most certainly was. Without any supporting evidence, we cannot firmly establish provenance and offer to mediate between the two.

Photograph by Hirsch or Horst

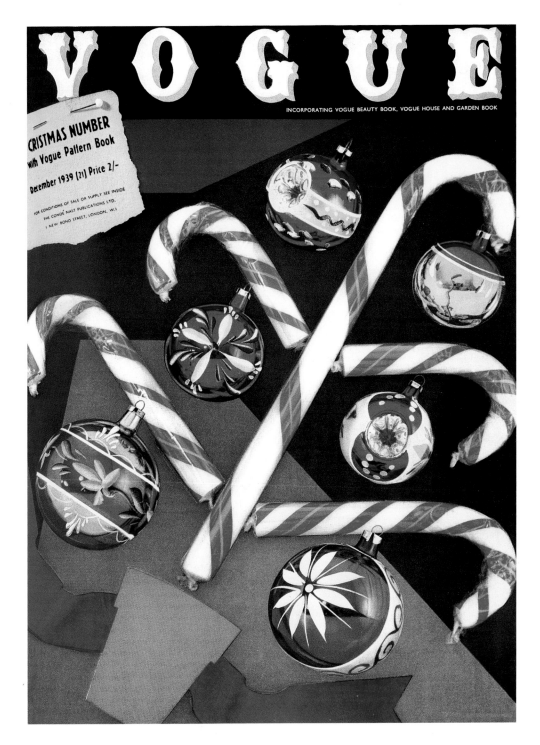

VOGUE

INCORPORATING VOGUE BEAUTY BOOK, VOGUE HOUSE AND GARDEN BOOK

CRISTMAS NUMBER
with Vogue Pattern Book

December 1939 (21) Price 2/-

FOR CONDITIONS OF SALE OR SUPPLY SEE INSIDE
THE CONDÉ NAST PUBLICATIONS LTD.
1 NEW BOND STREET, LONDON, W.1

DECEMBER 1939 Christmas Number

A rather homespun cover, unaccredited to any photographer, struck the right tone for the first Christmas of World War II. Though inevitably spent under government restrictions, festive spirits were high: 'Vogue hangs up a stocking for you, and fills it to the brim with gay things . . . [Our] lucky dip is full of cheap, cheerful presents.' In the world outside the magazine, shops' window displays were bolstered by blast tape and blackout curtains blocked out all light, twinkling or otherwise. Travel over Christmas was difficult due to new regulations, and some families, who had evacuated their children, were not together. Food, however, was still abundant, as rationing would not be brought in until 1940.

Photographer unknown

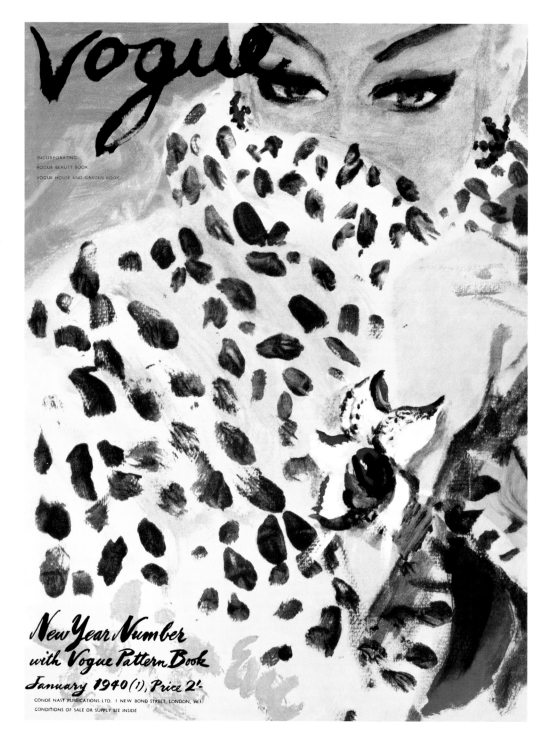

JANUARY 1940 New Year Number

As the 'Phoney War' continued, many magazines were shut down. *Vogue* survived, being considered good for morale on the Home Front. It never missed an issue, despite paper shortages and its best photographers seeing active service. Here it spelt out a mission statement that would see it through five long years: 'We take this stand . . . against all comers: that fashion is no surface frivolity but a profound instinct; that its pulse beats fast or slow, in time with the march of events, but beats with imperishable vitality; that as long as there is taste and coquetry, desire for change and love of self-expression, a sense of fitness and a sense of fantasy — there will be fashion.'

Illustration by Eric (Carl Erickson)

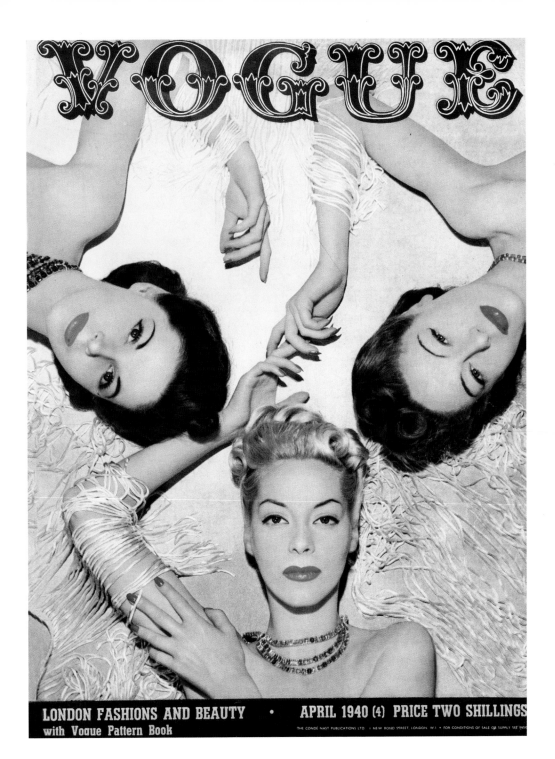

VOGUE

LONDON FASHIONS AND BEAUTY • **APRIL 1940 (4) PRICE TWO SHILLINGS**
with Vogue Pattern Book

THE CONDÉ NAST PUBLICATIONS LTD • 1 NEW BOND STREET, LONDON. W.1 • FOR CONDITIONS OF SALE OR SUPPLY SEE INSIDE

APRIL 1940 London Fashions and Beauty

Horst's three graces arranged themselves on the floor of *Vogue*'s New York studios for a special cover introducing some new cosmetic ranges by Elizabeth Arden. Understandably, they remained unavailable across the Atlantic till the war's end. This did not, however, stop *Vogue* from tempting readers with the lipsticks It's You (to be known later in Britain as Primula), Cyclamen and Burnt Sugar.

Photograph by Horst. Accessories: Marcus

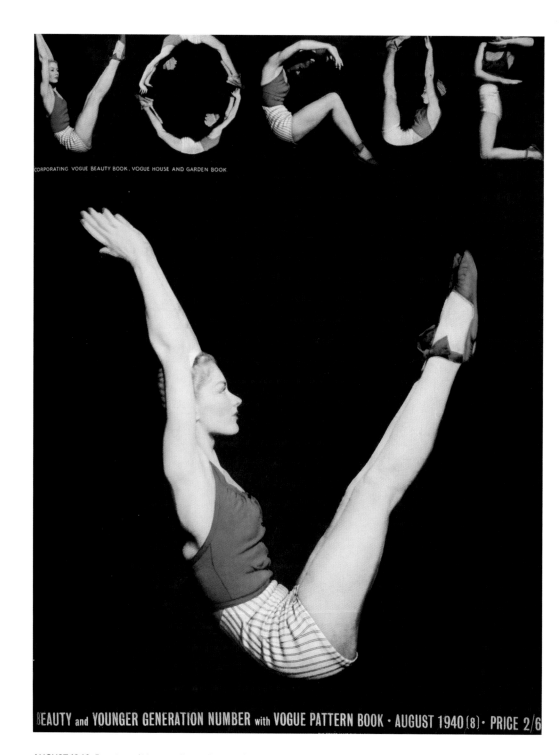

VOGUE

INCORPORATING VOGUE BEAUTY BOOK, VOGUE HOUSE AND GARDEN BOOK

BEAUTY and YOUNGER GENERATION NUMBER with VOGUE PATTERN BOOK · AUGUST 1940 (8) · PRICE 2/6

AUGUST 1940 Beauty and Younger Generation Number

Lisa Fonssagrives was — by dint only of public recognition — the first super-model. The term does her temperament and dignity no favours, as she behaved impeccably and loathed the limelight. In an age before models' egos were allowed to run unrestrained, she frequently and modestly referred to herself as 'just a clothes hanger'. Horst's witty 'V for Vogue' cover made typography unnecessary, while extolling the suppleness of her body. So definitive was it for Vogue that the idea was repeated in June 1991, to celebrate the magazine's 75th anniversary. Most of Horst's long career was spent in Paris and New York, though he made several trips to London for British Vogue.

Photograph by Horst. Model: Lisa Fonssagrives

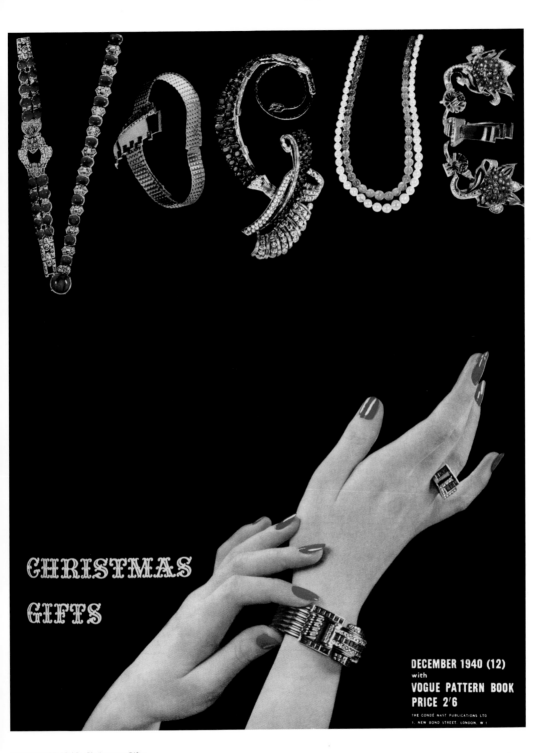

DECEMBER 1940 Christmas Gifts

Vogue's second *trompe-l'oeil* cover in one year was borrowed from the American edition. Understandably, in 1940, there was much one-way traffic. American *Vogue* lent its beleaguered younger sister key colour images to enable the continuation of the degree of luxury to which *Vogue* readers were by now accustomed. For some, perhaps, expensive trinkets were more comforting than ever in this, the darkest year of the war.

Photograph by Anton Bruehl

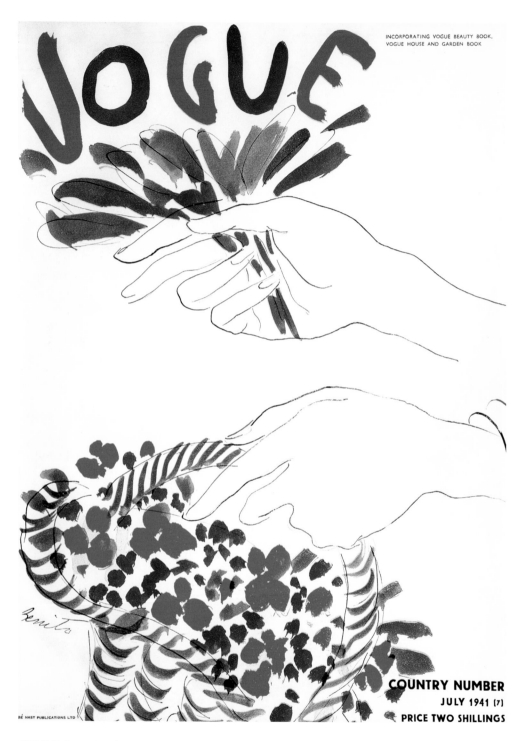

INCORPORATING VOGUE BEAUTY BOOK,
VOGUE HOUSE AND GARDEN BOOK

COUNTRY NUMBER
JULY 1941 [7]
PRICE TWO SHILLINGS

JULY 1941 Country Number

The countryside became a focus in the early days of the war. It was the 'nation's larder' and, as *Vogue* reminded readers, 'each of us must realise the necessity of stocking it'. At a dark hour for Britain, *Vogue* tapped into a spirit of Neo-Romanticism that underscored the virtues of the countryside. It acted as a source of peace, strength and reassurance that counterbalanced the frivolity of the world of fashion.

Illustration by Eduardo Benito

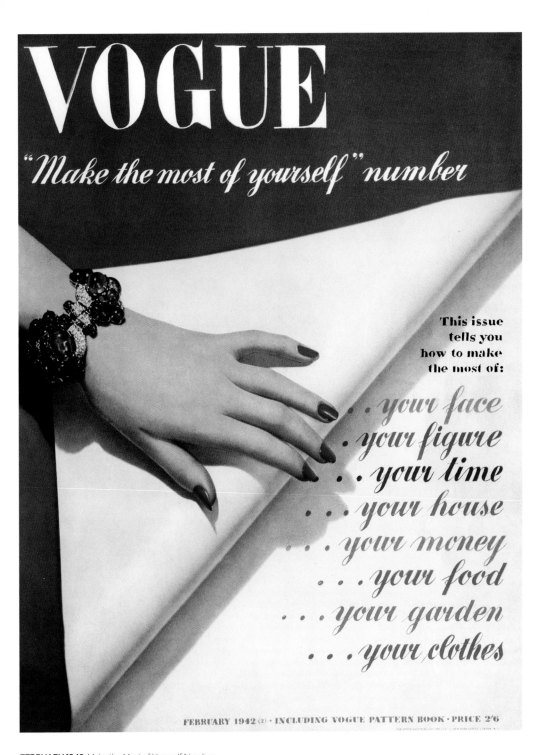

VOGUE

"Make the most of yourself" number

This issue
tells you
how to make
the most of:

. . . your face
. . your figure
. . . your time
. . . your house
. . . your money
. . . your food
. . . your garden
. . .your clothes

FEBRUARY 1942 (2) · INCLUDING VOGUE PATTERN BOOK · PRICE 2'6

FEBRUARY 1942 Make the Most of Yourself Number

Alexander Liberman had joined the art department of American *Vogue* in 1941, charged with emboldening its covers. Two years later, he was appointed art director. Almost immediately, he changed the entire slant of the magazine, eliminating over-elaborate fonts and introducing typefaces that reflected current-affairs magazines. As was so often the case, any new graphic rules applied equally to British *Vogue*. There was now a clear urgency to *Vogue* covers, born out of the ongoing crisis. Readers could be sure that what was spelt out simply on the cover would be found, easy to assimilate, inside.

Photographer unknown

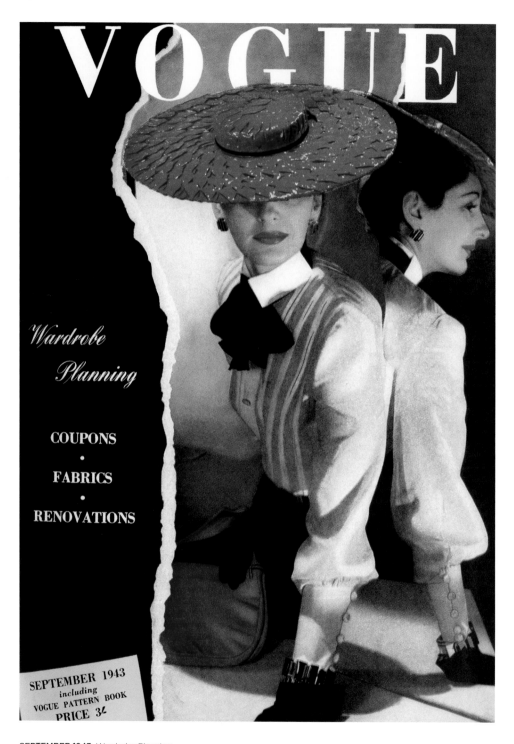

VOGUE

Wardrobe Planning

COUPONS

•

FABRICS

•

RENOVATIONS

SEPTEMBER 1943
including
VOGUE PATTERN BOOK
PRICE 3⁄-

SEPTEMBER 1943 Wardrobe Planning

Another eye-catching innovation for *Vogue*: the 'torn page'. This motif has become something of a design cliché ever since, shorthand for immediacy and urgency. This confirmed Liberman's objective to turn *Vogue* from just a magazine women found delightful to glance at into something it was imperative that they read. Whimsicality was naturally frowned on in the dark days of the war and *Vogue* spelt out some necessary constraints on the wartime wardrobe: coupons, fabrics (for homespun dressmaking) and renovations (the spirit of 'make do and mend'). The message could not be any clearer.

Photograph by John Rawlings

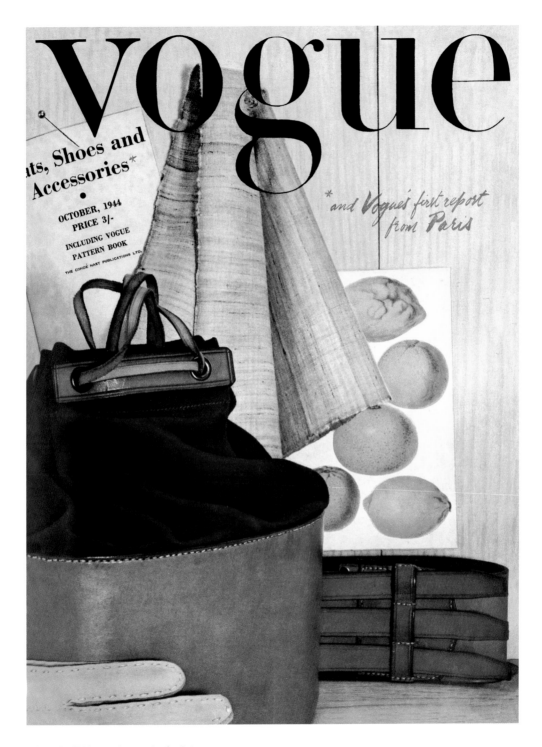

On the magazine cover within the photograph:

Vogue

ts, Shoes and
Accessories*
•
OCTOBER, 1944
PRICE 3/-
INCLUDING VOGUE
PATTERN BOOK
THE CONDÉ NAST PUBLICATIONS LTD.

*and Vogue's first report
from Paris

OCTOBER 1944 New Accessories for Autumn

The first cover by one of *Vogue*'s — and photography's — greatest names. Since 1943, Irving Penn's arena has mostly been the fashion magazine, and US *Vogue* almost exclusively, though his contribution began as an assistant in the art department. Penn was hired to oversee cover designs and communicate the art director's ideas to photographers. Most, already set in their ways, spurned his approach. Initially, Liberman found it less disheartening to allow Penn to shoot the covers they had concocted. In time, it became almost an imperative, as he outshone his colleagues. 'Liberman,' said Penn, 'a man of visual cultivation, understood the usefulness of a raw still life in a woman's magazine of luxury.'

Photograph by Irving Penn

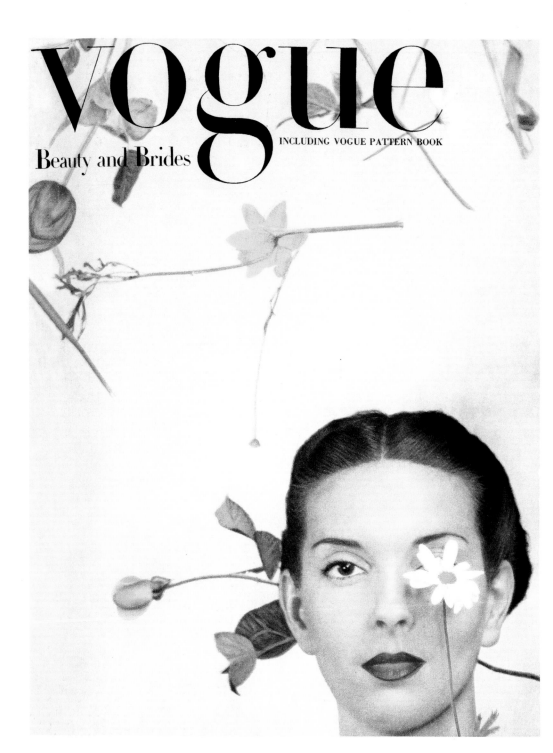

Vogue

Beauty and Brides

INCLUDING VOGUE PATTERN BOOK

FEBRUARY 1945 Beauty and Brides

'Why Flowers? Because they're the essence of beauty in the garden, on your hat or in the distilled fragrance of beauty,' stated *Vogue*. Gjon Mili, who photographed this bouquet cascading downwards, was a pioneer of stroboscopy. Along with Harold Edgerton, he succeeded in freezing moments invisible to the naked eye through the use of powerful flash photography at fractions (a millionth) of a second. Their most famous: the moment of impact when a speeding bullet pierced a target. Flowers notwithstanding, this issue of *Vogue* welcomed back the French edition, which was voluntarily suspended during the Occupation.

Photograph by Gjon Mili

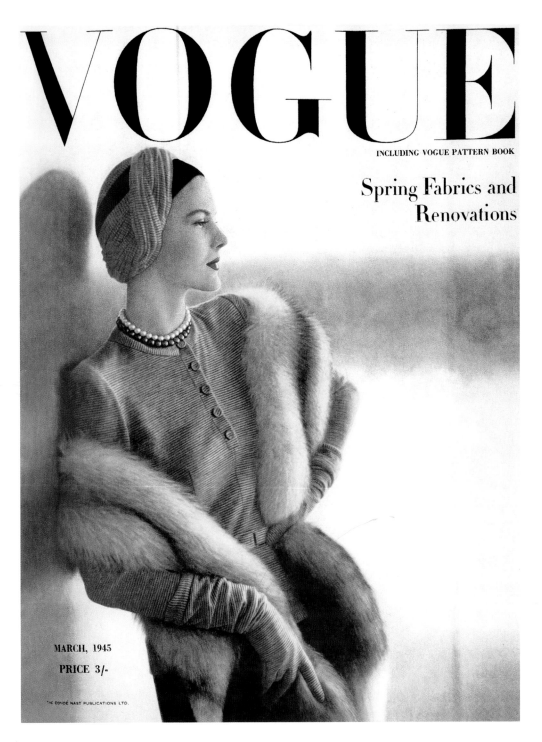

VOGUE

INCLUDING VOGUE PATTERN BOOK

Spring Fabrics and Renovations

MARCH, 1945

PRICE 3/-

THE CONDÉ NAST PUBLICATIONS LTD.

MARCH 1945 Spring Fabrics and Renovations

Though there was still room for highly decorative cover designs, once the war ended they became less frequent. The *Vogue* logo was mostly left untouched, unless a special commemorative issue demanded an unusual device. Instead, covers began to enter a new 'modern' age; the extravagance of the pre-war years — hand-drawn logos, a myriad of typefaces, theatricality — was replaced by cleaner lines and an increasing use of white space. Sensing change in the air, *Vogue*'s editorial was prescient, anticipating by two years Dior's New Look: 'In spite of different conditions, varying restrictions, the new trend in fashion is international — and it is away from masterful severity, towards a gentler femininity.'

Photograph by John Rawlings

113

JULY 1945 Sea and Country Number

'Has Spring,' asked *Vogue*, 'turned her back on this long winter to face a rosier set of tomorrows?' This roseate fantasia by Eugene Berman first appeared on the cover of the American edition. Very much of the era, Berman was a fashionable painter in the French Neo-Romantic style. 'Here,' the magazine exulted, 'he paints a little figure with a sweet neck, and sprinkles her with a collage of sentimentalia.'

Illustration by Eugene Berman

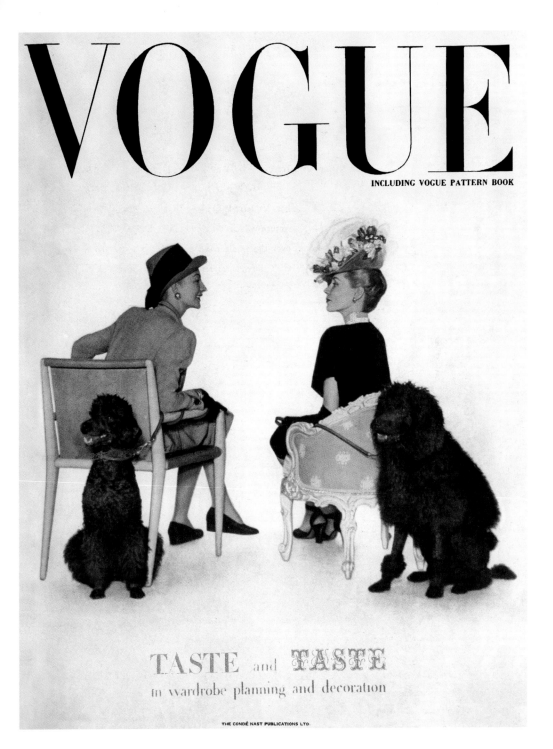

VOGUE

INCLUDING VOGUE PATTERN BOOK

TASTE and TASTE
in wardrobe planning and decoration

THE CONDÉ NAST PUBLICATIONS LTD.

SEPTEMBER 1945 Taste and Taste

What could be more British than a conversation about taste? A veiled criticism can find its mark with the sureness of a sniper's bullet. Though we can't eavesdrop on our two ladies — one sleekly understated, the other more 'obvious' — body language tells us much. The former, half-rising from her unadorned chair with a sly grin, relishes a barbed comment elegantly put. The latter's pursed lips and stiffened back reveal that it has hit home.

This, of course, was *Vogue*'s point. The austerity of the war years would last well into peacetime, and the moment of victory was no time for ostentatious displays. And what could be more British, too, than a pair of dogs, despite the antipathy shown by the under-coiffed to the over-groomed?

Photograph by John Rawlings

VOGUE

PEACE AND RECONSTRUCTION ISSUE OCTOBER 1945 PRICE THREE SHILLINGS INCLUDING VOGUE PATTERN BOOK THE CONDÉ NAST PUBLICATIONS LIMITED

OCTOBER 1945 Peace and Reconstruction Issue

Though the war in Europe ended in June 1945, celebrations were premature while the war in the Pacific continued. It was all finally over by September, after the dropping of the first atom bombs. This caught *Vogue* a little ill-prepared, with no suitable photograph commissioned for a peacetime cover. *Vogue*'s assistant art director hurriedly painted this simple skyscape. It is hard now to imagine a photograph making such a point so effectively.

Illustration by James de Holden-Stone

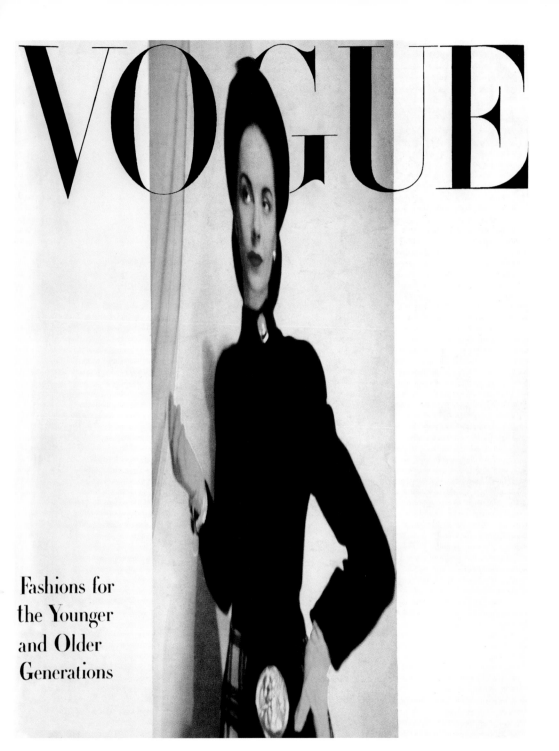

VOGUE

Fashions for the Younger and Older Generations

JANUARY 1946 Younger and Older Generations

A chance meeting with Cecil Beaton led to an introduction to *Vogue* for Erwin Blumenfeld, and his first pictures appeared in 1938. *Vogue*'s 'selling of dreams' suited him, as his photographs were clever fantasies. He had never had any inclination to document 'real life', and when something fascinating from the everyday world presented itself, he recalled, 'I never had my camera at the crucial moment. I am simply not a photojournalist'

In fact, where his cover photography was concerned, the opposite was true. He worked exclusively in the studio, borrowing the elements of shock and surprise from his Dadaist past — he had been a painter and collagist — and translating that into pictures of dresses, shoes and hats.

Photograph by Erwin Blumenfeld

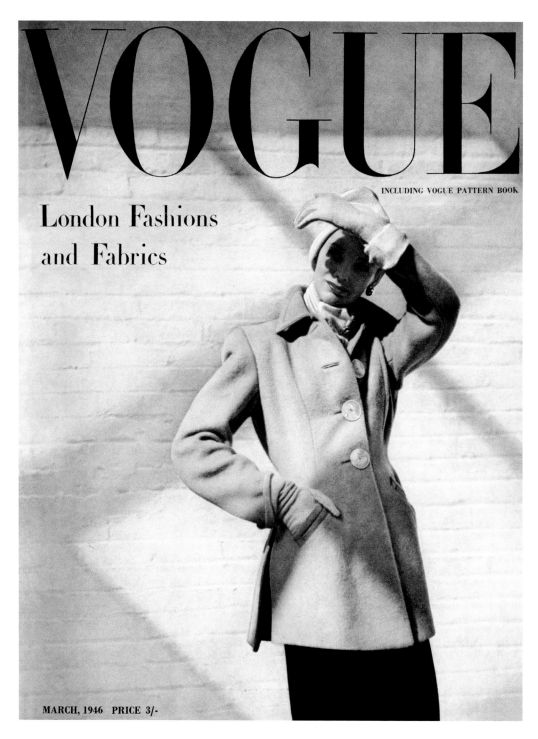

VOGUE

INCLUDING VOGUE PATTERN BOOK

London Fashions and Fabrics

MARCH, 1946 PRICE 3/-

MARCH 1946 London Fashions and Fabrics

A sunlit cover heralds the first spring of peacetime. Unusually, the model's face was allowed to be obscured in the name of spatial harmony, while shadow — usually an intrusion in later covers — is vital to its graphic strength. The effect of this is perhaps to temper postwar optimism (although, with rationing and domestic privations continuing, there was not much to look forward to on the immediate horizon). John Rawlings,

an American, had been loaned to British *Vogue* in the Thirties when native talent had appeared to be in short supply. His stay was brief but, back in New York, he continued to submit covers to the magazine.

Photograph by John Rawlings

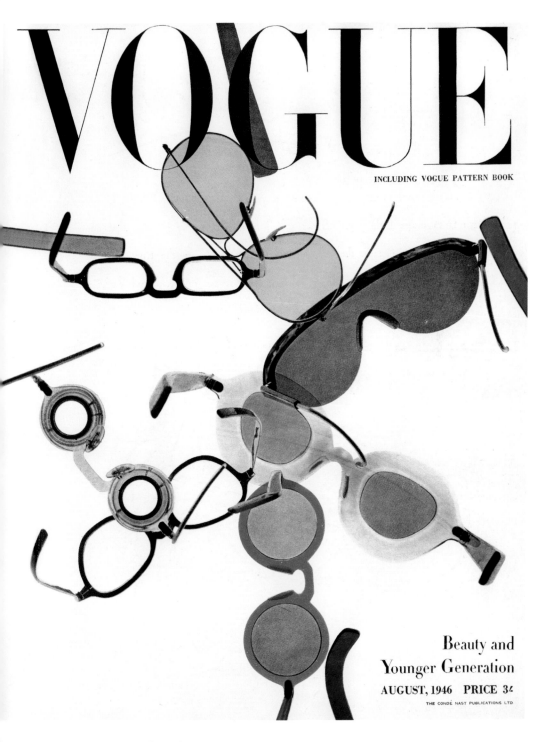

INCLUDING VOGUE PATTERN BOOK

Beauty and
Younger Generation
AUGUST, 1946 PRICE 3⁴
THE CONDÉ NAST PUBLICATIONS LTD

AUGUST 1946 Beauty and Younger Generation

Before Penn, still life was a black-and-white affair, adequate for the graphics of the how-to-do it beauty features. In the immediate postwar years, thanks to Penn (and Kodak Ektachrome film), it became riotously, vibrantly coloured. At *Vogue*, Penn remarked years later, he felt 'like a street savage surrounded by sophisticates'. With that in mind, he frequently subverted the still life by adding a note of discordance to the tableaux of luxuries he was asked to document. This assemblage of dropped sunglasses has all the hallmarks of a dramatic accident, in which, mercifully, nothing was broken. It was, of course, a typically labour-intensive and meticulous arrangement by a master, with nothing — colour, shape or form — left remotely to chance.

Photograph by Irving Penn

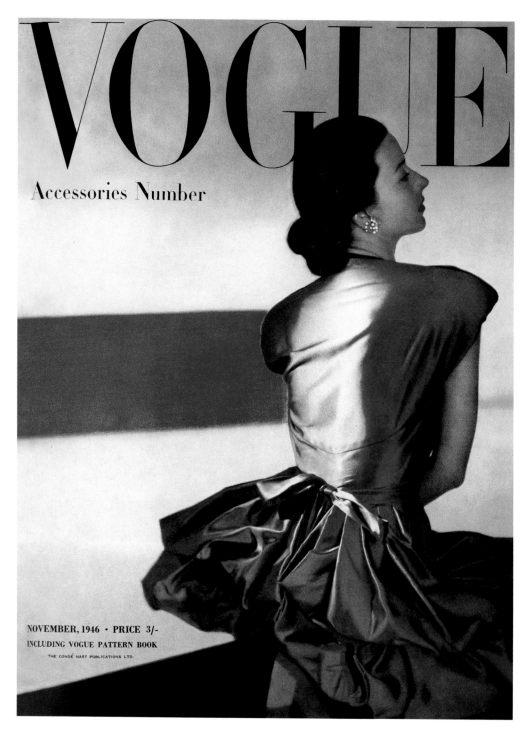

NOVEMBER 1946 Accessories Number

Horst's deceptively simple cover shows his mastery of studio lighting and perhaps his inventiveness with an uninspiring garment. A sheath of 'Parma blue rayon satin', it came with an unwieldy, if detachable, bustle to add formality. The highlights of the dress are picked out, while thrown out of focus are its less shapely upper body elements and the background bands of colour, there to give contrast.

Photograph by Horst

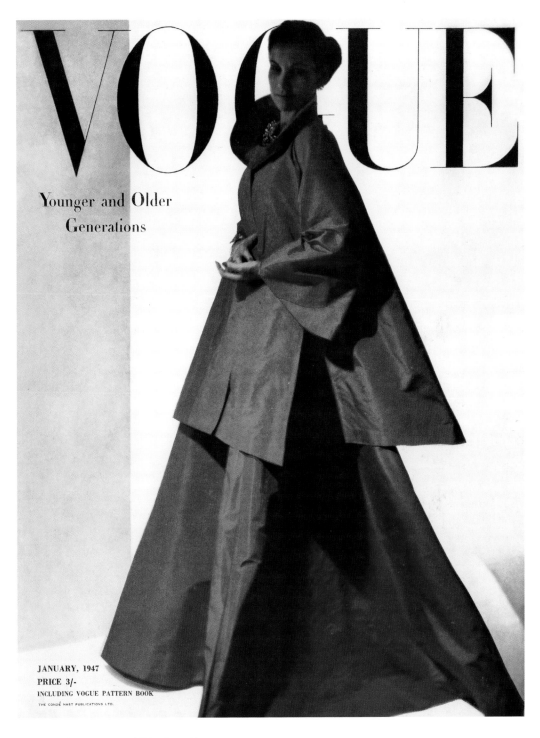

VOGUE

Younger and Older
Generations

JANUARY, 1947
PRICE 3/-
INCLUDING VOGUE PATTERN BOOK
THE CONDÉ NAST PUBLICATIONS LTD.

JANUARY 1947 Younger and Older Generations

While ushering in the New Look, Horst's cover probably spoke more clearly
to the older generation, who might find the formality of a heavyweight
Lanvin-Castillo evening dress more useful. Horst has photographed it
from a slightly lower vantage point to emphasise the pyramidal shape of
the enormous-skirted ballgown, and has tempered with shadow the
conspicuous tomato colour of the taffeta.

Photograph by Horst. Fashion: Lanvin-Castillo

VOGUE

London Season

JUNE, 1947
INCLUDING VOGUE PATTERN BOOK

PRICE 3/-
THE CONDÉ NAST PUBLICATIONS LTD.

JUNE 1947 London Season

The coverline attempts a pun on the Season (debutantes and balls) and the season (summer). 'Penn's cover,' wrote *Vogue*, 'symbolises the gaiety of a summer season — the butterfly fragility of a summer cool dress, fluttering through the social round, the cynosure and envy of all eyes.'

Photograph by Irving Penn

NOVEMBER 1947 Radiance of Sun and Sea

Something of a novelty for the time: a mixed-media collage-cum-illustration.
That this seaside assembly, complete with seaweed and anemone, should
appear in November was perhaps a novelty too far. *Vogue* justified it on the
contents page with a reminder that 'winter travel and sun may still be had'.

Illustration by Eugene Berman

APRIL 1948 Spring Fashions, Paris and London

Typically, Horst attempts a domestic vignette in the studio. The empty birdcage and sprigs of white flowers, while enhancing a feeling of artifice, do not detract from the pure New Look of the cover's fashion: full skirt, cinched waist, dolman sleeves, a deep neckline and 'bib' of pearls.

Photograph by Horst. Fashion: Vogue Patterns

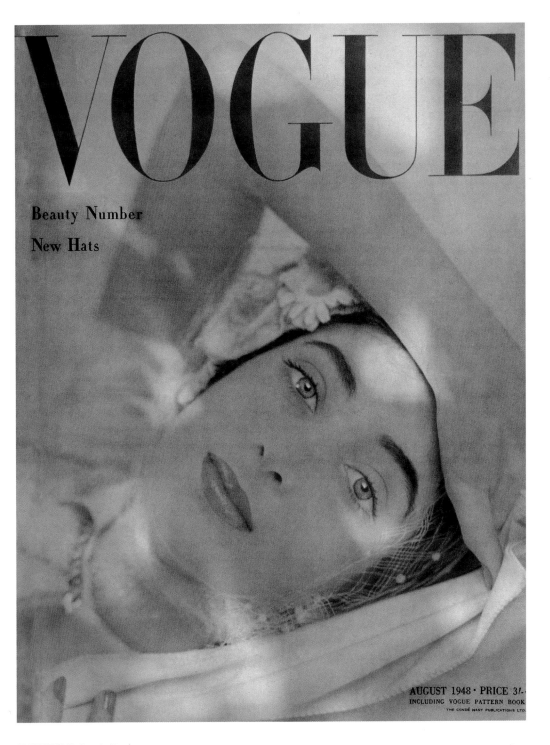

VOGUE

Beauty Number

New Hats

AUGUST 1948 · PRICE 3/-
INCLUDING VOGUE PATTERN BOOK
THE CONDÉ NAST PUBLICATIONS LTD.

AUGUST 1948 Beauty Number

An early, though subtle, admonition by *Vogue* to keep out of the sun.
The translucent green of Herbert Matter's photograph is broken only by
Gala's Heavenly Pink lipstick and nail colour. 'This was a trick,' Matter
wrote later. 'The girl was photographed in colour in the studio; a separate
transparency was made of the green pattern. The two transparencies
were "sandwiched" in position for the engraving.'

Photograph by Herbert Matter

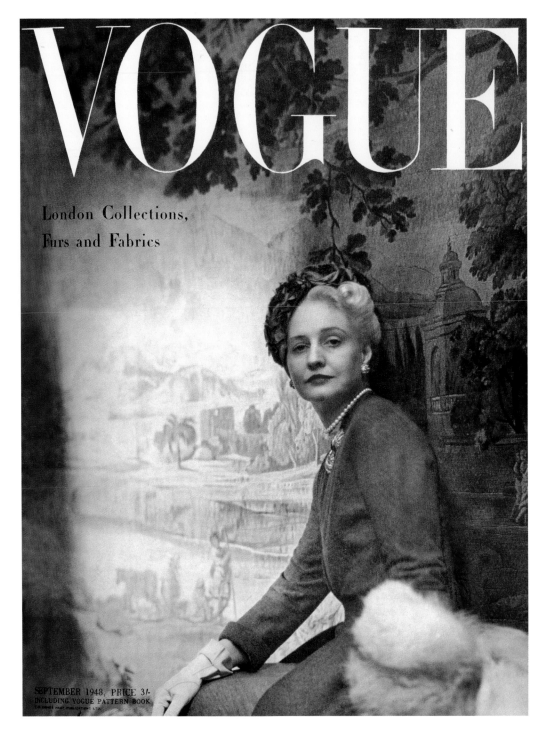

VOGUE

London Collections,
Furs and Fabrics

SEPTEMBER 1948, PRICE 3/-
INCLUDING VOGUE PATTERN BOOK
THE CONDÉ NAST PUBLICATIONS LTD.

SEPTEMBER 1948 London Collections, Furs and Fashions

Vogue shied away from spelling it out, but this was an attempt to remind women of 'a certain age' that the magazine was all-inclusive. Grey-haired models were never *de rigueur* for its covers, but Cecil Beaton played to the strengths of age and dignity, photographing his sitter as he might a member of the royal family. The notion of 'the older reader' found currency in the Fifties with the 'Mrs Exeter' pages. In these a model (of a certain age) played a fictitious Home Counties housewife dispensing *bon mots* to her immediate circle on anything from travelling with heavy luggage to culinary tips ('lobster can be demanding for the "quick luncheon"') and what to wear to the whist drive, hunt ball or private lunch in town.

Photograph by Cecil Beaton

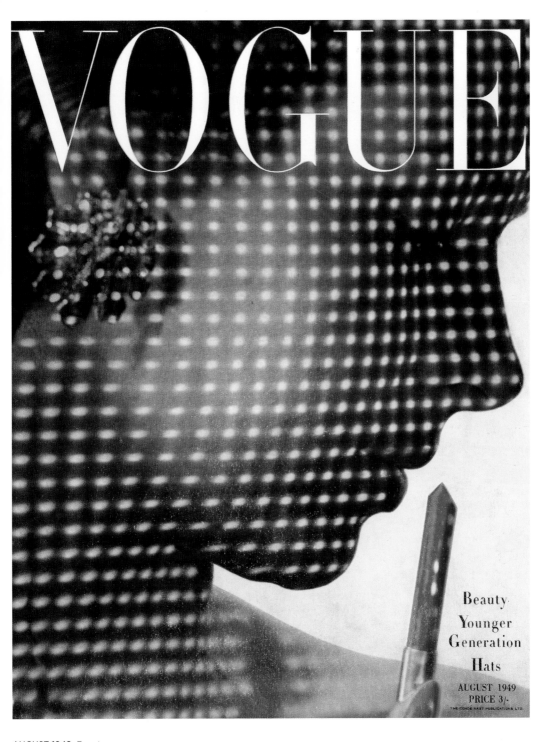

AUGUST 1949 Beauty

Blumenfeld's fractured, dreamlike fashion photographs are characterised by a reliance on darkroom technique — solarisation, superimposed images, the bizarre combination of positives and negatives. This beauty headshot was photographed through a simple screen.

Photograph by Erwin Blumenfeld

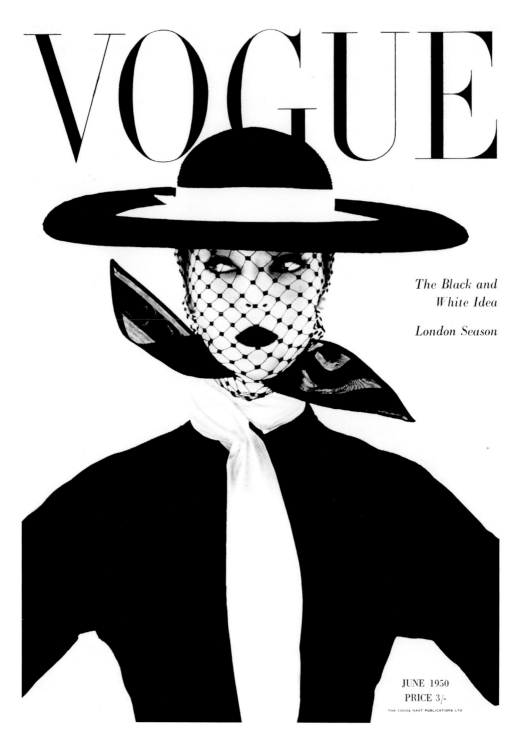

VOGUE

*The Black and
White Idea*

London Season

JUNE 1950
PRICE 3/-
THE CONDE NAST PUBLICATIONS LTD

JUNE 1950 The Black and White Idea

So simple and effective, it was odd that it hadn't been done before. What surprises could a magazine spring, that so revelled in its cutting-edge colour production? A wholly black-and-white cover, clearly, to mark the half-century. Irving Penn's is surely the greatest career *Vogue* has nurtured. However, a few years after this striking cover was made, his allocation of fashion pictures began to dwindle.

The reason given was that their very intensity disturbed *Vogue's* readers — one complaint was that they 'burned on the pages'. The photographer took this as the greatest compliment paid him.

*Photograph by Irving Penn. Model: Jean Patchett.
Fashion: Larry Aldrich and Lilly Daché*

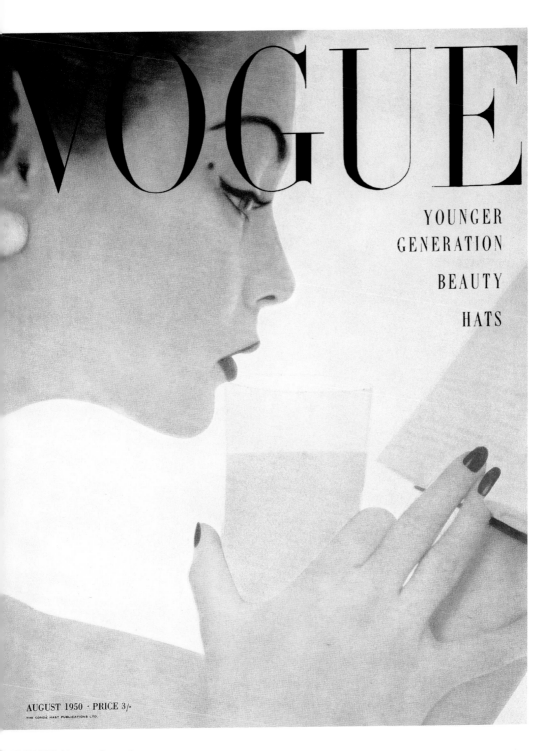

VOGUE

YOUNGER
GENERATION

BEAUTY

HATS

AUGUST 1950 · PRICE 3/-
THE CONDÉ NAST PUBLICATIONS LTD.

AUGUST 1950 Younger Generation

his cover illustrated *Vogue*'s '10-day plan for 10lbs. lighter'. This centred
hostly on skimmed milk, the shortcomings of which Miss Patchett attempts
o stave off by a sustained bout of reading.

Photograph by Irving Penn. Model: Jean Patchett

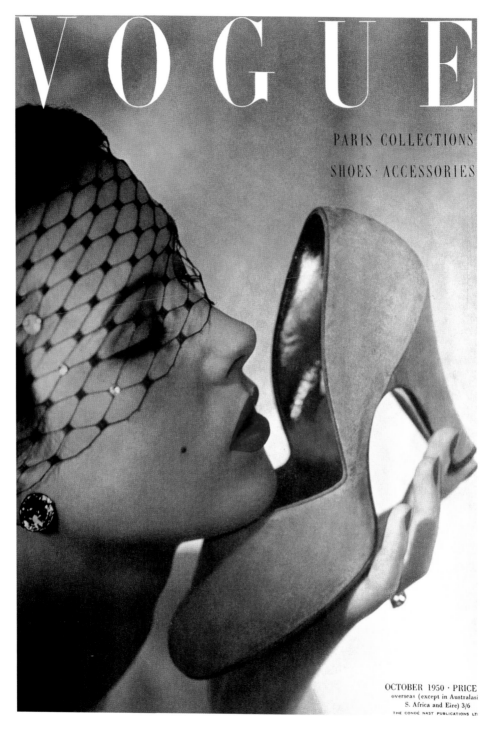

VOGUE

PARIS COLLECTIONS

SHOES · ACCESSORIES

OCTOBER 1950 · PRICE
overseas (except in Australasi
S. Africa and Eire) 3/6
THE CONDÉ NAST PUBLICATIONS LT

OCTOBER 1950 Paris Collections

One of the most unusual covers of the Fifties seemed to uphold
the common belief, held mostly by men, that women revere shoes
more than anything else. In this case, the object of veneration is a
topaz evening pump with a gold kid lining.

Photograph by Anthony Denney. Accessories: Rayne

VOGUE

BRITANNICA
NUMBER
1951

FEBRUARY 1951 · PRICE 3/-

OVERSEAS (EXCEPT IN AUSTRALASIA, S. AFRICA AND EIRE) 3/6

THE CONDÉ NAST PUBLICATIONS LTD.

FEBRUARY 1951 Britannica Number

In the year that saw renewed optimism in British industry and culture, *Vogue* fanfared homegrown achievements with a special issue. 'This land's our oyster,' it declared, 'which we with words and pictures will open, and maybe find a pearl in the process.' In true national style, however, *Vogue* managed to contain itself behind a veneer of modesty: 'We have tried to avoid claiming too much or blowing Britain's trumpet too loudly . . .'

Illustration by John Parsons

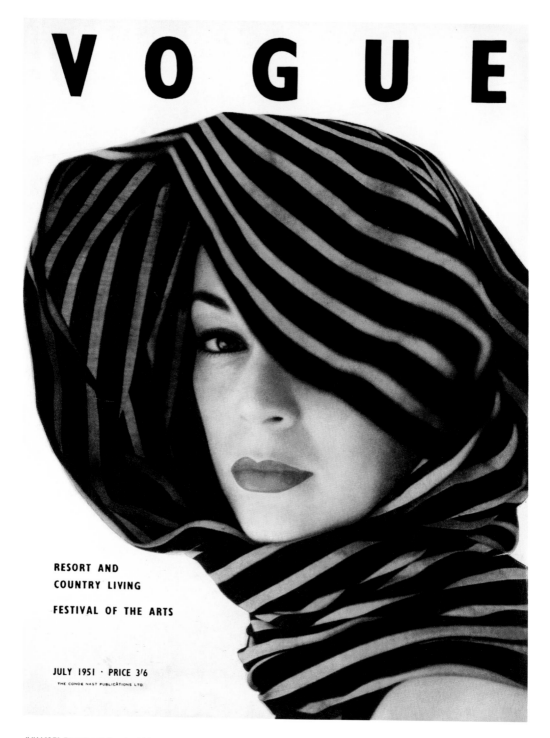

VOGUE

RESORT AND
COUNTRY LIVING

FESTIVAL OF THE ARTS

JULY 1951 · PRICE 3/6

THE CONDÉ NAST PUBLICATIONS LTD

JULY 1951 Resort and Country Living

This Mexican rebozo was, considered *Vogue*, 'protection against a withering foreign sun or our homebred sea breezes'. For its golden-jubilee issue in 1966, *Vogue* reproduced this photograph and paid its creator, though he was a notoriously difficult man, this compliment: 'Coffin was a perfectionist. He could create impeccable elegance from the simplest ingredients ... given a model and some make-up he could make a beauty.'

Photograph by Clifford Coffin

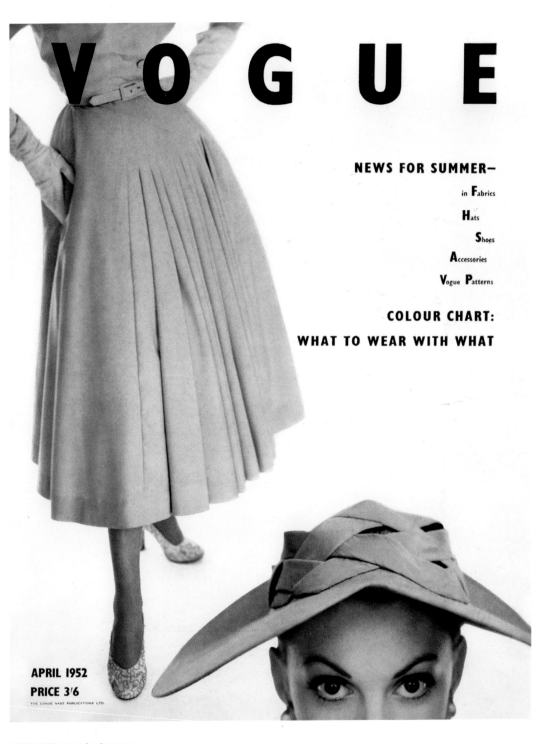

VOGUE

THE CONDÉ NAST PUBLICATIONS LTD.

NEWS FOR SUMMER—

in Fabrics

Hats

Shoes

Accessories

Vogue Patterns

COLOUR CHART:

WHAT TO WEAR WITH WHAT

APRIL 1952

PRICE 3/6

APRIL 1952 News for Summer

Vogue's ingenious way to illustrate a definitive coverline ('What to wear with what') was to divide the cover — and model — in two. Her body featured a blond tussore dress with slender Manilla shoes piped in blue. Her head: a floppy blue-latticed hat. This eye-catching conceit was not repeated.

Photograph by Don Honeyman. Fashion: Fortnum & Mason and Ferragamo

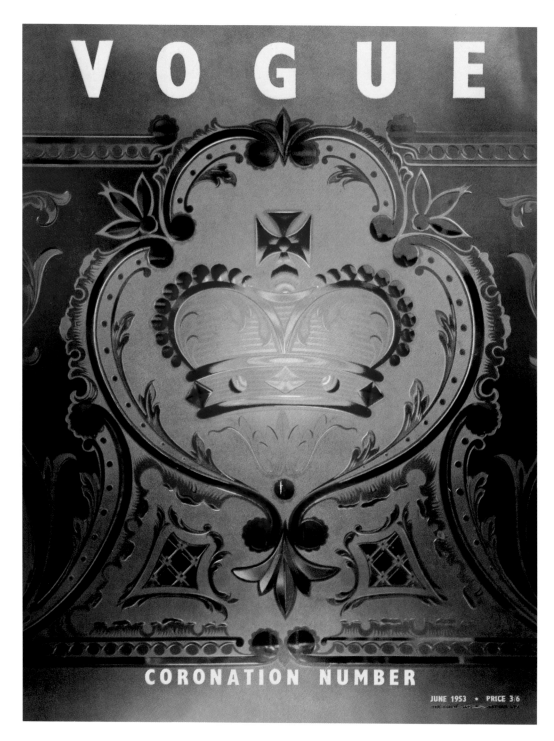

VOGUE

CORONATION NUMBER

JUNE 1953 • PRICE 3/6

JUNE 1953 Coronation Number

Vogue's excitement at the impending coronation of Elizabeth II was barely containable. One special issue was devoted solely to it, with follow-up reports from the abbey in two further issues. 'We may indeed find,' historian C.V. Wedgwood told readers, 'that we have moved into the glories of a second Elizabethan Age.' Cecil Beaton was dispatched to photograph the new queen, her consort and her maids of honour, as well as the Archbishop of Canterbury. Writer and illustrator Edward Ardizzone showed how a coronation street scene might look. Lady Sysonby reminisced about previous coronations, while Norman Parkinson was sent to a public house to photograph its windows for the cover.

Photograph by Norman Parkinson

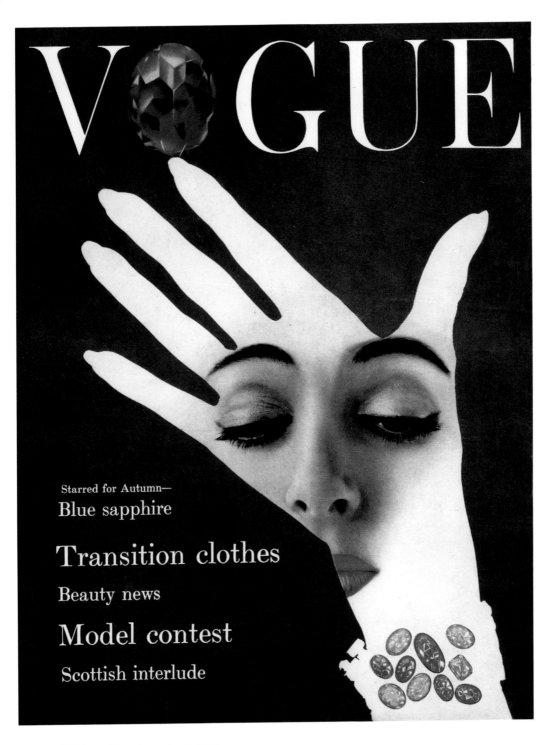

VOGUE

Starred for Autumn—
Blue sapphire

Transition clothes

Beauty news

Model contest

Scottish interlude

AUGUST 1954 Starred for Autumn: Blue Sapphire

A striking composite cover illustrating the colour choice for autumn: 'blue sapphire'. This was a special beauty issue, with make-up by Yardley chosen to complement the almost entirely blue fashion pages. The point was further brought home by a sapphire standing in for the O of *Vogue*'s logo.

Photograph by Norman Parkinson

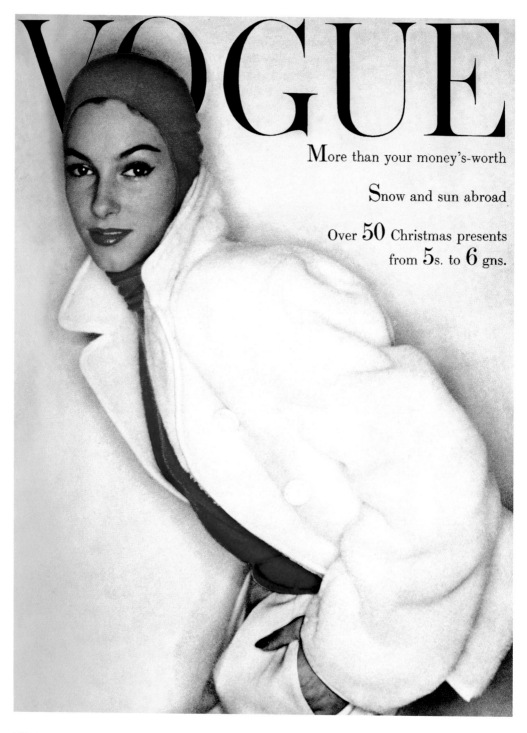

VOGUE

More than your money's-worth

Snow and sun abroad

Over 50 Christmas presents
from 5s. to 6 gns.

NOVEMBER 1954 More than Your Money's-Worth

Coffin was responsible for a notable innovation in lighting techniques. His adaptation of the ring-light, previously used in cosmetic dentistry, made an impact in fashion photography and was later used by photographers such as Nick Knignt and Juergen Teller. A ring of tungsten lamps around the camera lens gave an even, shadowless light on the subject while casting a halation of fine shadow around it. The thin black outline lent clarity to the cut and shape of the clothes. Coffin made use of it — with great success — in beauty photography, as it all but eliminated blemishes while enhancing skin tone.

Photograph by Clifford Coffin.
Fashion: Berg of Mayfair and Herbert Johnson

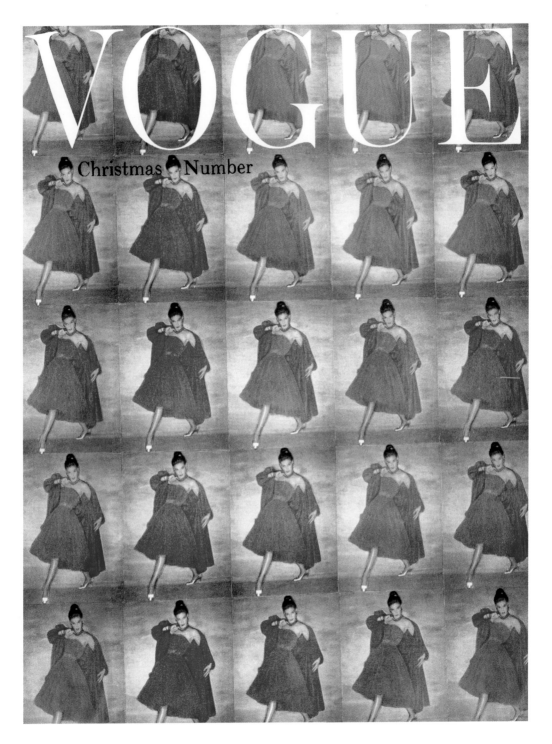

DECEMBER 1954 Christmas Number

Vogue's Christmas cover always merited special treatment. Alexander Liberman multiplied by 25 this Coffin picture, an out-take from US *Vogue*'s autumn-collections issue, to make an arresting seasonal statement. It won him the American Art Directors' Club prize for the year's best cover.

Photograph by Clifford Coffin. Fashion: Dior

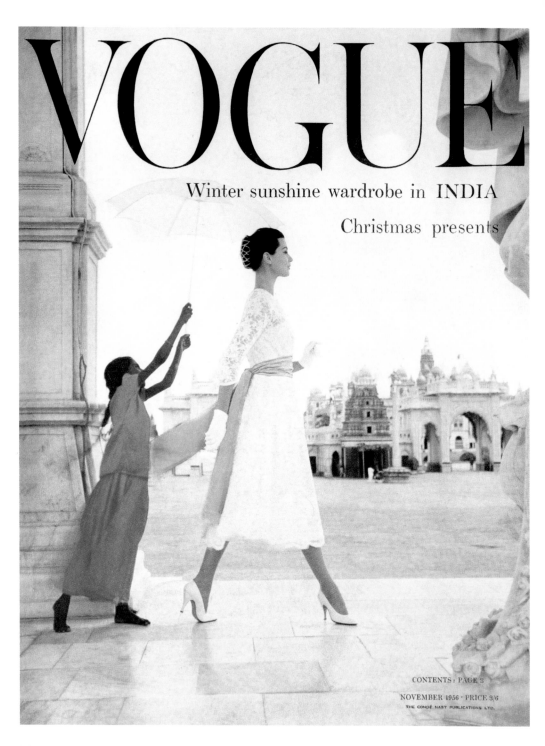

VOGUE

Winter sunshine wardrobe in INDIA

Christmas presents

NOVEMBER 1956 · PRICE 3/6

THE CONDÉ NAST PUBLICATIONS LTD.

NOVEMBER 1956 Winter Sunshine Wardrobe in India

'For the first week in India one's urgent wish is to be a photographer. The eye is stormed a million times a day: not only by colour of a full-throated kind . . . but still more by the Indian instinct for beauty.' Penelope Gilliatt surely articulated it for *Vogue* and its readers better than anyone previously. And for that same readership, Norman Parkinson articulated the rich hues of India with colour film better than anyone had done previously. American

Vogue's Diana Vreeland put it inimitably: 'How clever of you to know, Parks, that pink is the navy blue of India . . .' Here Barbara Mullen stalks the plinth of a maharaja's statue in the marble city of Mysore.

Photograph by Norman Parkinson.
Model: Barbara Mullen. Fashion: Julian Rose.

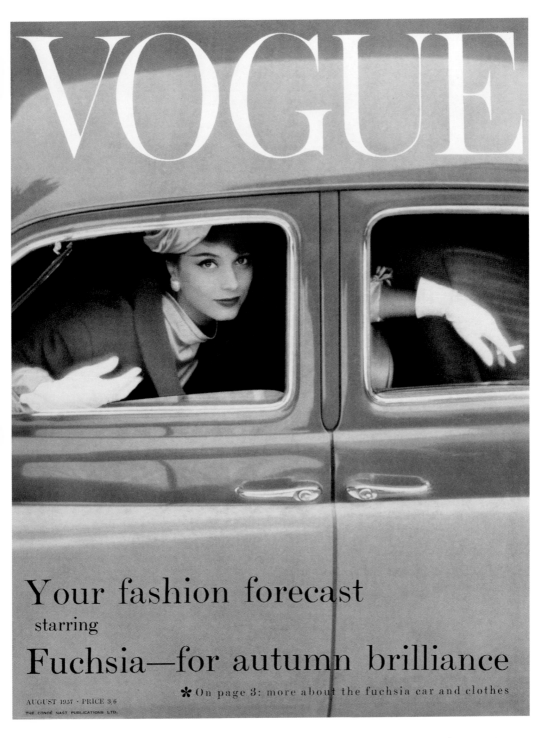

AUGUST 1957 Fuchsia: for Autumn Brilliance

Many great cover ideas get no further than that. Too costly, too outlandish, too impractical, too vulgar. It is not recorded who thought up celebrating the season's colour by spray-painting a family saloon purple — but it happened. The car shown here was the Rover 105, soon to become a sturdy British standby. *Vogue* noted that the Luton-based firm of spray-painters would gladly undertake any work for *Vogue* readers, but that fuchsia is 'not a colour scheme in the regular range'. A sign of the times, perhaps, but when this image was reused in 1991, the then editor-in-chief insisted on the cigarette being airbrushed out.

Photograph by Norman Parkinson.
Fashion: John Cavanagh for Berg of Mayfair

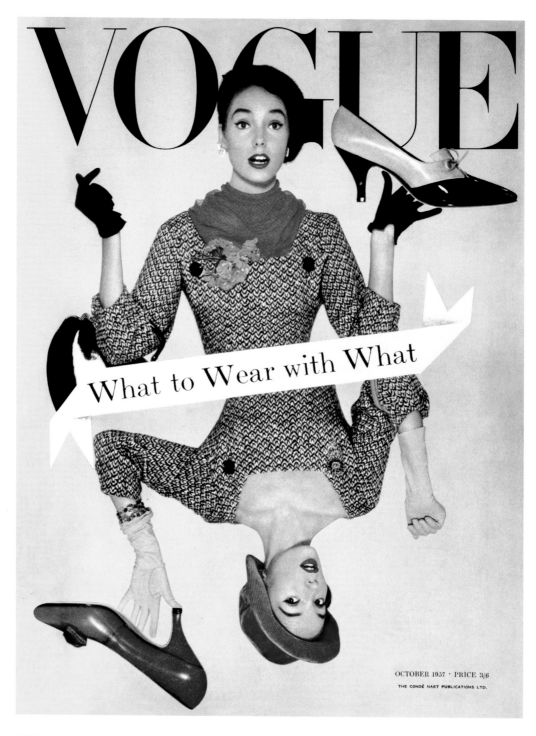

VOGUE

What to Wear with What

OCTOBER 1957 · PRICE 3/6
THE CONDÉ NAST PUBLICATIONS LTD.

OCTOBER 1957 What to Wear with What

Norman Parkinson adopts a playing-card motif to illustrate *Vogue's* popular advisory pages, which promised 'A topsy-turvy view of What to Wear with What — but no muddled thinking'.

Photograph by Norman Parkinson. Fashion: Dorville

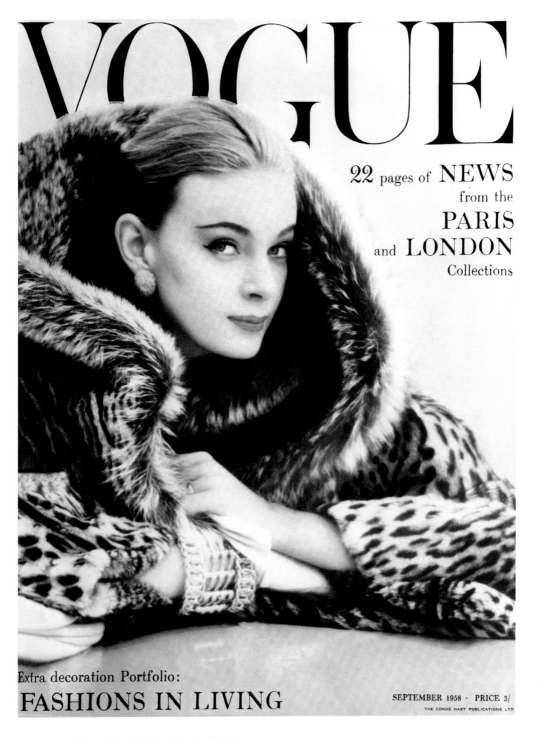

VOGUE

22 pages of NEWS
from the
PARIS
and LONDON
Collections

Extra decoration Portfolio:

FASHIONS IN LIVING

SEPTEMBER 1958 · PRICE 3/

THE CONDÉ NAST PUBLICATIONS LTD

SEPTEMBER 1958 News from the Paris and London Collections

Surprisingly for the period, fur was never popular for the cover of *Vogue*. This was a conspicuous exception, which the magazine called 'nothing short of fabulous'; glossy, smooth-faced ocelot with a shaggy collar of rolled raccoon. Parkinson's model, Nena von Schlebrugge, became his favourite in the Sixties, though he despaired of her stylistic dichotomies. She was neither flower child nor Chelsea girl, but 'hovered between the two like some half-filled helium balloon'. If something about her looks oddly familiar, then that is possibly because she is the mother of the cover girl on page 190.

Photograph by Norman Parkinson.
Model: Nena von Schlebrugge

141

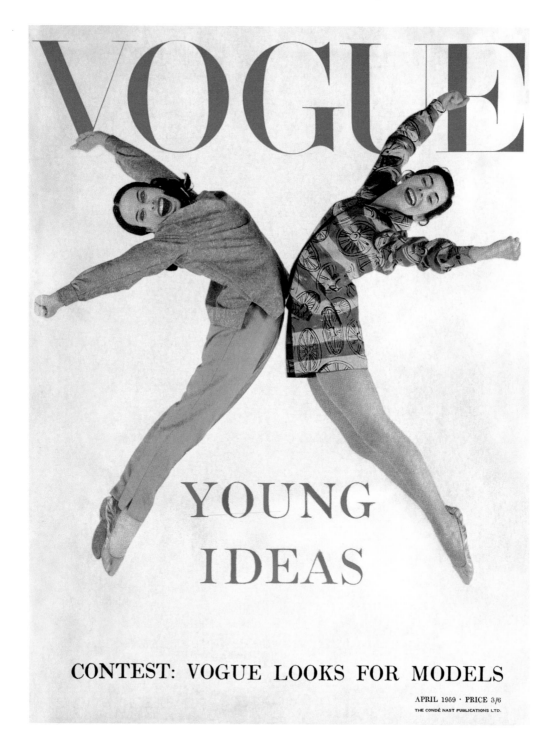

VOGUE

YOUNG IDEAS

CONTEST: VOGUE LOOKS FOR MODELS

APRIL 1959 · PRICE 3/6

THE CONDÉ NAST PUBLICATIONS LTD.

APRIL 1959 Young Ideas

Two young soloists from the Royal Ballet jump for joy as the magazine taps into a new market. *Vogue*'s enthusiasm for younger readers would reach new heights in the decade to come, but this marks the start. Unsure how to treat this new sub-species, it responded at first by offering up slightly more frivolous versions of grown-up clothes: a twinset was still a twinset, despite being 'garden-party pretty'. The magazine's suggestions of suitable arenas to wear 'young and exciting ideas' included Lord's, Ascot, Wimbledon and Henley. It ended its special report by reminding Young Ideas readers of a 'badge of honour — immaculate white gloves'.

Photograph by Norman Parkinson. Cover stars: Georgina Parkinson and Hylda Zinkin. Fashion: Fredrica and Estrava

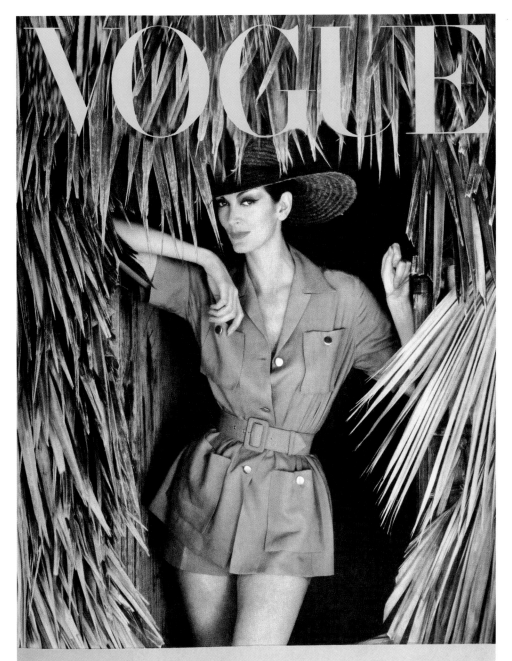

VOGUE

20 PAGES OF NEW HOLIDAY LOOKS IN THE BAHAMAS

JULY 1959 PRICE 3/6 THE CONDÉ NAST PUBLICATIONS LTD.

JULY 1959 New Holiday Looks in the Bahamas

Jet travel had opened up the world, and *Vogue* was quick to take advantage. Its furthest-flung ambassador was Norman Parkinson. His first major foreign trip for *Vogue* — to South Africa — was made in 1951, and his foreign assignments escalated throughout the decade, taking him to Jamaica, India, Australia and, here, the Bahamas. These stories corresponded to an increase in colour-page allocation, and Parkinson took pains to capture for readers the exoticism of the locales too: 'The world is my studio,' he told one interviewer. This shot was taken on Love Beach, on the north-western coast of Nassau.

Photograph by Norman Parkinson. Model: Carmen.
Fashion: Donald Davies and Londonus

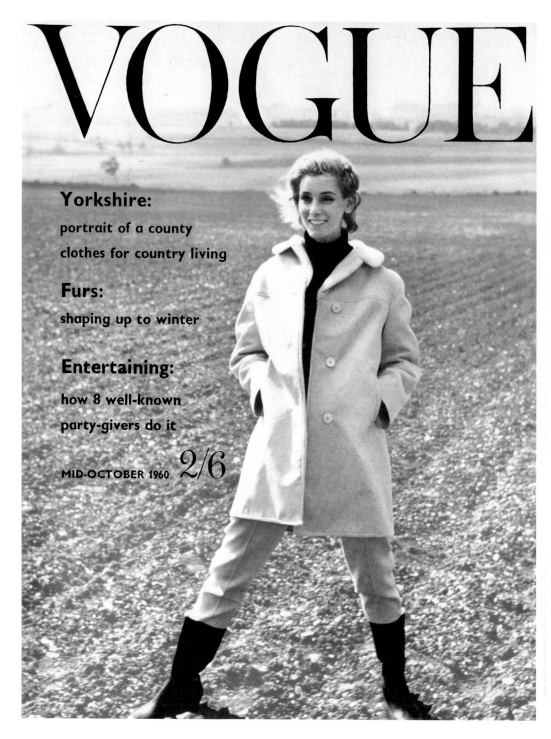

VOGUE

Yorkshire:

portrait of a county

clothes for country living

Furs:

shaping up to winter

Entertaining:

how 8 well-known

party-givers do it

MID-OCTOBER 1960 2/6

MID-OCTOBER 1960 Yorkshire: Portrait of a County

Frank Horvat came to *Vogue* from photojournalism, and his distaste for the artifice of fashion photography was evident. Reflecting the realism of such British-based New Wave film directors as Karel Reisz and Tony Richardson, Horvat's work exerted great influence on the coming generation of British fashion photographers. His models were ungroomed and his backdrops were mostly urban, often industrial. *Vogue* sent him and a fashion team to Yorkshire for a session remembered as almost entirely lacking in 'fashion'. Figures were shot at long distance on the brows of crags, with features barely recognisable and clothes indistinct. More conventional frames saw models walking the streets of Bradford in grainy, resolute monochrome.

Photograph by Frank Horvat. Fashion: Rodex

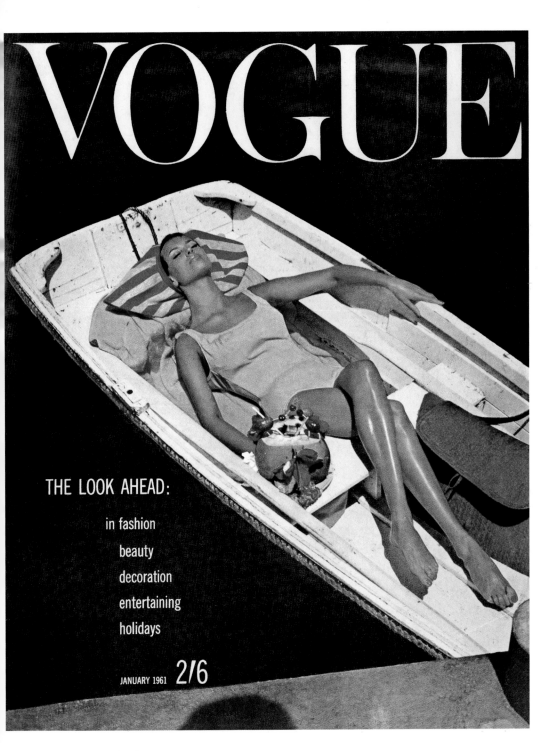

VOGUE

THE LOOK AHEAD:

in fashion

beauty

decoration

entertaining

holidays

JANUARY 1961 **2/6**

JANUARY 1961 The Look Ahead

William Bell's only cover for British *Vogue* was lifted from the US edition. It was rushed through at the last minute, presumably because nothing from the pages of travel fashion — 'Hot spots, cool clothes' — was either hot or cool enough to make the cover. In fact, they were in black and white. Despite the inkiness of the sea and the peculiar bolster-cum-headdress, this was a vibrant South Seas-style vignette, made the more so by the exotic tropical fruit.

Photograph by William Bell

VOGUE

Where's fashion

going

NOW

?

Eye-opener reports

from Paris

London Italy

Eye-catching budget clothes
at down-to-earth prices

September 1 1961 2/6

1 SEPTEMBER 1961 Where's Fashion Going Now?

This striking piece of graphic design was also borrowed from an earlier US
Vogue, but with a different coverline. ('Beauty in our Time' was the original.)
The question mark in the British version replaced a cut-out of a Dior-suited
model. Perhaps only the diehard film buffs among British *Vogue*'s readers
would have noticed that the eyes and the lips belonged to Sophia Loren — a
fact kept from them, presumably, because the central theme had changed.

Photographer unkno

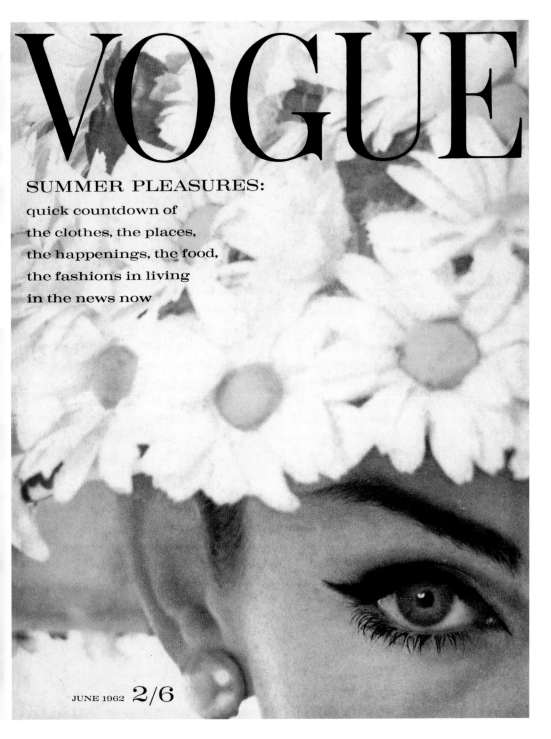

VOGUE

SUMMER PLEASURES:

quick countdown of
the clothes, the places,
the happenings, the food,
the fashions in living
in the news now

JUNE 1962 2/6

JUNE 1962 Summer Pleasures

Jean Shrimpton was destined to become the most famous British model of the next 10 years — rivalled only, later in the decade, by Twiggy. Bailey's close-up of a marguerite-covered cloche and one doe eye makes an elegant cover, rendering Shrimpton as a homespun Audrey Hepburn. In the decade that made them one of the world's most celebrated partnerships, this was not an allusion to which either warmed.

Photograph by David Bailey. Model: Jean Shrimpton.
Fashion: Simone Mirman

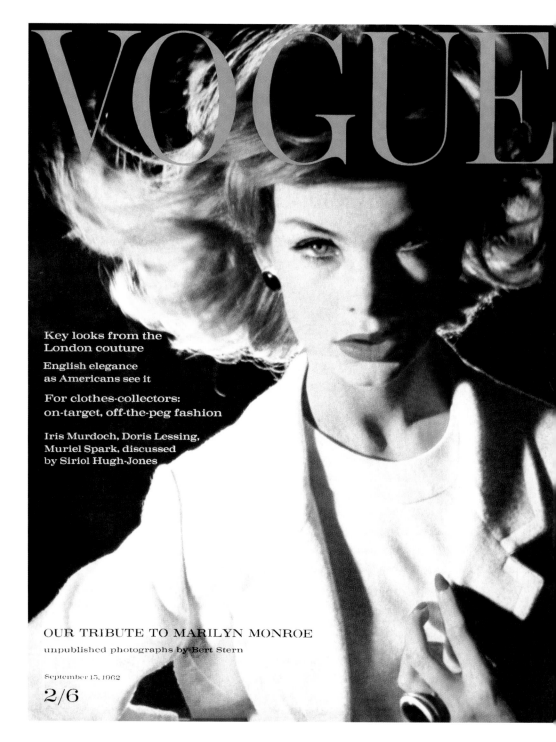

VOGUE

Key looks from the
London couture

English elegance
as Americans see it

For clothes-collectors:
on-target, off-the-peg fashion

Iris Murdoch, Doris Lessing,
Muriel Spark, discussed
by Siriol Hugh-Jones

OUR TRIBUTE TO MARILYN MONROE

unpublished photographs by Bert Stern

September 15, 1962

2/6

15 SEPTEMBER 1962 Key Looks from the London Couture

For almost four intense years, Bailey worked with virtually no other model, and the collaboration of Bailey and Shrimpton became a photographic legend. It was, as one commentator put it, 'a whirlwind romance via the camera'. This cover was more hard-edged than any they had attempted before. Shrimpton's allure was such that it cut firmly across cultural and social divides and for Bailey, as he demonstrated here, she mixed sophistication with vulnerability. More mundanely, this white dress and jacket marked an early appearance for 'a swinging new fabric': a Terylene mix.

Photograph by David Bailey. Model: Jean Shrimpton.
Fashion: San Clair

MAY 1963 The New Beauty

David Bailey did not have a monopoly on Shrimpton. Despite his efforts to give her a more up-to-the-minute 'edge', other photographers still saw in her reticence an updated, introverted Audrey Hepburn lookalike. And, just sometimes, it worked.

Photograph by William Klein. Model: Jean Shrimpton. Fashion: Dior

JUNE 1963 What Makes Britain Wear Well?

The miniskirt may have been around for a year or so, the Beatles too, but for *Vogue* the Sixties, classless and permissive, started here. And an inexpensive, disposable red ring, to which *Vogue* added a patriotic flourish, summed it all up. If that didn't indicate the times, the typography certainly did. The dynamic, off-kilter coverline became a staple for the magazine's art department. *Vogue*'s irrepressible model (wearing Rave Red lipstick by Outdoor Girl) was Sandra Paul, better known to us today as Mrs Michael Howard, wife of a former Conservative Party leader. She is now unlikely to become the first *Vogue* cover girl to call 10 Downing Street home.

Photograph by Peter Rand. Model: Sandra Paul.
Accessories: Adrien Mann

VOGUE

THE NEW BIG VOGUE NOVEMBER 1963 THREE SHILLINGS

1 NOVEMBER 1963 New Big Vogue

Vogue had responded to the popularity of British fashion by reinventing itself as a slightly bigger bible than previously. This move into an uncharted territory of trendiness brought about, in this issue, a glossy white page, a square cover photograph with rounded-off corners (mimicking a Kodachrome slide), and for the *Vogue* banner to be distanced from the image beneath (usually it was laid on top of a full-bleed picture). Brian Duffy's contribution was Garboesque in its allure and quite unlike *Vogue*. What can be said for this design was that it was prescient, looking remarkably like that for the groundbreaking magazine *Nova*, which was still a couple of years into the future.

Photograph by Brian Duffy. Fashion: Otto Lucas

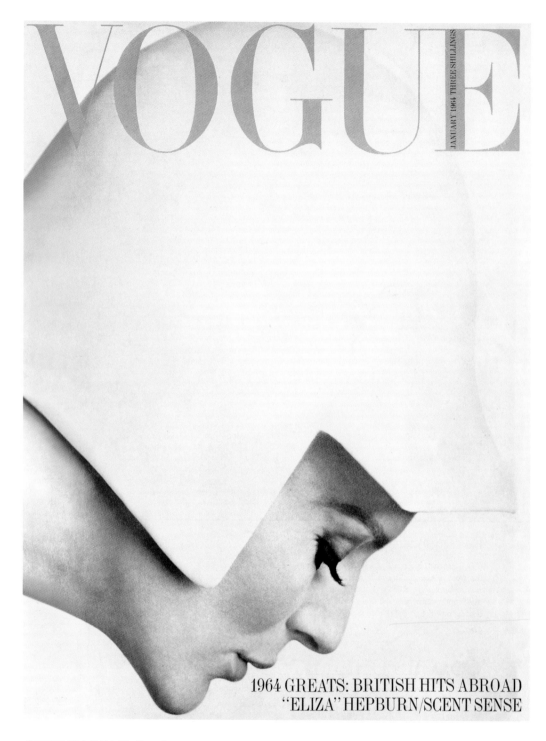

VOGUE

1964 GREATS: BRITISH HITS ABROAD
"ELIZA" HEPBURN/SCENT SENSE

JANUARY 1964 British Hits Abroad

This squared-off helmet of white patent leather owed much to the futuristic, space-age creations of Paco Rabanne, Cardin and Courrèges, then at the cutting edge of fashion design. It was designed by James Wedge, who later became a well-known photographer (and partner for four years of the actress Helen Mirren). He was then Britain's leading milliner. That his designs had an impact overseas was recognised by this striking *Vogue* cover.

Photograph by Brian Duffy. Model: Paulene Stone.
Fashion: James Wedge.

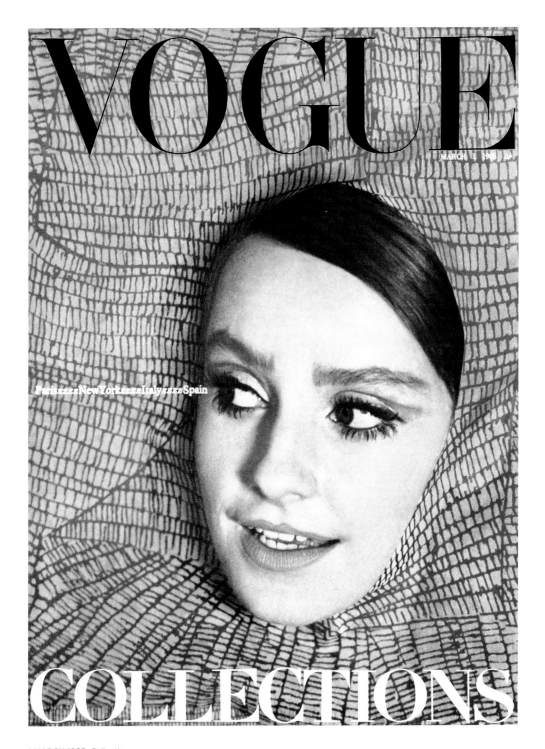

VOGUE

MARCH 1 1965 3/-

Paris≈≈≈NewYork≈≈≈Italy≈≈≈Spain

COLLECTIONS

1 MARCH 1965 Collections

Rather disquietingly, Norman Parkinson's spider-siren entraps the 'great looks from the new international collections. All round her: new, light, shimmering cobweb print'.

Photograph by Norman Parkinson.
Fashion: Ascher for John Cavanagh

VOGUE

JUNE 1965 3/-

WHERE THE ACTION IS
an entertaining summer

JUNE 1965 Where the Action Is

Vogue's flower person emphasised the new hair that was becoming *de rigueur*. (Haight-Ashbury was still over a year away.) The late fashion historian Valerie Lloyd remained convinced that this was 'probably a wig'.

Photograph by David Bailey. Model: Jean Shrimpton.
Accessories: Corocraft and Adrien Mann

VOGUE

JULY 1965 3/-

*marvellous mad midsummer
sand swim sea sun
sheiks sophia
and how to
scintillate
almost
anywhere
even at a picnic*

JULY 1965 Sophia Loren

A sign of things to come. Sophia Loren was by no means the first household name to appear on the front of British *Vogue*, but she was the first to appear for no discernible reason other than the fact she made a beautiful-looking cover. (She was currently filming *Lady L* at Castle Howard.) Traditionally at least, where the celebrity cover was concerned, there would be some supporting feature inside — a film puff, a location report, a day-in-the-life, a beauty regime. In this case, nothing at all. In such unusual circumstances, *Vogue* struggled a little with the coverlines, opting for a descriptive stream-of-consciousness.

Photograph by David Bailey

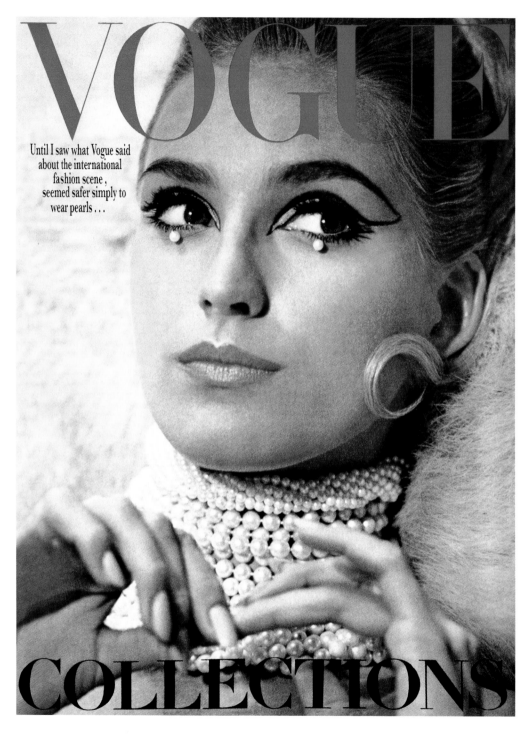

VOGUE

Until I saw what Vogue said about the international fashion scene , seemed safer simply to wear pearls . . .

COLLECTIONS

1 SEPTEMBER 1965 Collections

A cover that did not necessarily spawn a popular look but heralded a new tone in cover copy: gently ironic and self-mocking. The pearlescent look was attained here by Orlane's Shimmering Pearl make-up.

Photograph by Norman Parkinson. Accessories: Mikimoto

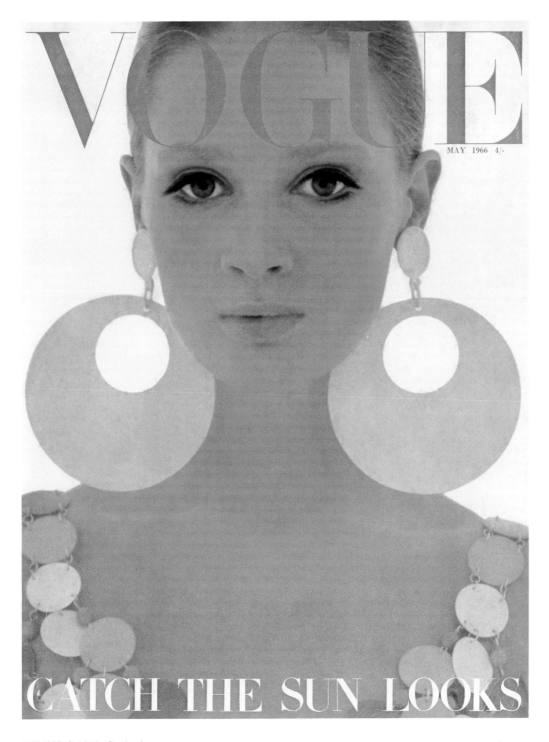

VOGUE

MAY 1966 4/-

CATCH THE SUN LOOKS

MAY 1966 Catch the Sun Looks

Bailey had Shrimpton; Terence Donovan had Celia Hammond. Occasionally both crossed over, neither with conspicuous success. Donovan's pictures of Shrimpton were quirky enough, but understandably he lacked Bailey's instant rapport. Similarly, Hammond was not a frequent model for Bailey, for much the same reason. This, however, is a radiant exception, though the giant disc earrings threaten to distract the eye from anything else.

Photograph by David Bailey. Model: Celia Hammond.
Fashion: Paco Rabanne

157

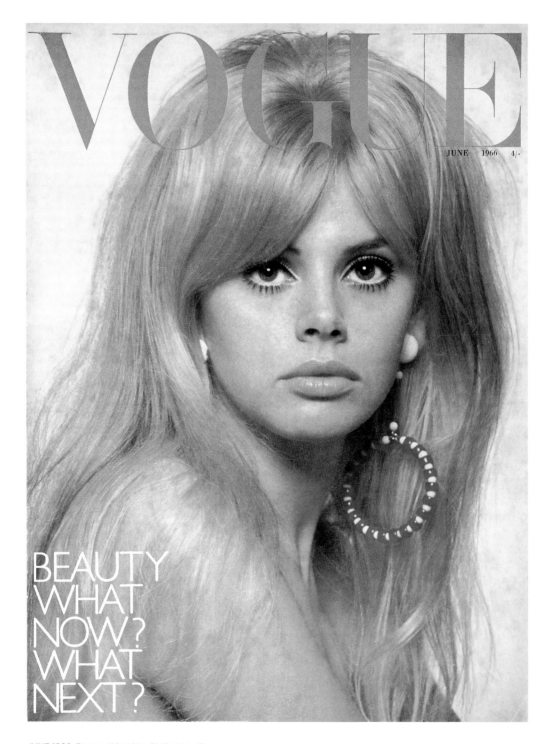

VOGUE

BEAUTY
WHAT
NOW?
WHAT
NEXT?

JUNE 1966 Beauty: What Now? What Next?

'Golden Looks for a Golden Summer', trumpeted *Vogue*, and who better to personify it than the Swedish starlet Britt Ekland. She had just finished *After the Fox*, a Euro-pudding directed by an Italian Neo-Realist (Vittorio De Sica), starring an English comedian (Peter Sellers). A New York Jewish comedy writer (Neil Simon) had a hand in the script and it was scored by the world's most successful songwriters (Burt Bacharach and Hal David). It was not a success. The Swede, who was then married to the Englishman, divorced him after it opened. Several years later, Peter Sellers also became, briefly, a *Vogue* cover photographer (page 167).

Photograph by David Bailey. Cover Star: Britt Ekland.
Accessories: de Sevigne for Florsheim. Hair: Roger at Vidal Sassoon.

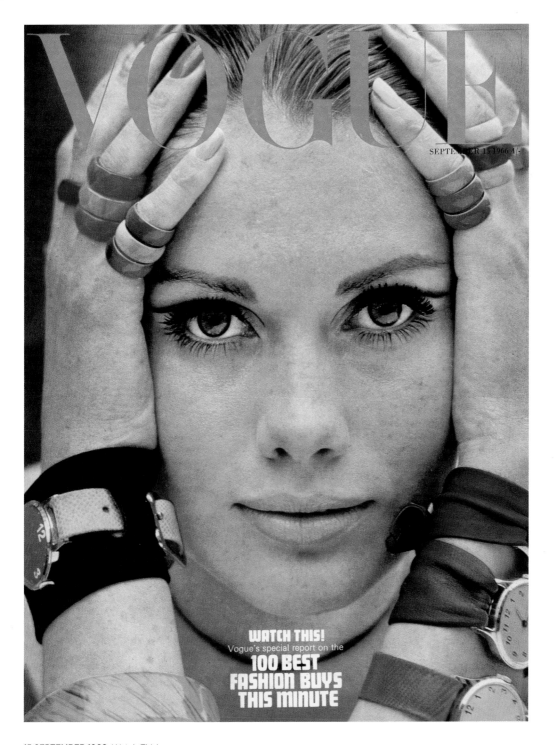

WATCH THIS!
Vogue's special report on the
**100 BEST
FASHION BUYS
THIS MINUTE**

15 SEPTEMBER 1966 Watch This!

Saul Leiter is one of the great unsung figures of postwar American photography. Along with his friend Robert Frank, Richard Avedon and Diane Arbus, he was part of a putative New York School which flourished between 1936 and 1963. Several members who had slipped from view were subsequently rehabilitated, chiefly Louis Faurer. But not Leiter — upon whom, as one enthusiast observed, 'fame sits so lightly'.

*Photograph by Saul Leiter. Model: Maud Wikstrom.
Accessories: Ingersoll, Corocraft and Adrien Mann*

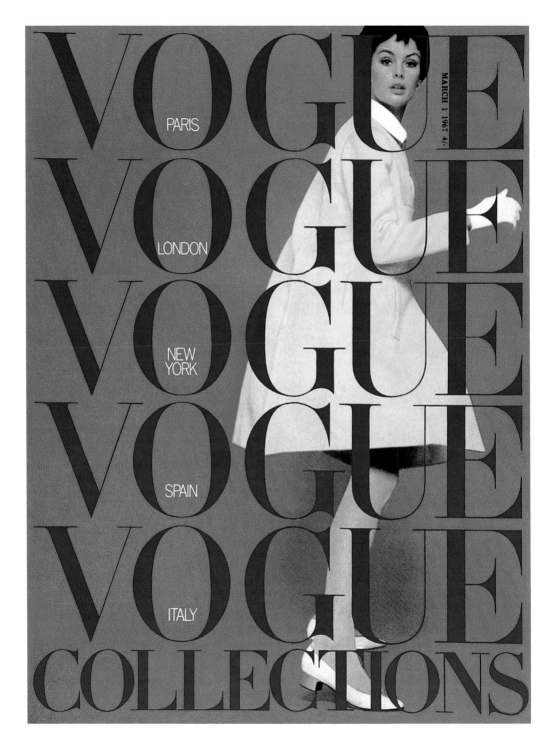

VOGUE
PARIS
VOGUE
LONDON
VOGUE
NEW YORK
VOGUE
SPAIN
VOGUE
ITALY
COLLECTIONS

MARCH 1 1967 4/-

1 MARCH 1967 Vogue Collections

Jean Shrimpton in a yellow 'tent' coat is all but subsumed beneath an art director's graphic design. By this period, the full-length shot was a comparative rarity on *Vogue* covers, and was suggested to Bailey by Alexander Liberman.

Photograph by David Bailey. Model: Jean Shrimpton

VOGUE

JUNE 1967 4/-

What makes up the
total look in beauty?

Whose **face** has
the most impact?

Which **fashion** is the
most flattering now?

SPECIAL BEAUTY ISSUE

JUNE 1967 Special Beauty Issue

A special beauty issue for the Summer of Love and another design-led cover. Strips of detail from three separate exposures make a quasi-filmic sequence illustrating 'this summer's face' in triplicate — 'smooth and shining with an unpowdery gleam'.

Photograph by David Bailey. Model: Celia Hammond

VOGUE

OCTOBER 15 1967 4/-

GREAT NEW LOOKS

WITH MORE THAN A DASH OF FLATTERY

BEAUTY
THROUGH A MAGNIFYING GLASS

WHAT'S NEW IN PRINT: CASHMERE

ELIZABETH AND RICHARD BURTON
OBSERVATIONS BY A FAMOUS DIRECTOR

AUSTRALIA: THE LUCKY COUNTRY

15 OCTOBER 1967 Great New Looks

Before 1967, she was long-haired, stick-thin Lesley Hornby. After a seven-hour haircut, suggested by her boyfriend Justin de Villeneuve (originally known as plain Nigel Davies), and some photographs by his friend Barry Lategan, a new persona emerged: Twiggy. She was a sensation, in demand by Richard Avedon, Helmut Newton, Bert Stern and many others. Here the face of the moment wears the futuristic outfit of the moment: an exaggerated silver-studded turtleneck, part of a felt culotte suit. Her hair, incidentally, was styled for this shoot by the studio that first gave her the seven-hour trim.

Photograph by Ron Traeger. Model: Twiggy.
Fashion: Emmanuelle Khanh for Cacharel. Hair: Oliver at Leonard

VOGUE

4/-
APR 15

GREAT FASHION FORM NOW

dashing looks
for a headstart
on spring

beautiful facts
on the health track-
teeth, hair, vitality.
Olympic diet

AND YOU'VE NEVER LOOKED BETTER

15 APRIL 1968 And You've Never Looked Better

The studio wind machine was employed to great effect on Celia Hammond. In time, Just Jaeckin would make the transition to film director. Among his oeuvre: *Emmanuelle* (1974), *The Story of O* (1975), *Lady Chatterley's Lover* (1981) and the arguably more exotic *The Perils of Gwendoline in the Land of the Yik Yak* (1984). He seems to have slipped from view. Celia Hammond now runs cat sanctuaries in London, Kent and Sussex.

Photograph by Just Jaeckin. Model: Celia Hammond.
Accessories: Oliver Goldsmith.

163

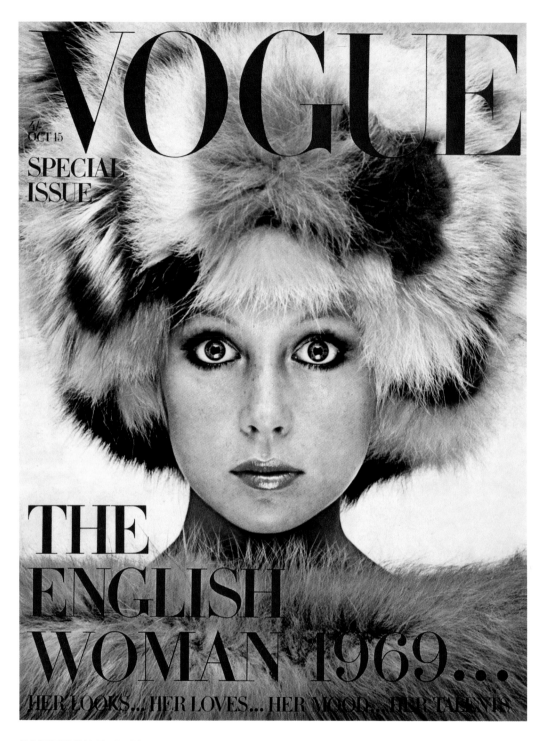

15 OCTOBER 1969 The English Woman 1969

For *Vogue*, a startled Patti Boyd in an outsize Cossack hat represented the quintessential Englishwoman. Other candidates included Lady Charlotte Ponsonby, Lady Strathallan and actress Judy Bowker. The theme continued throughout the issue: Cecil Beaton profiled Lady Diana Cooper, Roy Strong described the 'English countenance' and Polly Devlin interviewed socialist firebrand Barbara Castle, at that time Secretary of State for Employment.

Photograph by Barry Lategan. Model: Patti Boyd.
Fashion: Graham Smith

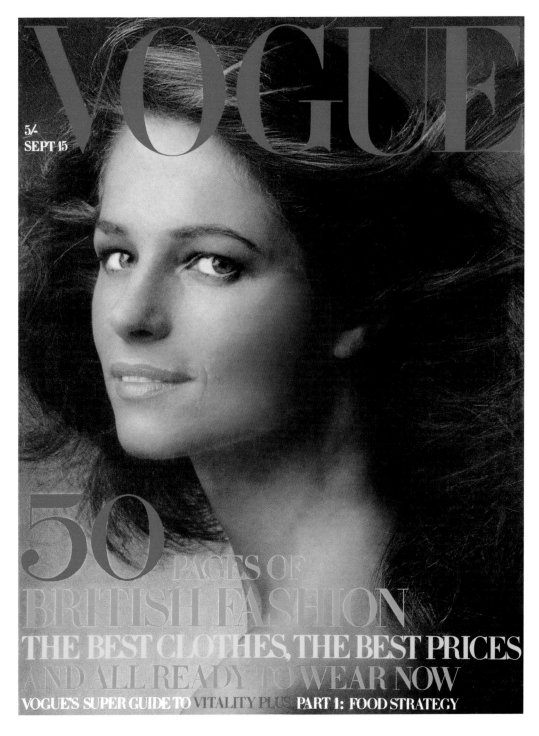

VOGUE

5/-
SEPT 15

50 PAGES OF
BRITISH FASHION
THE BEST CLOTHES, THE BEST PRICES
AND ALL READY TO WEAR NOW
VOGUE'S SUPER GUIDE TO VITALITY PLUS PART 1: FOOD STRATEGY

15 SEPTEMBER 1970 The Best Clothes, the Best Prices

'Who better,' asked *Vogue*, 'to launch great British fashion?' None better than Charlotte Rampling, a *bona fide* British star burnished with a gloss of Innoxa Toasted Satin Sheen foundation. In 1970 her films were coming thick and fast and included *The Ski Bum* and *Vanishing Point* (although her scenes in the latter ended up on the cutting-room floor). She was also about to film a guest-starring role in the TV series *Mission: Impossible*.

Photograph by Clive Arrowsmith. Cover star: Charlotte Rampling.
Hair: Oliver at Leonard

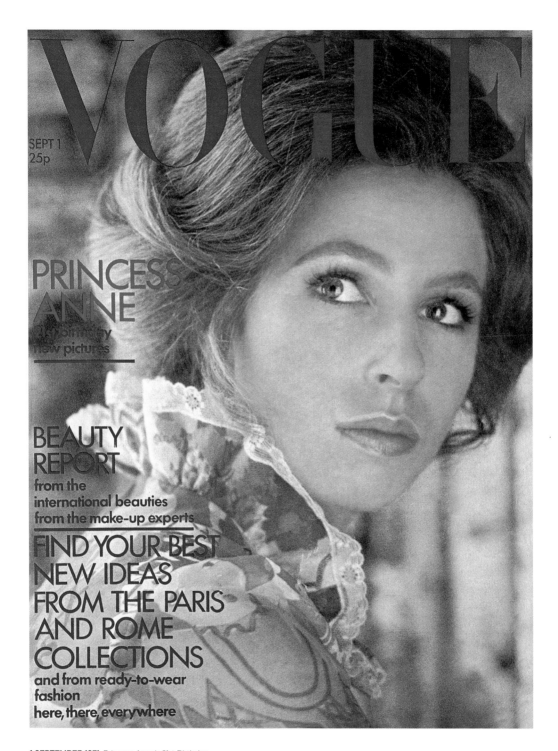

VOGUE

SEPT 1
25p

PRINCESS
ANNE
21st birthday
new pictures

BEAUTY
REPORT
from the
international beauties
from the make-up experts

FIND YOUR BEST
NEW IDEAS
FROM THE PARIS
AND ROME
COLLECTIONS
and from ready-to-wear
fashion
here, there, everywhere

1 SEPTEMBER 1971 Princess Anne's 21st Birthday

Parkinson — by now, along with Cecil Beaton, one of *Vogue*'s senior photographers — was a firm favourite of the royal family. Unsurprising, considering his jovial deference: 'That Royal Family of ours is just a family, forget the Royal bit. Of course, one maintains one's respectful distance (one remembers not to give the Queen a thump of joyful recognition).' Parkinson's informal portfolio of Princess Anne showed a young woman who clearly had a firm sense of self-identity. As US *Vogue* remarked of her: 'Direct, pretty, clever, HRH Princess Anne, whose straight-out job is being a princess, is remarkably good at it.'

Photograph by Norman Parkinson

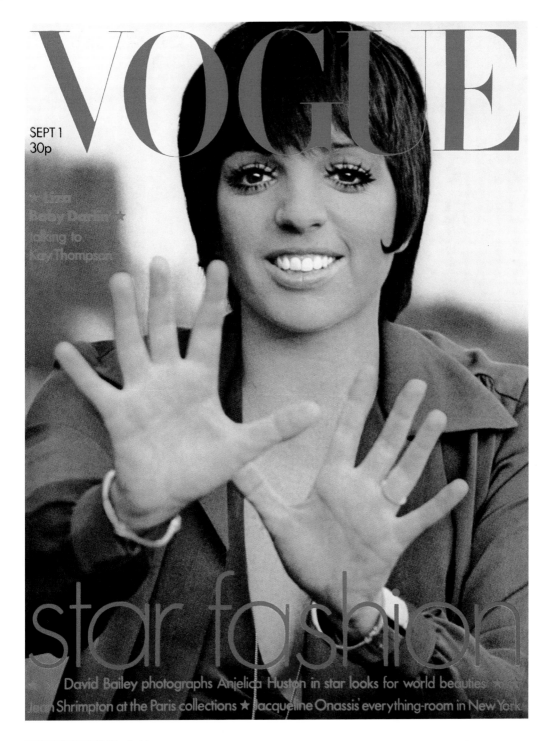

VOGUE

SEPT 1
30p

★ Liza
Baby Darlin' ★
talking to
Kay Thompson

star fashion

David Bailey photographs Anjelica Huston in star looks for world beauties ★
Jean Shrimpton at the Paris collections ★ Jacqueline Onassis' everything-room in New York

1 SEPTEMBER 1973 Star Fashion

It is likely that his great friend the Earl of Snowdon taught Peter Sellers
how to wield a camera, and a few of the tricks of the trade too. The
discernible white pressure points on Liza Minnelli's fingertips indicate
that Sellers shot her through a pane of glass.

Photograph by Peter Sellers. Cover Star: Liza Minnelli. Fashion: Halston

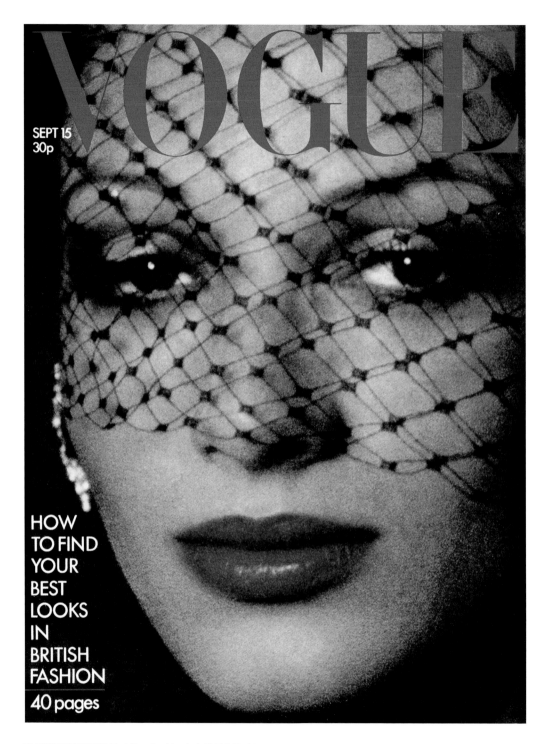

VOGUE

SEPT 15
30p

HOW
TO FIND
YOUR
BEST
LOOKS
IN
BRITISH
FASHION
40 pages

15 SEPTEMBER 1973 Find Your Best Looks in British Fashion

There is something darkly glamorous and 'continental' about Bailey's grainy image. Helmut Newton's covers for French *Vogue* made copious use of black veiling, as well as the tallest stiletto heels, but British *Vogue* had not seen the former until now and was not yet ready for the latter.

Photograph by David Bailey. Model: Lamy

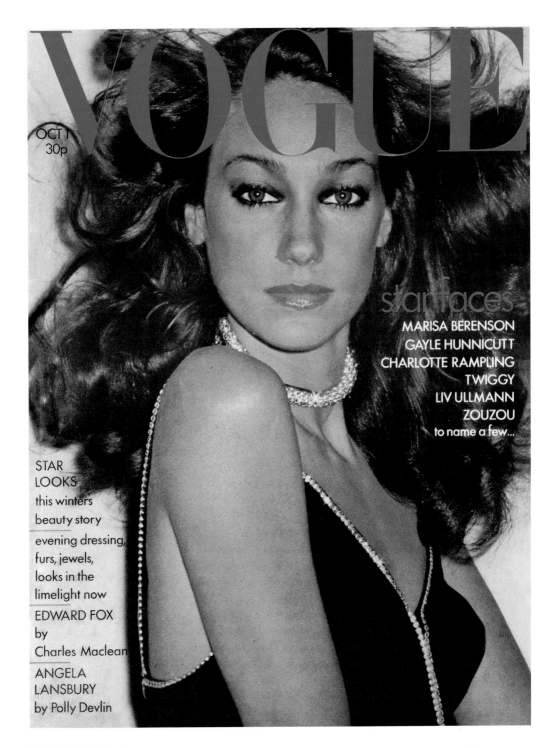

VOGUE

OCT 1
30p

star faces

MARISA BERENSON
GAYLE HUNNICUTT
CHARLOTTE RAMPLING
TWIGGY
LIV ULLMANN
ZOUZOU
to name a few...

STAR
LOOKS
this winter's
beauty story
evening dressing,
furs, jewels,
looks in the
limelight now
EDWARD FOX
by
Charles Maclean
ANGELA
LANSBURY
by Polly Devlin

1 OCTOBER 1973 Star Faces

The line-up for *Vogue*'s 'Star Faces' issue was a roll call of mid-Seventies chic and here one of its subjects, actress and model Marisa Berenson, gets the ring-flash treatment. Newton had revisited Clifford Coffin's ring-light (see page 136) and then adapted it to flash. Using it for the first time in 1973, he shot the collections without having had time to test it beforehand. 'Once I had the results, I was shocked. The light was beautiful, the girl looked great, but to my horror, she had enormous red eyes like some kind of vampire bat. I kept staring at the film: maybe it's not so bad; maybe it's even effective . . . '

Photograph by Helmut Newton. Cover star: Marisa Berenson.
Fashion: Chloë. Hair: Christophe at Carita, Paris

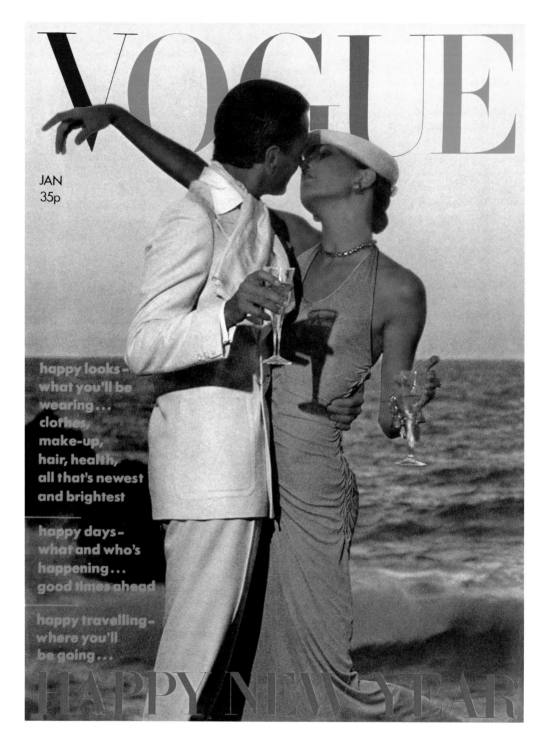

VOGUE

JAN
35p

happy looks –
what you'll be
wearing…
clothes,
make-up,
hair, health,
all that's newest
and brightest

happy days –
what and who's
happening…
good times ahead

happy travelling –
where you'll
be going…

HAPPY NEW YEAR

JANUARY 1974 Happy New Year

'We had a wonderful time – the most wonderful time of my youth,' said Manolo Blahnik, half of this duo (the other: actress Anjelica Huston). The *Vogue* team started in the South of France, but the cover and most of the pictures inside were shot in Corsica. Blahnik was one of only a handful of men to have appeared on the cover (Helmut Berger and Alan Bates were two others). According to fashion editor Grace Coddington,

Blahnik was neurotic about his appearance: 'The only question he asked more than "Which tie do you like better" was "Do I look all right?"'

Photograph by David Bailey. Cover stars: Manolo Blahnik and Anjelica Huston. Fashion: Walter Albini and Bruce Oldfield. Fashion editor: Grace Coddington

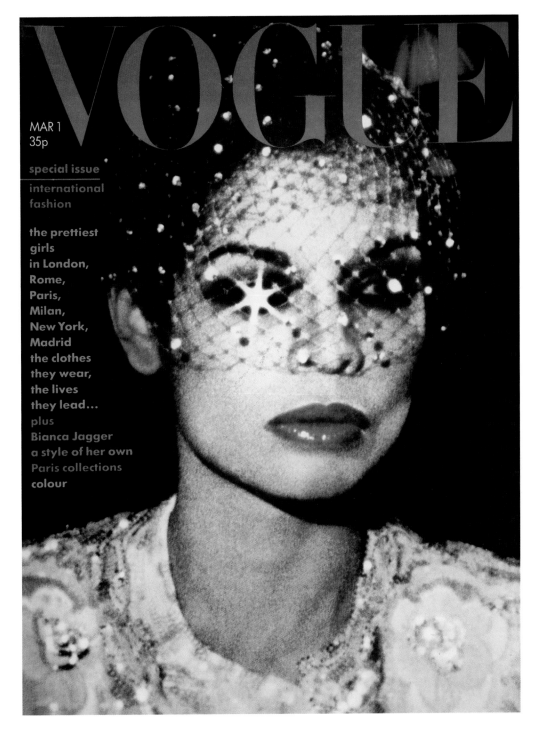

VOGUE

MAR 1
35p

special issue
international
fashion

the prettiest
girls
in London,
Rome,
Paris,
Milan,
New York,
Madrid
the clothes
they wear,
the lives
they lead...
plus
Bianca Jagger
a style of her own
Paris collections
colour

1 MARCH 1974 International Fashion

The epitome of jet-set chic was also a perfectionist. After spending at least four hours at the hairdresser's, Mrs Mick Jagger — according to Eric Boman, who wrote a profile to accompany his pictures — would 'take half an hour putting on a dress (Mick says "If you ask her to lunch, forget it"). She'll stand in front of the mirror and fiddle with her make-up although someone just spent two hours on it. And when she's ready, she looks breathtaking . . . But I saw her eight hours ago, before the whole act, and I know she was unbelievable then.'

Photograph by Eric Boman. Cover star: Bianca Jagger.
Fashion: Jean-Louis Scherrer. Hair: Yves at Jacques Dessange.
Make-up: Serge Lutens at Dior

171

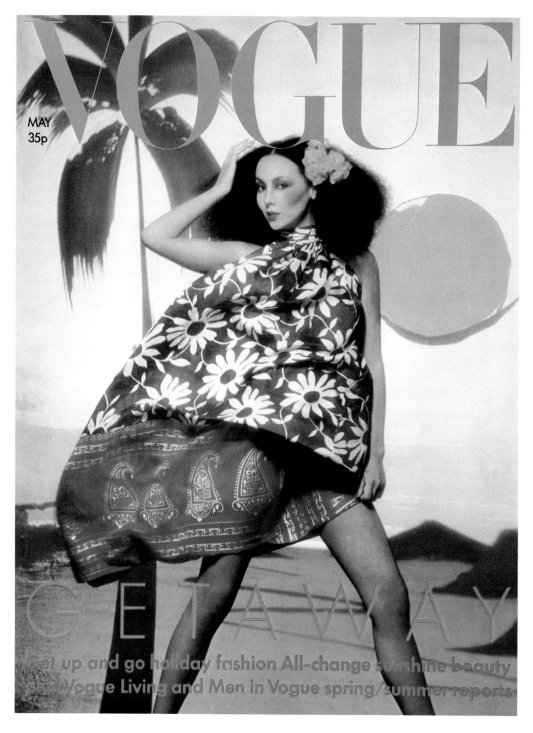

MAY 1974 Getaway

'If you haven't been to Brazil, fly there at once!' ordered *Vogue*. Which is more than Bailey and his new muse, Marie Helvin, did. This cover was shot in a studio, with Helvin photographed against over-painted Brazilian landscapes that Bailey had shot previously, unaccompanied. This was their first session together. Helvin recalled that when the cover came out, 'Everyone wanted to know who the great new Brazilian model was.'

Photograph by David Bailey. Model: Marie Helvin.
Fashion: Jean Muir. Hair: Oliver at Leonard. Make-up: Barbara Daly.

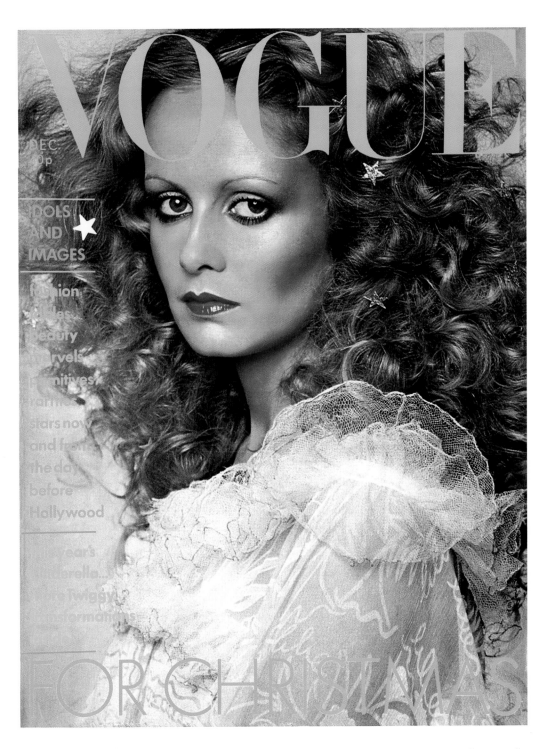

DECEMBER 1974 For Christmas

Twiggy, appearing in *Cinderella* with the two stars of TV's *Steptoe and Son*, continued the make-believe theme for *Vogue*'s Christmas issue. She dressed up as Garbo, a boyish flapper and an unconvincing Grace Kelly.

*Photograph by Barry Lategan. Model: Twiggy.
Fashion: Zandra Rhodes. Hair: Celine. Make-up: Barbara Daly*

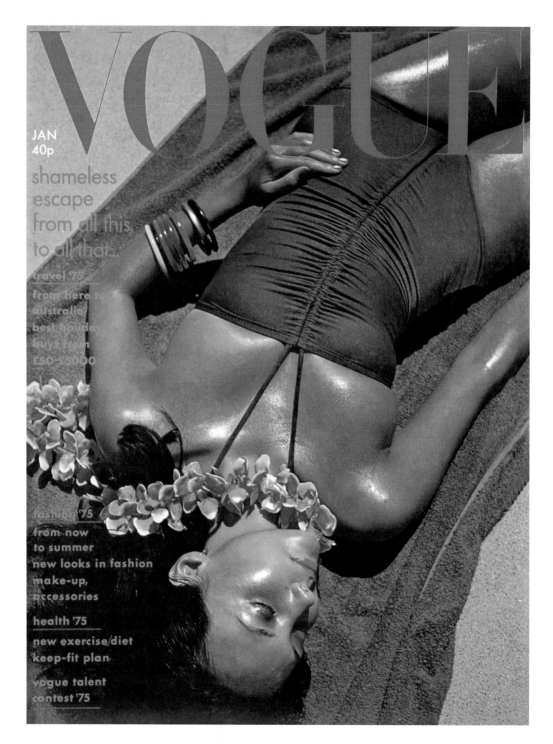

VOGUE

JAN
40p

shameless
escape
from all this,
to all that...

travel '75
from here to
australia
best holiday
buys from
£50-£5000

fashion '75
from now
to summer
new looks in fashion
make-up,
accessories

health '75
new exercise/diet
keep-fit plan

vogue talent
contest '75

JANUARY 1975 Shameless Escape

Not that you could tell, this beach scene was shot in Queensland, near the Great Barrier Reef. This trip to Australasia had also taken in Tahiti, where Helvin was required to sport a blonde wig and lime-green tights. 'I felt a fool,' she said. 'It was my first trip abroad for British *Vogue*. I was expecting luxury and first-class hotels all the way. When I arrived in Queensland, I discovered Bailey and I were to be sharing a tiny bedsit with the fashion editor and travel writer. Bailey and I ended up sleeping in the kitchen . . . ' Perhaps the enforced proximity worked, for within a few months of this issue coming out, Bailey and Helvin were married.

Photograph by David Bailey.
Model: Marie Helvin. Fashion: C&A

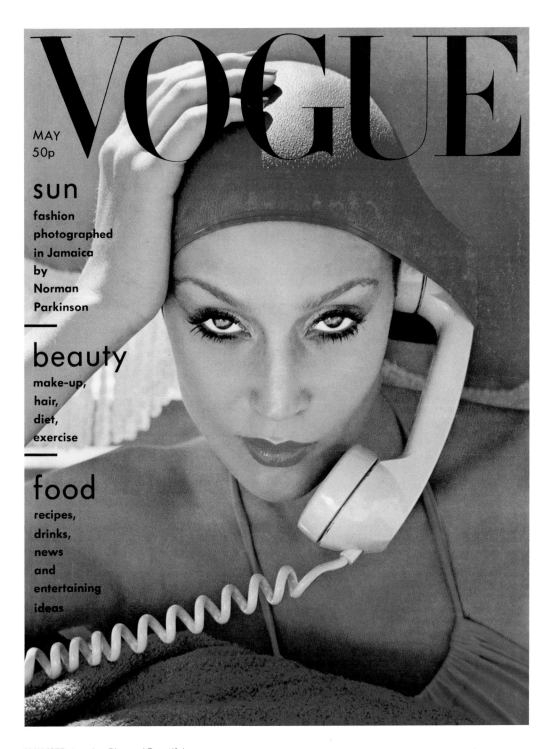

MAY 1975 Jamaica: Blue and Beautiful

This was Jerry Hall's first session with Parkinson and they became good friends — after a little misunderstanding over a horse. The tall Texan (who once, she claimed, broke horses for a living) fell foul of a Jamaican filly when it shied. Parkinson recalled that 'Jerry flew over its head like some blue ballistic missile. When we got to her [she was] hanging motionless as laundry might on a calm day.' Both horse and rider survived.

Photograph by Norman Parkinson.
Model: Jerry Hall. Fashion: Wiki

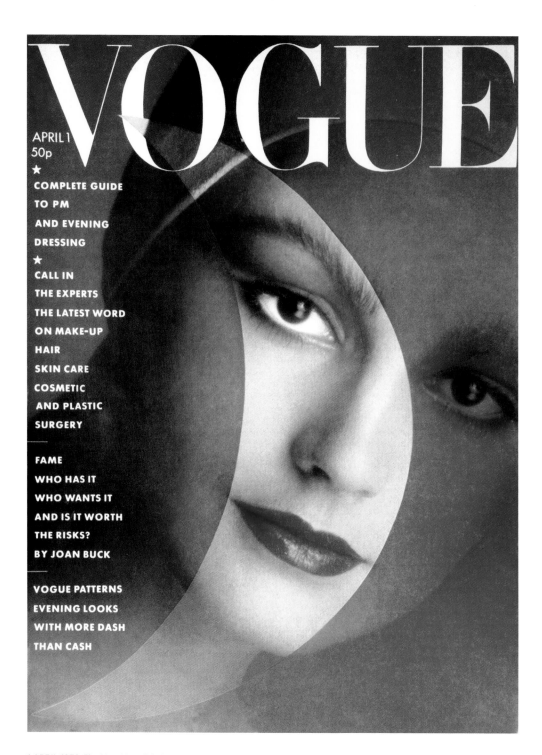

VOGUE

APRIL 1
50p

★

COMPLETE GUIDE
TO PM
AND EVENING
DRESSING

★

CALL IN
THE EXPERTS
THE LATEST WORD
ON MAKE-UP
HAIR
SKIN CARE
COSMETIC
AND PLASTIC
SURGERY

FAME
WHO HAS IT
WHO WANTS IT
AND IS IT WORTH
THE RISKS?
BY JOAN BUCK

VOGUE PATTERNS
EVENING LOOKS
WITH MORE DASH
THAN CASH

1 APRIL 1976 The New Moonlighting

Vogue's focus on eveningwear was the excuse for a crescent moon
art-directed almost out of recognition from a headshot by Bailey. The
original photograph is one of which Bailey is probably not over-fond,
and this overlaid gimmick draws attention to its demerits rather than
obliterating them. Yet in retrospect it succeeds for its winning period
charm. Which is not to damn it with faint praise.

Photograph by David Bailey

176

15 OCTOBER 1976 Diamond Jubilee, 1916–1976

Technically two issues late, this special commemorative issue demanded an extravagant cover and an extravagant gesture. Terry Jones, then art director, conceived the whole cover as transparent, as though the reader 'was looking at the magazine through a pane of glass'. The logo — each letter painstakingly engraved in Waterford glass — was to be photographed in such a way as to catch the spectrum of colours. Halfway through the intricate first stages, the editor told Jones that the cover would have to be red. As a compromise Jones suggested blue ('for Britain'), but the argument for his original idea remains, he says, 'as clear as daylight'. The extravagant gesture: one copy of *Vogue* contained a real diamond.

Photograph by James Mortimer

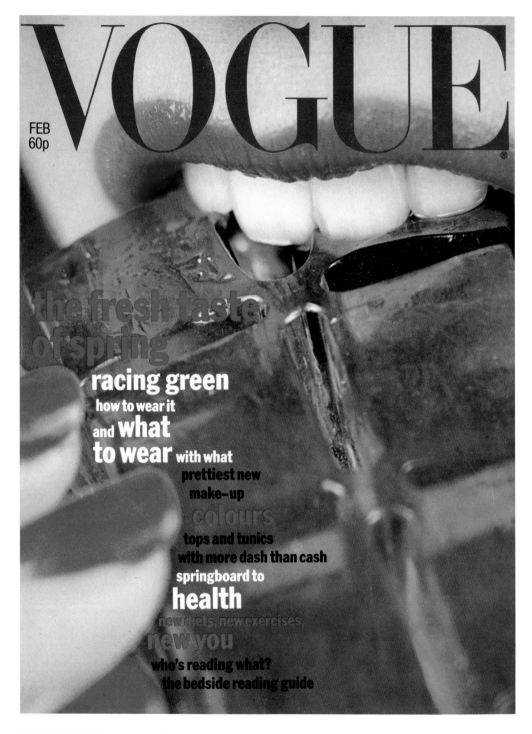

VOGUE

FEB
60p

the fresh taste
of spring

racing green
how to wear it
and **what
to wear** with what
**prettiest new
make–up**
colours
**tops and tunics
with more dash than cash
springboard to
health**
new diets, new exercises,
new you
**who's reading what?
the bedside reading guide**

FEBRUARY 1977 The Fresh Taste of Spring

Jelly. It shouldn't have worked, but somehow *Vogue* carried it off. It was an unwritten rule that foodstuffs and eating — bar the odd summery ice cream — was not a fit subject for *Vogue* covers. This oddity is a striking exception, but illustrated perfectly spring's vibrant colour. The main focus of the concept gave the magazine's copywriters a headache. They couldn't ignore it, so they dressed it up a little: 'Rowntree's jelly . . . full of gelatine, a valuable source of protein and good for strengthening nails.' It is also widely believed by magazine publishers that green covers do not, as a rule, make bestsellers. There is no indication that this almost forensic close-up has played any part in this received wisdom.

Photograph by Willie Christie. Make-up: Barbara Daly

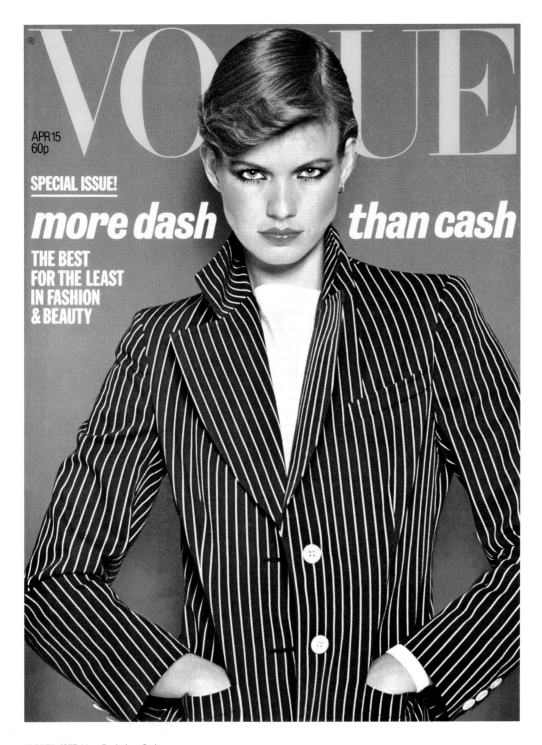

15 APRIL 1977 More Dash than Cash

A new mannish silhouette became apparent in *Vogue*'s spring pages. The coverline advertised the new chic at low prices, but while the boat-neck top was £9, the cotton blazer was a not negligible £53. With the G of *Vogue* masked by the model's head, this simple and effective cover would perhaps have set *Vogue*'s founder, Condé Nast, spinning in his grave. It was a rule that was never breached — at least at British

Vogue in Nast's heyday — that the magazine's logo should shine through unencumbered by art directors' 'gimmickry'.

Photograph by Eric Boman. Model: Beska.
Fashion: Daks and Top Shop. Hair: Kerry at Molton Brown

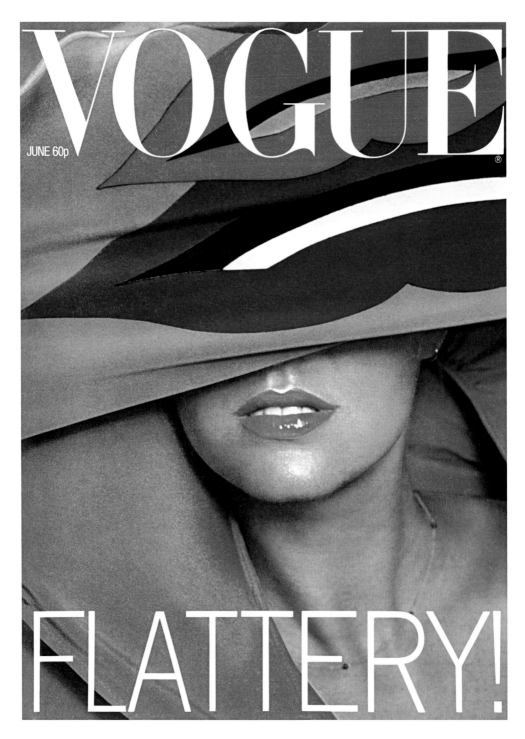

JUNE 1977 Flattery!

Another innovation for *Vogue*: the sponsored, pullout, gatefold cover.
This extravagance was bankrolled by Revlon's Ravishing Red lipstick.
Lategan's obscuring of most of his model's face allowed the product
to be seen to its best advantage, and the motifs on the hood of an
anorak helped press the point home. The cover was shot at Golden
Bay, Malta, though you'd be hard-pushed to know it from this.

Photograph by Barry Lategan. Fashion: Krizia

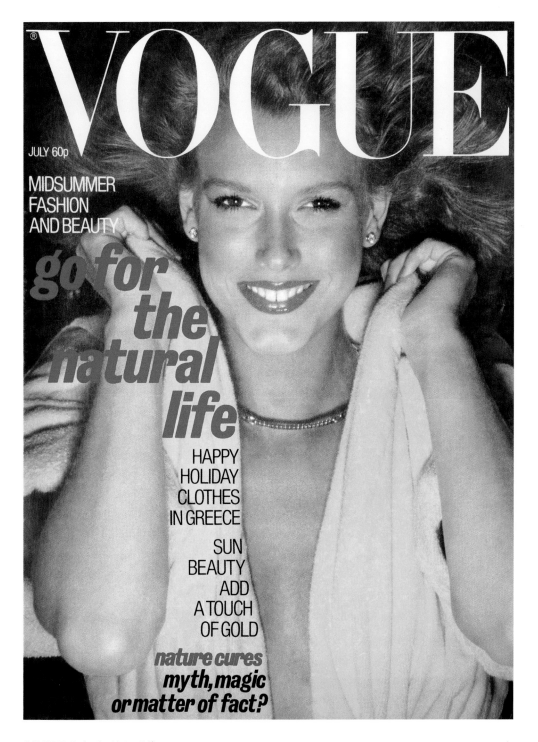

VOGUE

JULY 60p

MIDSUMMER
FASHION
AND BEAUTY

*go for
the
natural
life*

HAPPY
HOLIDAY
CLOTHES
IN GREECE

SUN
BEAUTY
ADD
A TOUCH
OF GOLD

nature cures
**myth, magic
or matter of fact?**

JULY 1977 Go for the Natural Life

The natural life did not necessarily encompass the natural look. To get
to this final stage, *Vogue*'s make-up designer used Yardley Complete
Make-up in Deep Almond, a blusher, a Feather Finish Powder, pearlised
creme eyeshadow, highlit with another (Sand Stick), Multilash Mascara
and Cognac Moisture Creme lipstick applied over another (Suki Pearl).
Less discernible was scent by Je Suis.

Photograph by Willie Christie. Fashion: Night Owls.
Hair: Kerry at Molton Brown

181

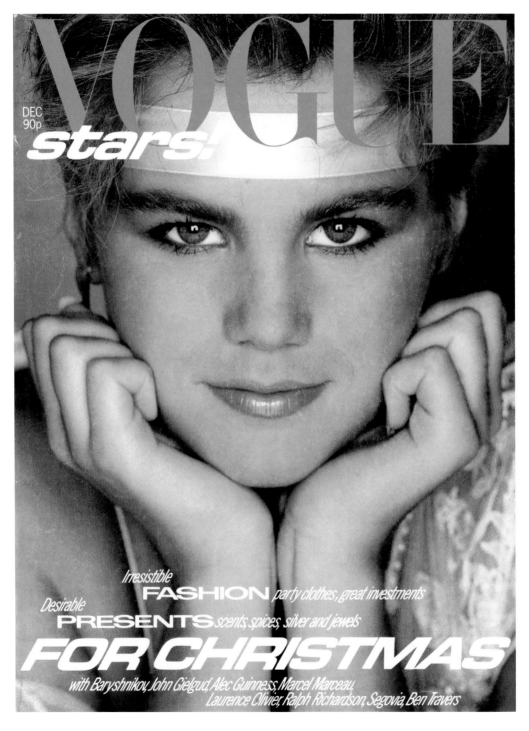

VOGUE

DEC
90p

stars!

Irresistible
FASHION *party clothes, great investments*
Desirable
PRESENTS *scents, spices, silver and jewels*
FOR CHRISTMAS
*with Baryshnikov, John Gielgud, Alec Guinness, Marcel Marceau,
Laurence Olivier, Ralph Richardson, Segovia, Ben Travers*

DECEMBER 1980 Stars!

The turn of the decade saw *Vogue* make a radical shift in cover design; the era of quirky, eye-catching graphics was, for the time being, over. *Vogue* became more all-encompassing and spoke directly to its readership with information-packed and exclamatory coverlines. With Alexander Liberman in New York overseeing the look of all the *Vogues*, homogeneity of a kind was sought, while still allowing for flourishes of national character. British

Vogue, under editor Beatrix Miller, was occasionally considered 'eccentric' and 'highbrow'. (From now on, it becomes standard practice to credit the stalwarts of the cover shoot: hair and make-up.)

*Photograph by Alex Chatelain. Fashion: Emanuel.
Hair: Howard Fugler. Make-up: Joey Mills.*

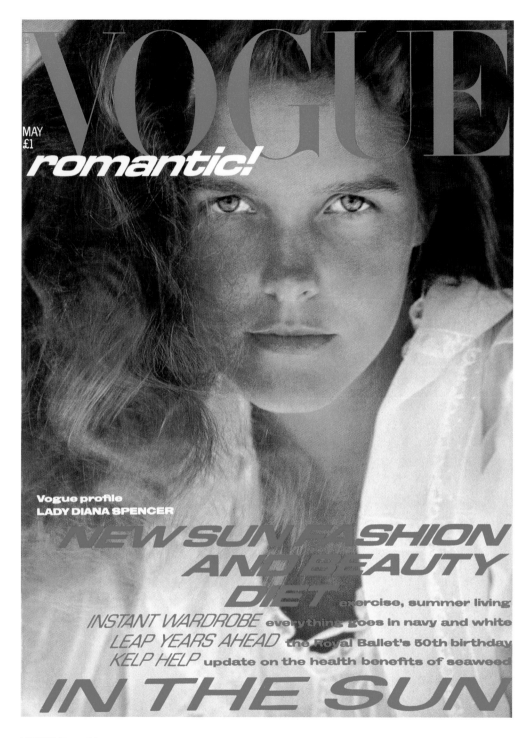

VOGUE

MAY
£1

romantic!

Vogue profile
LADY DIANA SPENCER

NEW SUN FASHION
AND BEAUTY
DIET exercise, summer living
INSTANT WARDROBE everything goes in navy and white
LEAP YEARS AHEAD the Royal Ballet's 50th birthday
KELP HELP update on the health benefits of seaweed
IN THE SUN

MAY 1981 Romantic!

The world of Bruce Weber tends to towards open skies, gun dogs, grand production values, unselfconscious nudity and gilded youth. The best has the whole lot rolled into one. What has made Weber such a lasting force in fashion and advertising photography since his breakthrough in the early Eighties may be just one simple fact: there is no distinction, at least to the naked eye, between his commercial work and private oeuvre.

He shoots only for himself: 'I enjoy clothes. I enjoy photography. I have been spoiled.' He is fond of declaring that 'the wonderful thing about having a camera . . . is that you never know where it's going to take you'.

Photograph by Bruce Weber. Model: Sloane Condren.
Fashion: Yvonne Langley. Hair: Howard Fugler

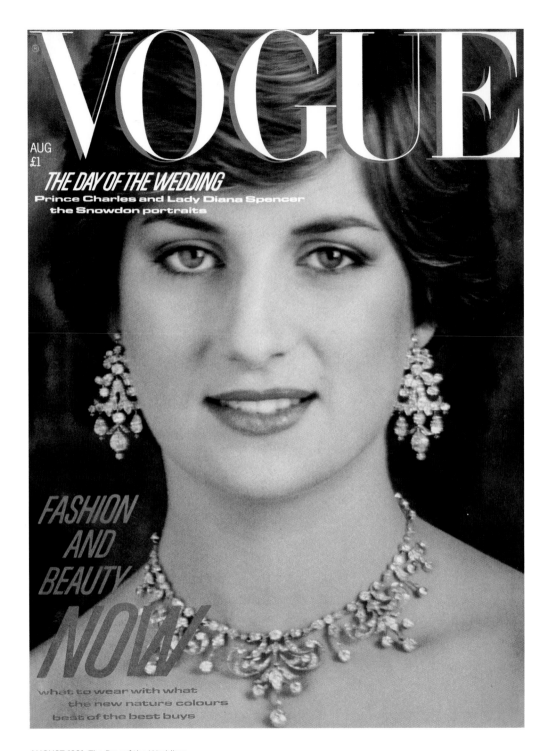

VOGUE

AUG
£1

THE DAY OF THE WEDDING
Prince Charles and Lady Diana Spencer
the Snowdon portraits

FASHION
AND
BEAUTY
NOW

what to wear with what
the new nature colours
best of the best buys

AUGUST 1981 The Day of the Wedding

Throughout spring and the hot summer of 1981, you could not avoid the
impending marriage of the heir to the throne. Media coverage tended
inevitably to sidetrack the Prince of Wales in favour of his 20-year-old
bride, Lady Diana Spencer. *Vogue* brought out a separate souvenir
issue, detailing the dozens of royal weddings it had witnessed since
1916, including that of the prince's grandmother in 1923 (see page 30).

Photograph by Snowdon

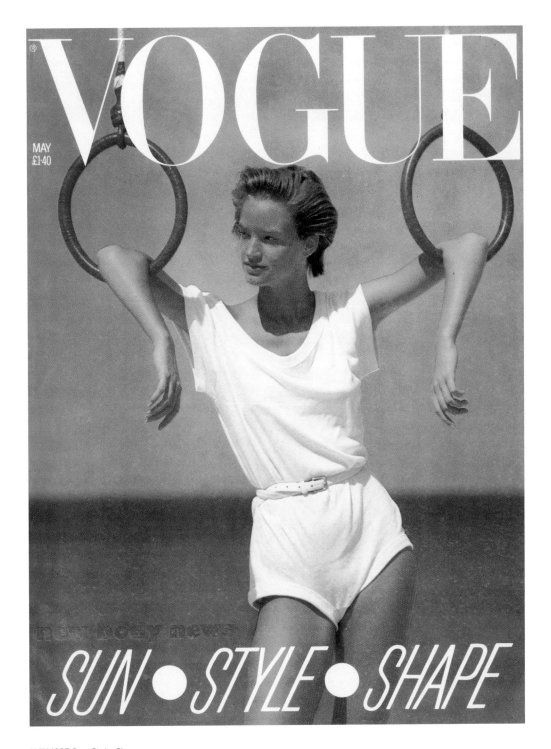

VOGUE

MAY
£1·40

SUN • STYLE • SHAPE

MAY 1983 Sun, Style, Shape

This cover was taken from Patrick Demarchelier's first major assignment for British *Vogue*, on location in Barbados. Bonnie Berman was for the most part an untried entity (she had been discovered at the coat check of the restaurant Mr Chow in New York). For Demarchelier, it was not a straightforward shoot. 'We decided to pursue a sort of acrobatic, healthy look. Since there wasn't anything available there to buy, we made our own props [from] rope and tape stored on the boat and constructed the swings and rings.'

Photograph by Patrick Demarchelier. Model: Bonnie Berman.
Fashion: Norma Kamali. Fashion editor: Grace Coddington.
Hair: Didier Malige. Make-up: Mariella Smith-Masters

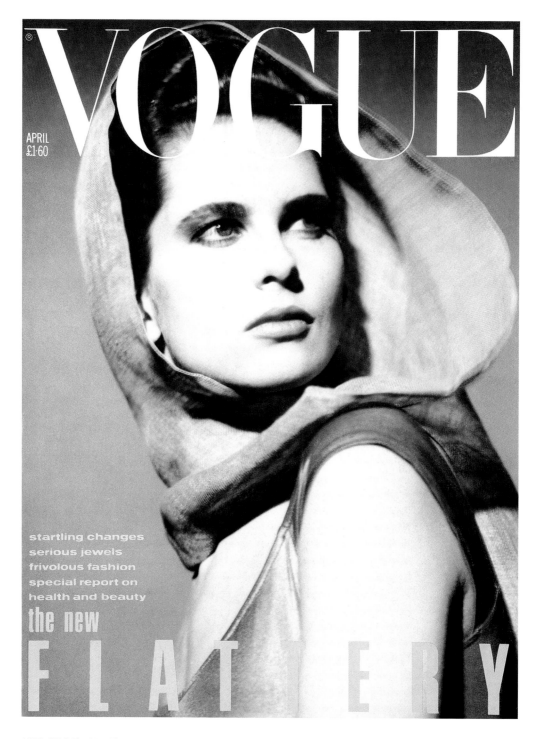

APRIL 1984 The New Flattery

What made Paolo Roversi's work stand out so much during the Eighties was its unusual form. He was probably the first to make regular use of 10 x 8in Polaroid film, the peculiar tones and unpredictable colour balance of which gave his work an almost Impressionistic sensibility, also out of tune with the times. The stillness was due, perhaps, to the long exposure times Roversi has always preferred. Since he considers his fashion pictures as (in essence if not in practice) portraits, the long exposures enabled his pictures to be 'more touching and more human'.

Photograph by Paolo Roversi. Model: Elizabetta Ramella.
Fashion: Norma Kamali and Issey Miyake.
Fashion editor: Grace Coddington. Hair: Didier Malige

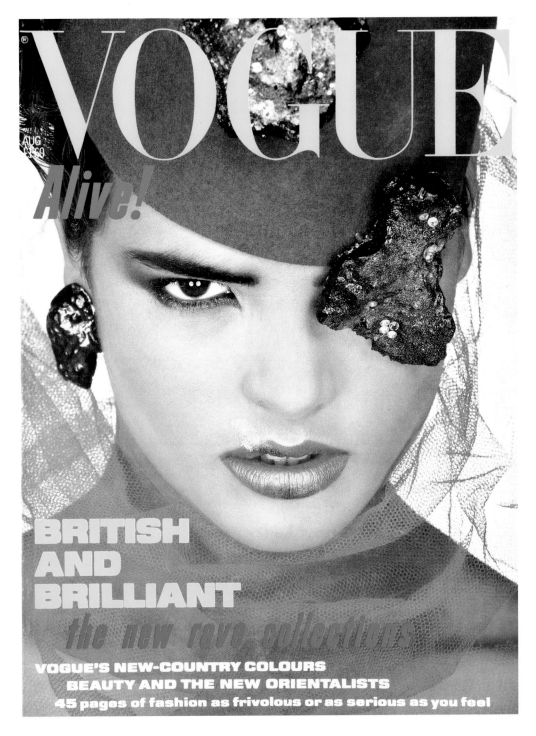

VOGUE

AUG
£1.50

Alive!

**BRITISH
AND
BRILLIANT**

the new rave collections

**VOGUE'S NEW-COUNTRY COLOURS
BEAUTY AND THE NEW ORIENTALISTS**
45 pages of fashion as frivolous or as serious as you feel

AUGUST 1984 British and Brilliant

One of the most unusual *Vogue* covers of the Eighties was also one of its bestsellers. A few years after the New Romantic movement made pillbox hats, veils and striking make-up *de rigueur*, *Vogue* produced an eye-catching approximation. The pink netting was 59p a metre from John Lewis, the brooches were fashioned out of rocks studded with diamanté, while Glenna Franklin artfully smudged the cosmetics. Talisa

Soto was discovered by Bruce Weber and could usually be found as, say, a frontierswoman in one of his homages to the American past.

Photograph by Albert Watson. Model: Talisa Soto.
Fashion: Fred Spurr and John Lewis.
Hair: Kerry Warn. Make-up: Glenna Franklin

187

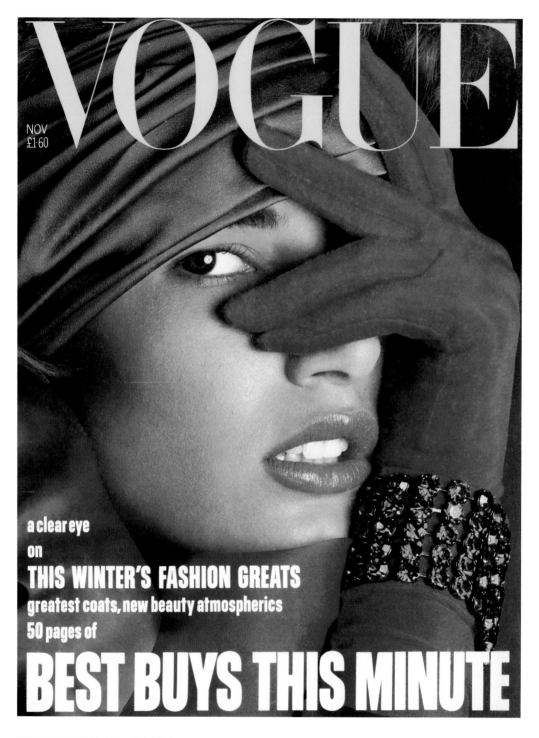

VOGUE

NOV
£1·60

a clear eye
on
THIS WINTER'S FASHION GREATS
greatest coats, new beauty atmospherics
50 pages of
BEST BUYS THIS MINUTE

NOVEMBER 1984 Best Buys This Minute

Vogue repeated Albert Watson's partiality for the one-eyed cover image. It was, perhaps, an unconscious tribute to the youth-and-style magazine *i-D*, whose influence on fashion and fashion photography was reaching an early peak. A conceit of *i-D*'s covers was — and remains to this day — a deliberate obscuring of one of the cover model's eyes. Watson titled his much-acclaimed compilation of photographs *Cyclops*, after the one-eyed monsters of Greek myth. It is not widely known (but perhaps unsurprising, given the clues) that Watson himself sees out of only one eye.

*Photograph by Albert Watson. Model: Suzanne Lanza.
Accessories: Graham Smith, Dents and Butler & Wilson.
Hair: Kerry Warn. Make-up: George Newell.*

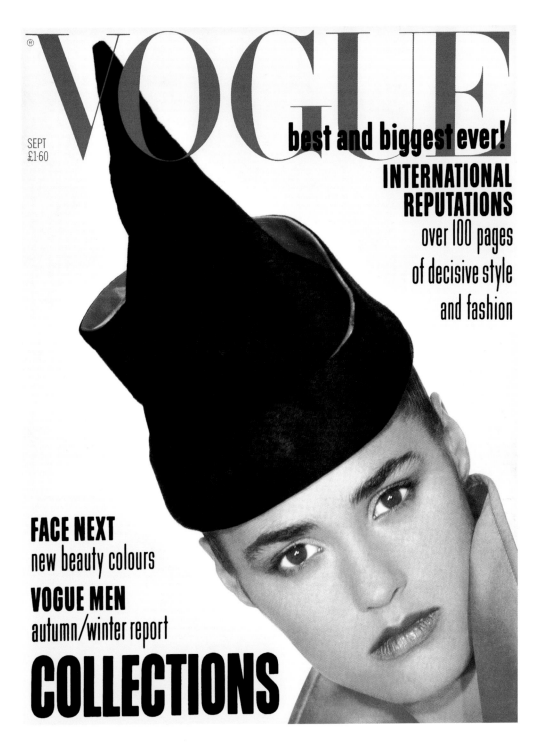

VOGUE

SEPT
£1·60

best and biggest ever!

INTERNATIONAL REPUTATIONS
over 100 pages
of decisive style
and fashion

FACE NEXT
new beauty colours

VOGUE MEN
autumn/winter report

COLLECTIONS

SEPTEMBER 1985 International Reputations

A simple, if stark, headshot is given extra impetus by an off-kilter twist.
The realignment worked, as the cover was another bestseller. *Vogue*'s
cover girl enjoyed a long career, which continued after her marriage to
the lead singer of the band Duran Duran. Shortly after this shoot, she was,
incidentally, the subject of 80-year-old Horst's first full fashion sitting for
British *Vogue* since the Thirties, which would also turn out to be his last.

*Photograph by Patrick Demarchelier. Model: Yasmin Parvaneh.
Fashion: Montana. Hair: Didier Malige. Make-up: Mary Greenwell.*

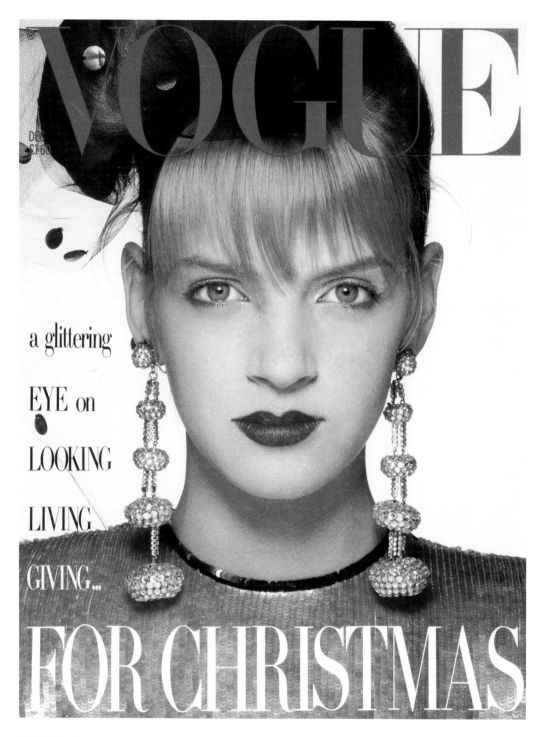

VOGUE

DEC
£1.60

a glittering

EYE on

LOOKING

LIVING

GIVING...

FOR CHRISTMAS

DECEMBER 1985 A Glittering Eye

A favourite of Norman Parkinson's — like her mother, the model Nena von Schlebrugge (see page 141), before her — Uma Thurman's earliest appearances in *Vogue* were as a model in fashion photographs. She was recognisable in the languorous domestic interiors of Sheila Metzner, as well as the starker tableaux of Patrick Demarchelier. Less than a decade later, she was a *bona fide* star and when *Vogue* interviewed her then, she was preparing for her role in Quentin Tarantino's film *Pulp Fiction* (1994), which would blow away for ever any lingering traces of the fragile ingénue seen modelling fashion for *Vogue*.

Photograph by Patrick Demarchelier. Model: Uma Thurman. Fashion: Geoffrey Beene. Hair: Didier Malige. Make-up: Linda Mason

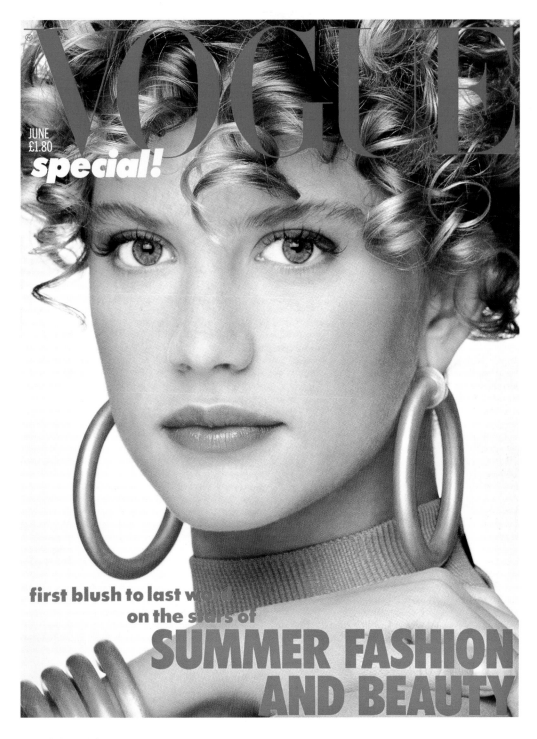

VOGUE

JUNE
£1.80

special!

first blush to last word
on the stars of
SUMMER FASHION
AND BEAUTY

JUNE 1986 Special!

Demarchelier was in demand by *Vogue* throughout the Eighties for his skill at the cover shot. In an era that became awash with women's fashion magazines, he was a crucial weapon in the battle for newsstand attention. As Grace Coddington, his frequent collaborator, put it, 'When confined to a close-up cover it's really difficult to get a different picture every time. Demarchelier is always able to get life into a very small space . . . '

Photograph by Patrick Demarchelier.
Model: Lisa Kauffmann. Fashion: Azzedine Alaïa.
Hair: Julien. Make-up: Mary Greenwell.

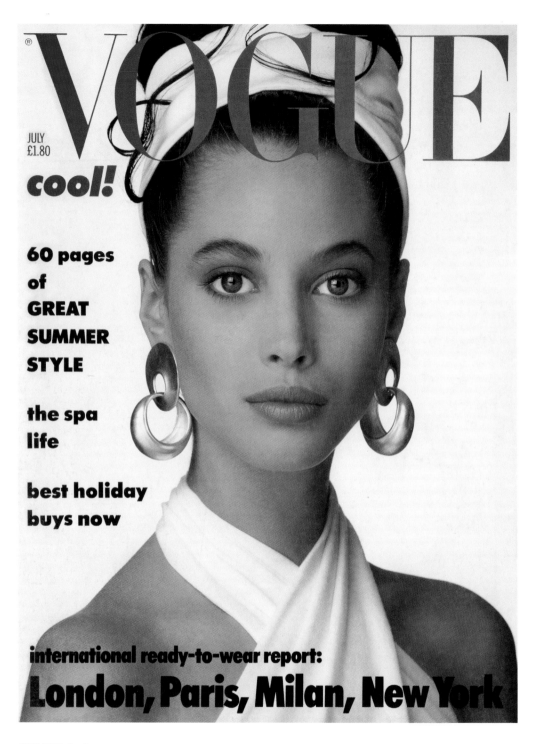

VOGUE

®

JULY
£1.80

cool!

**60 pages
of
GREAT
SUMMER
STYLE**

**the spa
life**

**best holiday
buys now**

international ready-to-wear report:
London, Paris, Milan, New York

JULY 1986 Cool!

'Supermodels like Christy Turlington . . . they're too beautiful, they just scare you,' remarked David Bailey, who does not customarily take fright. The former supermodel, no less terrifying after 20 years, is now an entrepreneur with Nuala, her own line in yogawear. 'When I was modelling for Calvin Klein,' she recalls, 'I used to do underwear PAs [personal appearances] and there was all kinds of craziness — people asking me to sign their underwear, you name it. With Nuala you tend to attract kind people.' Turlington took time out from modelling to study religion and philosophy, but has not retired entirely: 'I have only surrendered slightly.'

Photograph by Patrick Demarchelier. Model: Christy Turlington.
Fashion: Donna Karan. Hair: Julien. Make-up: Mary Greenwell.

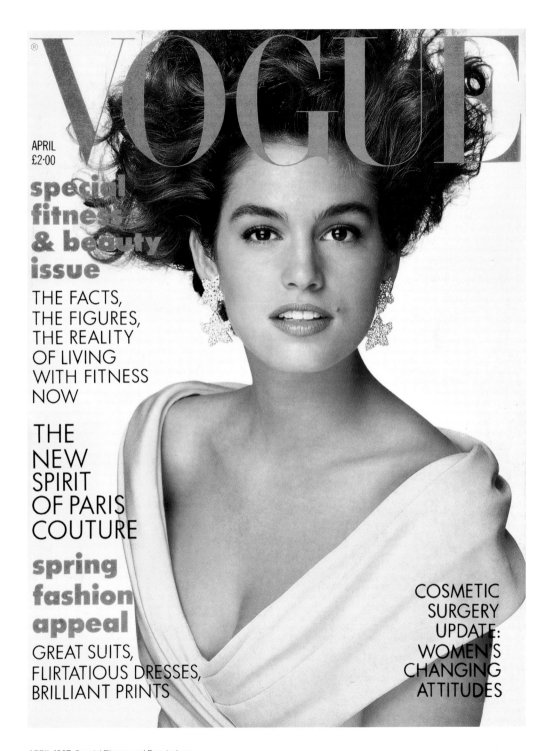

VOGUE

APRIL
£2·00

special fitness & beauty issue

THE FACTS,
THE FIGURES,
THE REALITY
OF LIVING
WITH FITNESS
NOW

THE
NEW
SPIRIT
OF PARIS
COUTURE

spring fashion appeal

GREAT SUITS,
FLIRTATIOUS DRESSES,
BRILLIANT PRINTS

COSMETIC
SURGERY
UPDATE:
WOMEN'S
CHANGING
ATTITUDES

APRIL 1987 Special Fitness and Beauty Issue

The supermodels only became so when, sometime in 1989, Patrick Demarchelier, Steven Meisel and Gianni Versace took Linda, Tatjana, Naomi, Christy and Cindy and redefined their looks. It couldn't have happened before (fashion wasn't opulent enough); it couldn't have started later (grunge was on the horizon). They were among the highest-earning young women of their generation, who encapsulated, for the rest of us, the look of their time. Cindy Crawford's famous beauty-spot made her emphatically individual, as it does here in this early cover — that, and a stupendous business-orientated brain.

*Photograph by Patrick Demarchelier. Model: Cindy Crawford.
Fashion: Oscar de la Renta. Hair: Didier Malige. Make-up: Sophie Levy*

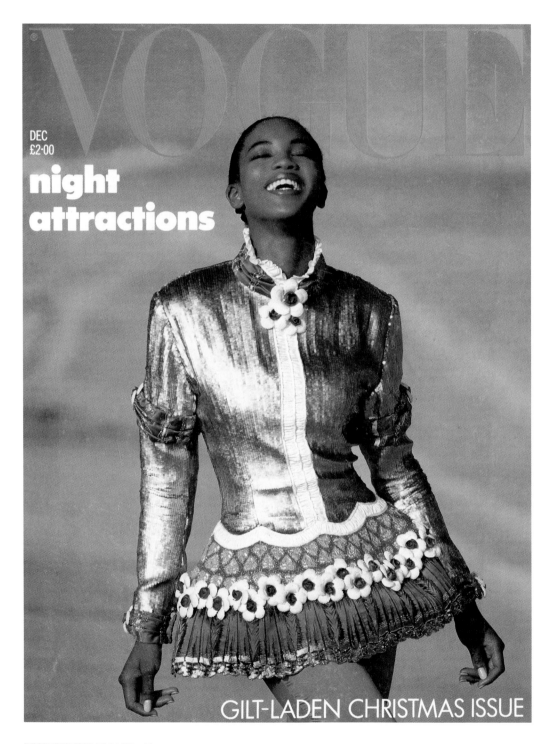

VOGUE

night attractions

GILT-LADEN CHRISTMAS ISSUE

DECEMBER 1987 Night Attractions

This shimmering Christmas issue marks Naomi Campbell's debut on the cover of *Vogue*, and since then there have been many, as she has made the journey from bright-as-a-button south London teenager to diva of unpredictable *hauteur*. She made legions of fans for her refusal to be pigeonholed, trying her hand at music, film and video appearances, merchandising — you name it (though the hand that wrote her novel was

not her own). This cover also illustrates an Eighties phenomenon: the minimalist and ambiguous coverline. 'Night Attractions' works rather as a mood-enhancer — arguably more tempting than a list of specifics.

Photograph by Patrick Demarchelier. Model: Naomi Campbell. Fashion: Chanel. Hair: Didier Malige. Make-up: Mary Greenwell

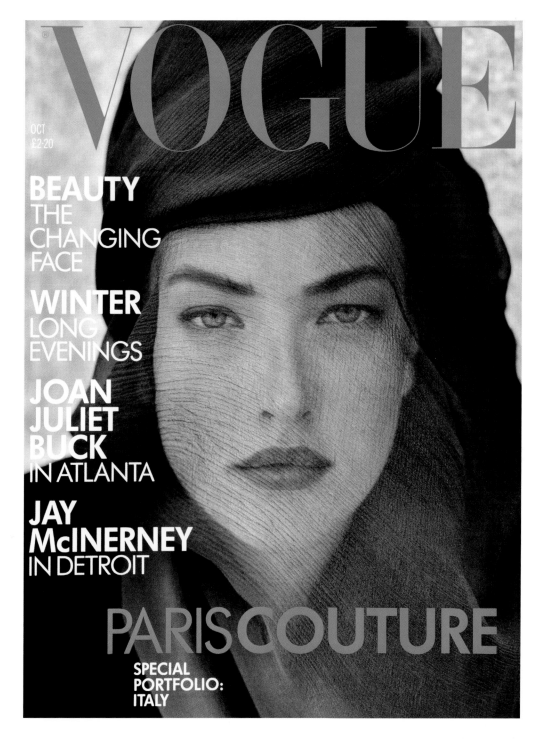

VOGUE

OCT
£2·20

BEAUTY
THE
CHANGING
FACE

WINTER
LONG
EVENINGS

**JOAN
JULIET
BUCK**
IN ATLANTA

**JAY
McINERNEY**
IN DETROIT

PARIS COUTURE

SPECIAL
PORTFOLIO:
ITALY

OCTOBER 1988 The Changing Face

Like his *Vogue* contemporaries Bruce Weber, Steven Meisel and Annie Leibovitz, Herb Ritts photographed celebrity and fashion — most often both in the same picture. His particular skill was in convincing the viewers that supermodels, screen stars, celebrities and even presidents and first ladies were accessible and — save for more expensive clothing — not too far removed from our own world. Ritts's death at a relatively young age prompted a tribute from US *Vogue* editor Anna Wintour, in which she mournfully asked: 'and who now will be able to give *Vogue* such images of optimism, vigour and sexuality?'

Photograph by Herb Ritts. Model: Tatjana Patitz. Fashion: Amimodo.
Fashion editor: Sarajane Hoare. Make-up: George Newell

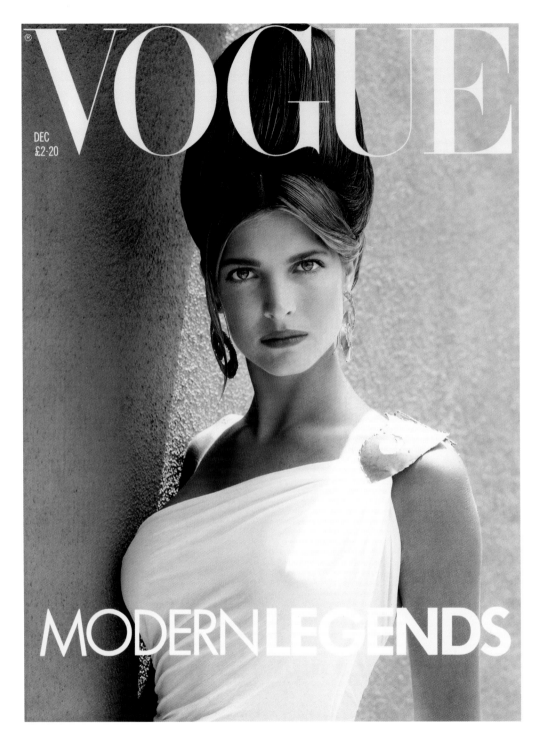

DECEMBER 1988 Modern Legends

This was about as far removed as *Vogue* could get from the traditional seasonal offering, being shot in sun-suffused California. The labour-intensive hairstyle and the almost Spartan simplicity of di Sant'Angelo's dress had distinct echoes with *Vogue*'s own past. Such statuesque tableaux had found favour in the early Thirties as an affirmation of a taste for Neoclassical ideals of physical beauty. Ritts's work echoed these traditions and sensibilities half a century on. His portrayal of the male nude, with which he is often associated, continued this Homeric thread.

Photograph by Herb Ritts. Model: Stephanie Seymour.
Fashion: Giorgio di Sant'Angelo. Fashion editor: Sarajane Hoare.
Hair: Serena Radealli. Make-up: George Newell.

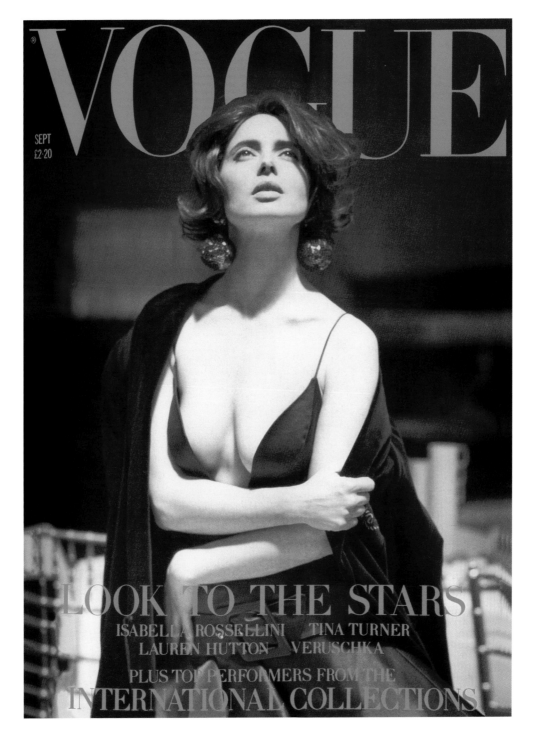

VOGUE

SEPT
£2·20

LOOK TO THE STARS
ISABELLA ROSSELLINI TINA TURNER
LAUREN HUTTON VERUSCHKA
PLUS TOP PERFORMERS FROM THE
INTERNATIONAL COLLECTIONS

SEPTEMBER 1989 Look to the Stars

Steven Meisel is one of the most prolific fashion photographers of the modern age. This cover, one of the few he has made for British *Vogue*, is taken from a fashion story called 'Circus', starring Isabella Rossellini, Lauren Hutton, Veruschka, Tina Chow and Madeleine Potter. It was an ambitious undertaking. ('Fashion without a safety net! For one night only!') As fashion editor Sarajane Hoare recalled: '"Don't go over budget!"

screamed Liz Tilberis [*Vogue*'s then editor]. I couldn't face explaining that Lauren Hutton had been on the phone to LA non-stop.'

Photograph by Steven Meisel. Cover star: Isabella Rossellini.
Fashion: Thierry Mugler. Fashion editor: Sarajane Hoare.
Hair: Oribe. Make-up: François Nars.

197

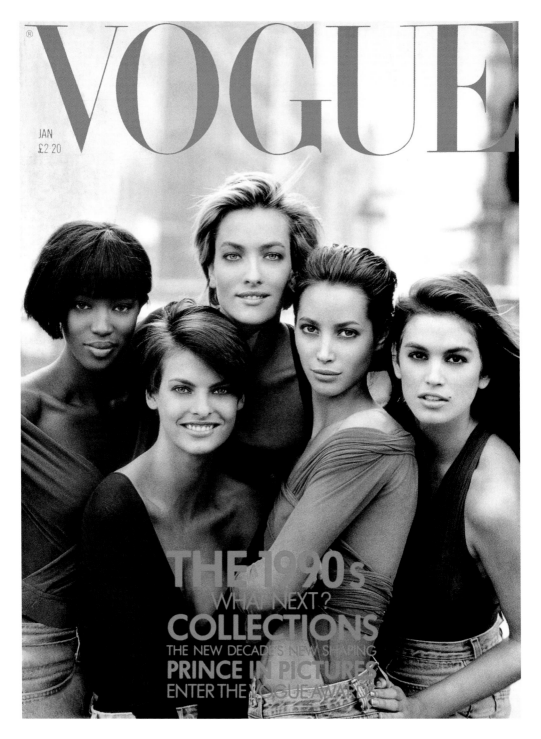

® VOGUE

JAN
£2.20

THE 1990s
WHAT NEXT?
COLLECTIONS
THE NEW DECADE'S NEW SHAPING
PRINCE IN PICTURES
ENTER THE VOGUE AWARDS

JANUARY 1990 The 1990s: What Next?

They are (in case you didn't know) Naomi Campbell, Linda Evangelista, Tatjana Patitz, Christy Turlington and Cindy Crawford. The pages of *Vogue* were never going to be big enough to contain their soaring ambitions. The minutiae of their social lives were picked over, their occasional utterances given almost Delphic significance. As *Vogue*'s Sarah Mower put it at the time: 'On them are projected the fantasies of fashion editors, designers, photographers and, ultimately, the public. Their appearance is a symbolic index of where women stand now, of what we approve of in each other, of how we want to be . . .'

Photograph by Peter Lindbergh. Fashion: Giorgio di Sant'Angelo.
Fashion editor: Brana Wolf. Hair: Christiaan. Make-up: Stephane Marais

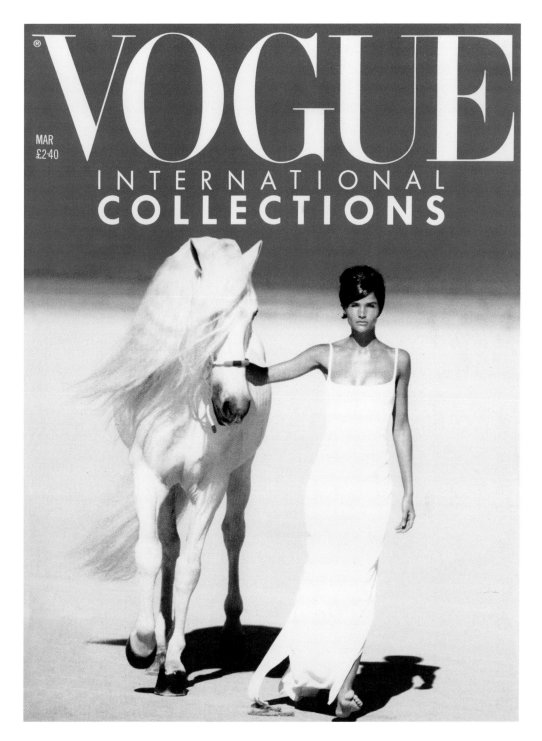

MARCH 1990 International Collections

The painter Howard Hodgkin told art historian David Sylvester, in *Vogue*: 'I don't think there is any other century which has its own colour, but this one has. And that is white. White, before this century, was a luxury, worn on special occasions. It meant purity partly because it needed to be constantly washed. First soap-flakes then detergents and dry cleaning; all these new ways of cleaning clothes and our surroundings made

white, from being first a luxury, then something exotic . . . and finally something that everybody had, and a very, very powerful colour.'

Photograph by Peter Lindbergh. Model: Helena Christensen.
Fashion: Giorgio di Sant'Angelo. Fashion editor: Sarajane Hoare.
Hair: Odile Gilbert. Make-up: Laura Mercier

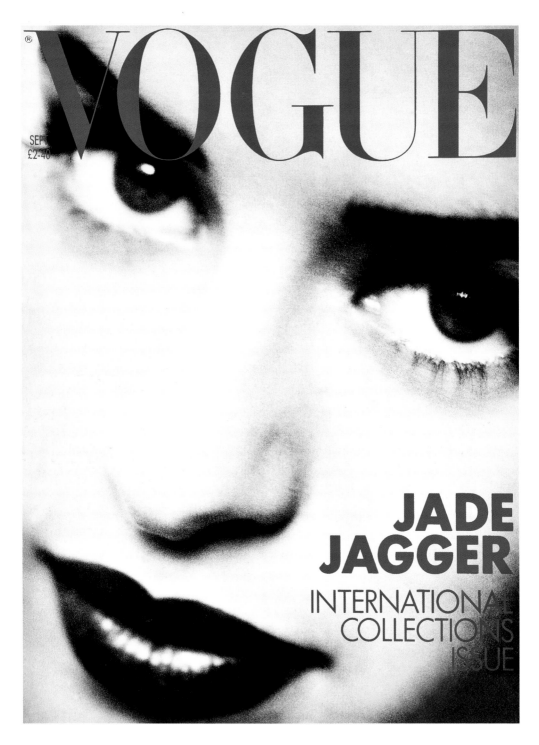

SEPTEMBER 1990 Jade Jagger

Sixteen years after her mother appeared on the cover (see page 171), Jade Jagger is billed above the collections. In the days before she became a designer, she was 'the sometime toy-child of the Warhol world', as Nicky Haslam noted in *Vogue*, adding that she had recently been 'working on a flower stall in Portobello Road . . . What Jade has to offer is her past, of course, but now she has her future, which is here on the launch pad.'

Photograph by Peter Lindbergh.
Hair: Elizabeth Dijan. Make-up: Stephane Marais.

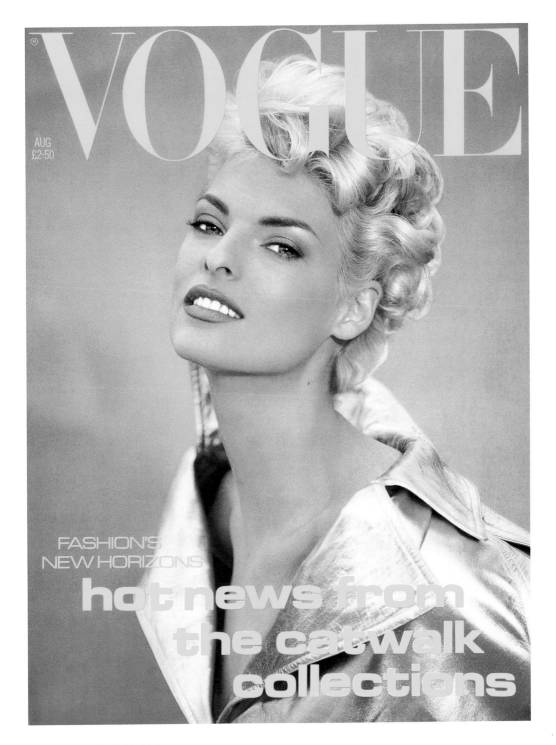

AUGUST 1991 Fashion's New Horizons

By now, Linda Evangelista had already uttered the words for which she would become internationally known — something about 'not waking up for less than $10,000 a day'. Such hubris would have felled a lesser mortal. But it only served to cement the name and reputation of one of the world's most beautiful women. For a moment (mercifully brief, she recalled), how she altered her appearance was almost the subject of academic debate. When her hair changed its colour to platinum blonde, on the advice of her champion Steven Meisel, it was all but front-page news. *Vogue* had little option but to respond with a cover.

Photograph by Patrick Demarchelier. Model: Linda Evangelista. Fashion: Michael Kors. Hair: Sam McKnight. Make-up: Denise Markey

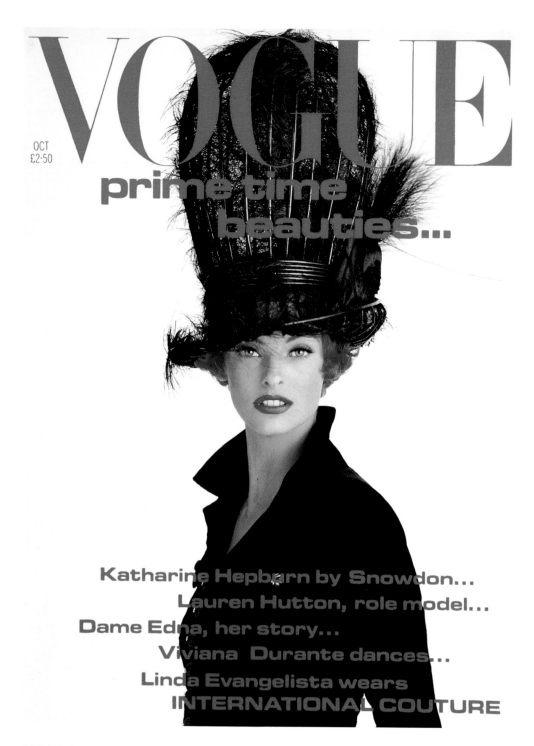

VOGUE

OCT
£2·50

prime time
beauties...

Katharine Hepburn by Snowdon...
Lauren Hutton, role model...
Dame Edna, her story...
Viviana Durante dances...
Linda Evangelista wears
INTERNATIONAL COUTURE

OCTOBER 1991 Prime Time Beauties

'This hat thing,' wrote Sarajane Hoare, 'has to be an English obsession.' Hoare's notion of what exactly constituted English elegance — quirkiness, daring and a firm sense of history — stamped an imprimatur on the magazine that the nascent 'grunge' movement found hard to shift. This striking look, which seemed so eccentrically English, was in fact put together by a German working for a French fashion house and an Irish milliner, photographed by a New York-based Frenchman on a Canadian with a new flaming-red hairstyle, styled by a Scot.

Photograph by Patrick Demarchelier. Model: Linda Evangelista. Fashion: Karl Lagerfeld for Chanel and Philip Treacy. Fashion editor: Sarajane Hoare. Hair: Sam McKnight. Make-up: Mary Greenwell

202

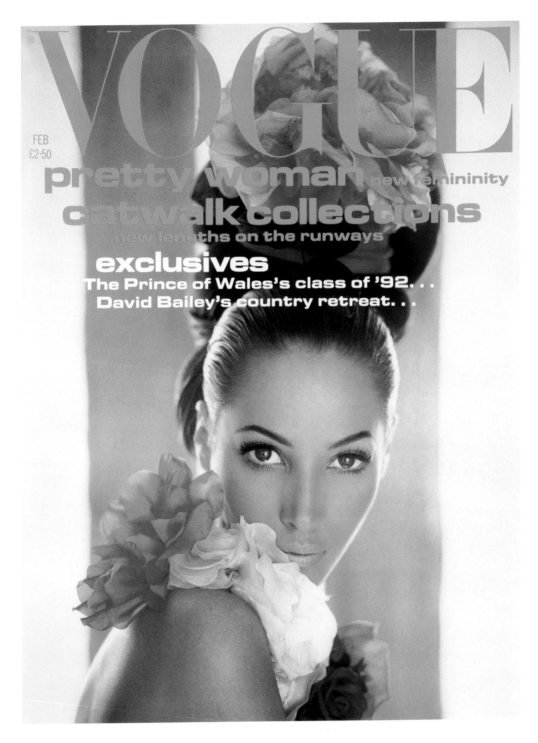

VOGUE

FEB
£2·50

pretty woman new femininity
catwalk collections
new lengths on the runways
exclusives
The Prince of Wales's class of '92. . .
David Bailey's country retreat. . .

FEBRUARY 1992 Pretty Woman

Fashion editor Lucinda Chambers's collaborations with Javier Vallhonrat have often been overlooked in favour of her work with Nick Knight and Mario Testino. This may have much to do with Vallhonrat's ambivalent attitude towards fashion photography, from which he took a long break. Only recently has he come back to it, while continuing in parallel as a much regarded and collected photographic artist.

Photograph by Javier Vallhonrat. Model: Christy Turlington. Fashion: Graham Smith and Un Jardin en Plus. Fashion editor: Lucinda Chambers. Hair: Julien D'Ys. Make-up: Linda Cantello

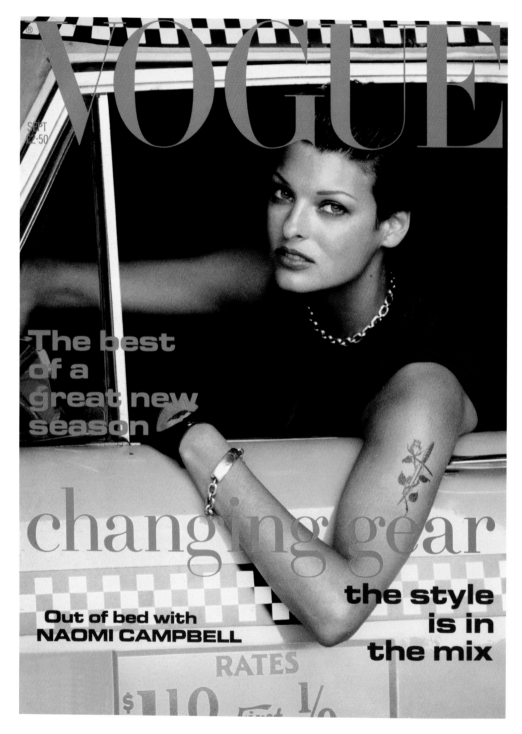

VOGUE

SEPT
£2·50

The best
of a
great new
season

changing gear

Out of bed with
NAOMI CAMPBELL

the style
is in
the mix

RATES
$110 first 1/9

SEPTEMBER 1992 *Changing Gear*

That fashion magazines transport the reader to a world of utter fantasy has never been in question. *Vogue* was born in an age which the writer John Lardner has called 'a time of escape from reality, of stunts and swells, of midnight bathing parties at the Plaza fountain, of skies filled with confetti. It was an age of artifice and exhibitionism.' In this spirit of make-believe, Peter Lindbergh with Lucinda Chambers cast Evangelista in one of her least believable roles: that of New York cab driver, complete with tattoo. 'Out of rank', concurred the magazine's contents page.

Photograph by Peter Lindbergh. Model: Linda Evangelista. Fashion: Principles. Fashion editor: Lucinda Chambers. Hair: Odile Gilbert. Make-up: Stephane Marais

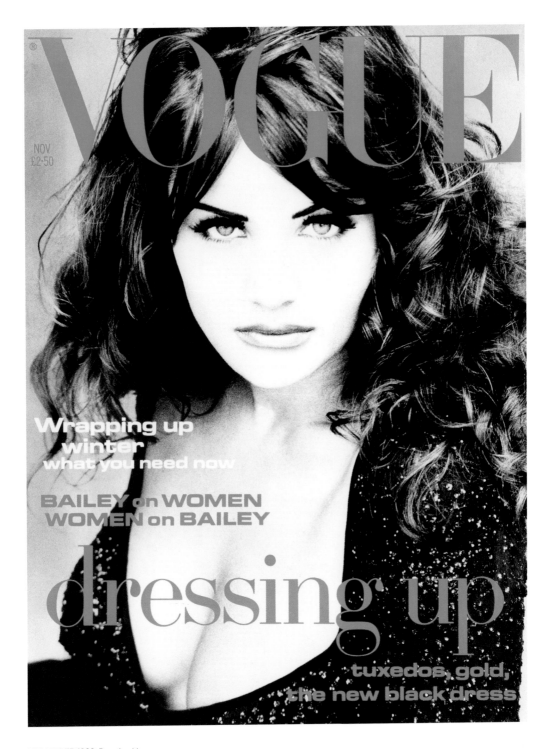

VOGUE

NOV
£2-50

Wrapping up
winter
what you need now

BAILEY on WOMEN
WOMEN on BAILEY

dressing up

tuxedos, gold,
the new black dress

NOVEMBER 1992 Dressing Up

The black-and-white cover was, by the Nineties, something of a rarity,
not least because newsstand sales relied on the vitality of a colour cover
attracting potential readers. The shocking-pink logo and coverlines were
most likely considered vibrancy enough. The smouldering eyes of model
Helena Christensen, and her generous cleavage, added a certain *Dolce
Vita* charm to the tableau.

*Photograph by Max Vadukul. Model: Helena Christensen.
Fashion: Jasper Conran. Fashion editor: Jayne Pickering.
Hair: Thomas McKiver. Make-up: Thierry Moduit.*

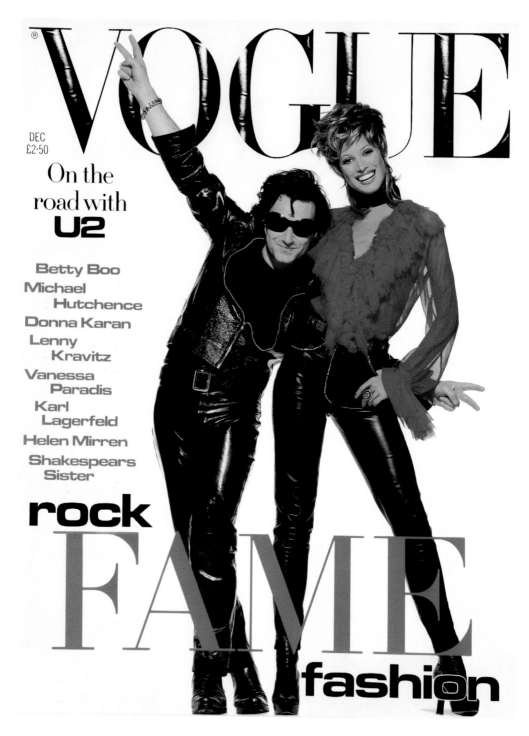

VOGUE

DEC
£2·50

On the
road with
U2

Betty Boo
Michael
Hutchence
Donna Karan
Lenny
Kravitz
Vanessa
Paradis
Karl
Lagerfeld
Helen Mirren
Shakespears
Sister

rock
FAME
fashion

DECEMBER 1992 Rock, Fame, Fashion

'Only one other man had been on the cover of the magazine since it
began,' wrote Andrew MacPherson, 'so doing this one with Bono and
Christy was more than just a beautiful day in a New York studio.' Not
strictly true about men on the cover, but it was comparatively rare and
this was the most dynamic yet. How distressing that the originals were
destroyed in a fire: 'something', MacPherson adds, 'that left me numb.'

Photograph by Andrew MacPherson. Cover star: Bono.
Model: Christy Turlington. Fashion: Vivienne Westwood and Versace.
Fashion editor: Camilla Nickerson.
Grooming: Nassim Khalifa. Make-up: Miranda Joyce

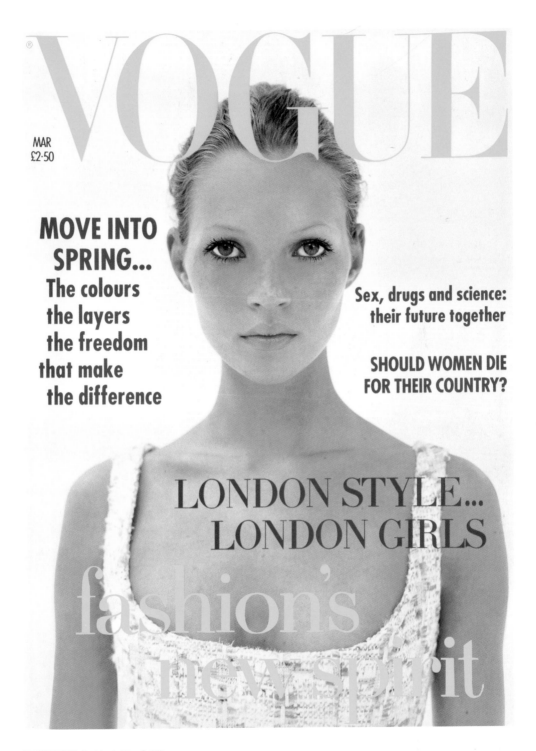

VOGUE

MAR
£2·50

MOVE INTO SPRING...
**The colours
the layers
the freedom
that make
the difference**

**Sex, drugs and science:
their future together**

**SHOULD WOMEN DIE
FOR THEIR COUNTRY?**

LONDON STYLE...
LONDON GIRLS

*fashion's
new spirit*

MARCH 1993 Fashion's New Spirit

'She was just this cocky kid from Croydon,' recalled Corinne Day. 'She wasn't like a model, but I knew she was going to be famous.' As Day predicted, Kate Moss became famous quickly, going on to change the perception of beauty and fashion across the globe. This issue of *Vogue* heralded something of a new spirit in fashion, which some labelled 'grunge', others 'anti-fashion'. But it really meant a relaxing of rules and of stereotypes, so that a south London teenager could wear a pale-pink and ice-blue tweed bustier by Chanel as if made for it.

*Photograph by Corinne Day. Model: Kate Moss.
Fashion: Chanel. Fashion editor: Lucinda Chambers.
Hair: James Brown. Make-up: Linda Cantello*

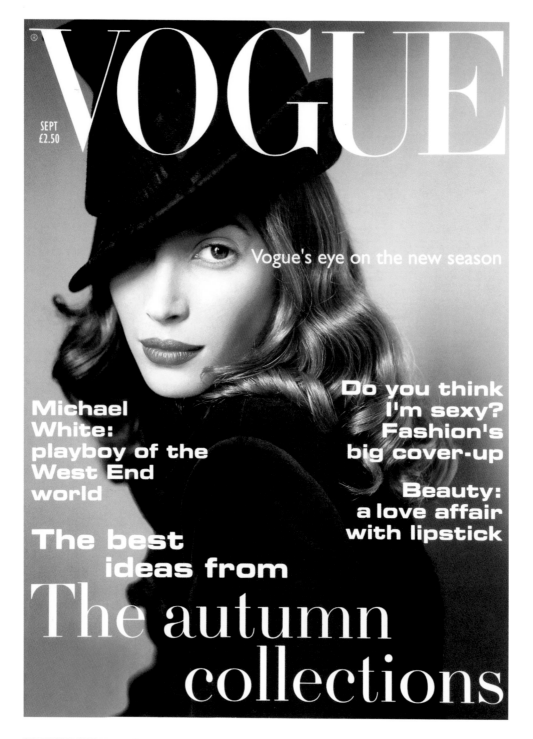

VOGUE

SEPT
£2.50

Vogue's eye on the new season

Michael White: playboy of the West End world

Do you think I'm sexy? Fashion's big cover-up

Beauty: a love affair with lipstick

The best ideas from

The autumn collections

SEPTEMBER 1993 Vogue's Eye on the New Season

On being told he was the nearest thing *Vogue* had ever got to a latter-day Cecil Beaton, Mario Testino, one of the magazine's greatest image makers of recent times, replied that that was the 'biggest compliment' he'd yet been given. Which is not to say that Testino isn't cutting-edge. For *Vogue* he has displayed a sexiness, hard-edged and glinting, as well as an exultant glee in fashion's most opulent moments.

Photograph by Mario Testino. Model: Christy Turlington.
Fashion: Roland Klein and Philip Treacy. Fashion editor: Jayne Pickering
Hair: Marc Lopez. Make-up: Lesley Chilkes

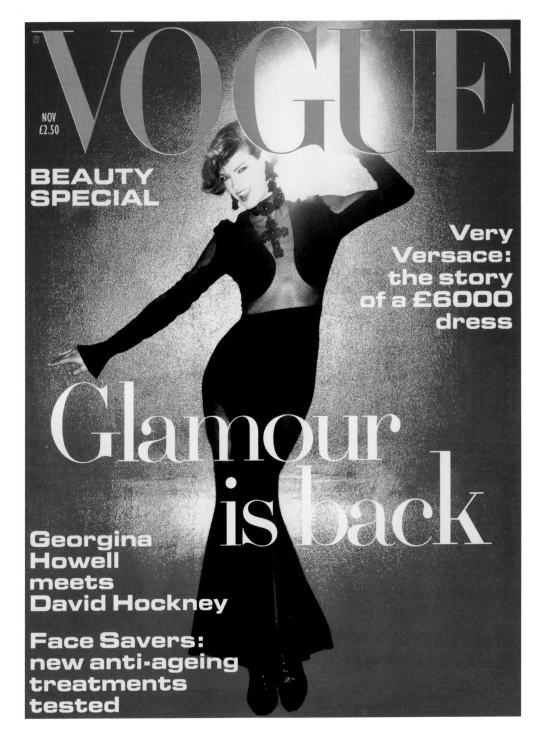

NOVEMBER 1993 Glamour is Back

Taking a cue from Helmut Newton's energetic Seventies photographs for *Nova*, Nick Knight's updated versions heralded a new era of confidence and chic. These were the more forceful for being devised while fashion magazines were being refreshed by the anyone-can-do-it aesthetic of grunge. A virtuoso display of composition, technical brilliance and something known as 'whiplash eyes', they announced (possibly with a certain

relief on the part of the magazine) that glamour was back. It also marked the return of the ring-flash, which Newton had used to great effect.

Photograph by Nick Knight. Model: Linda Evangelista.
Fashion: Karl Lagerfeld. Fashion editor: Lucinda Chambers.
Hair: Julien D'Ys. Make-up: Linda Cantello

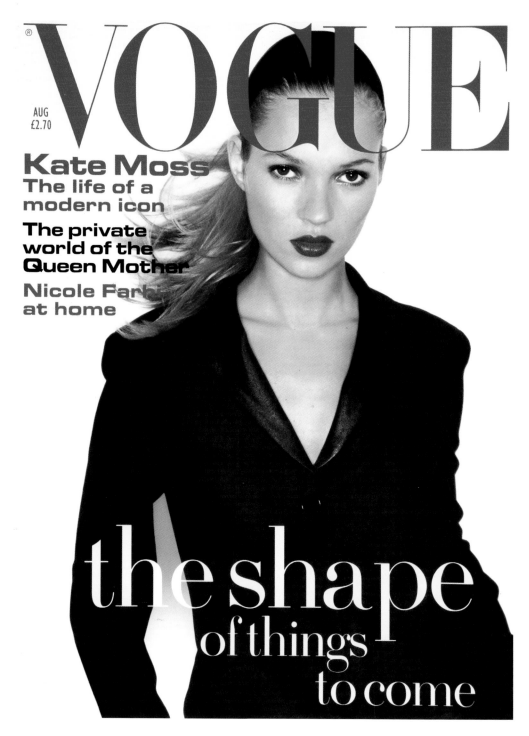

VOGUE

AUG
£2.70

Kate Moss
The life of a
modern icon

The private
world of the
Queen Mother

Nicole Farhi
at home

the shape
of things
to come

AUGUST 1994 The Shape of Things to Come

Nick Knight and Linda Evangelista's 'Glamour is Back' cover had started
the ball rolling, but this striking photograph of Kate Moss, for her second
cover, finally nailed the lid on the London-girl look. *Vogue*'s Lucinda
Chambers had done much to bring it to the collective public gaze. 'This
cover marked the moment,' explained editor Alexandra Shulman, 'when
the waif look started to morph into a more glamorous one.'

Photograph by Juergen Teller. Model: Kate Moss. Fashion: Helmut Lang.
Fashion editor: Tiina Laakkonen. Hair: Guido. Make-up: Dick Page.

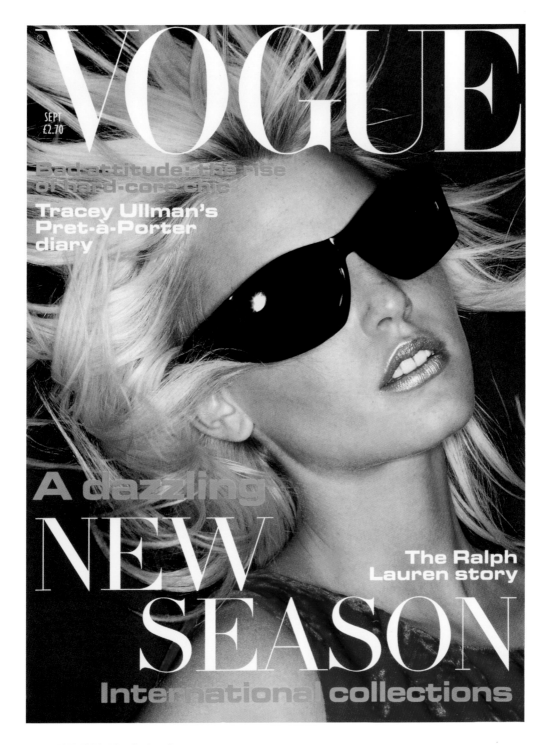

VOGUE

SEPT
£2.70

Bad-attitude: the rise
of hard-core chic

Tracey Ullman's
Pret-à-Porter
diary

A dazzling

NEW
SEASON

The Ralph
Lauren story

International collections

SEPTEMBER 1994 A Dazzling New Season

The new season dazzled best on Nadja Auermann, 5ft 11in with improbably
long legs, last of the great supermodels. Her photographic narratives
with fellow Berliner Helmut Newton are now keenly collected. Together
they satirised her statuesque Aryan physique: a story on high heels found
Auermann in a wheelchair and callipers; for a play upon the Greek myth
of Leda, readers were shocked to find her all but ravished by a swan.

Photograph by Nick Knight. Model: Nadja Auermann.
Fashion: Dolce & Gabbana. Fashion editor: Lucinda Chambers.
Hair: Julien D'Ys. Make-up: Linda Cantello

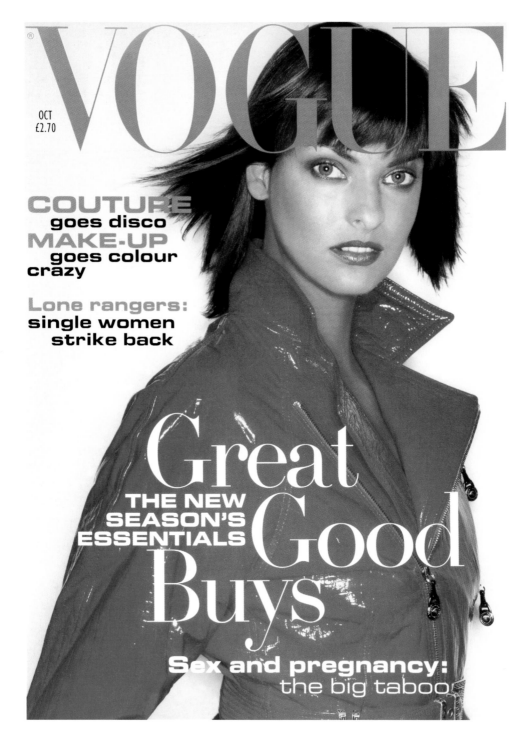

VOGUE

OCT
£2.70

COUTURE
goes disco
MAKE-UP
goes colour
crazy

Lone rangers:
single women
strike back

Great
Good
Buys

THE NEW
SEASON'S
ESSENTIALS

Sex and pregnancy:
the big taboo

OCTOBER 1994 Great Good Buys

The year he made this cover, Juergen Teller identified a new aesthetic, one that was formulated within the pages of the youth-oriented 'style' press but was increasingly encroaching on the high end of the market. He liked, he remarked, to 'scrape down the characters and tell a story'. One might have considered the sleek and flawless queen of the super-models ill-suited to a lens that was so detached from the mainstream,

but of all of them Linda Evangelista was the one most willing to flirt with trends in photography, and then embrace them wholeheartedly.

Photograph by Juergen Teller. Model: Linda Evangelista.
Fashion: Versace. Fashion editor: Tiina Laakkonen.
Hair: Guido. Make-up: Miranda Joyce

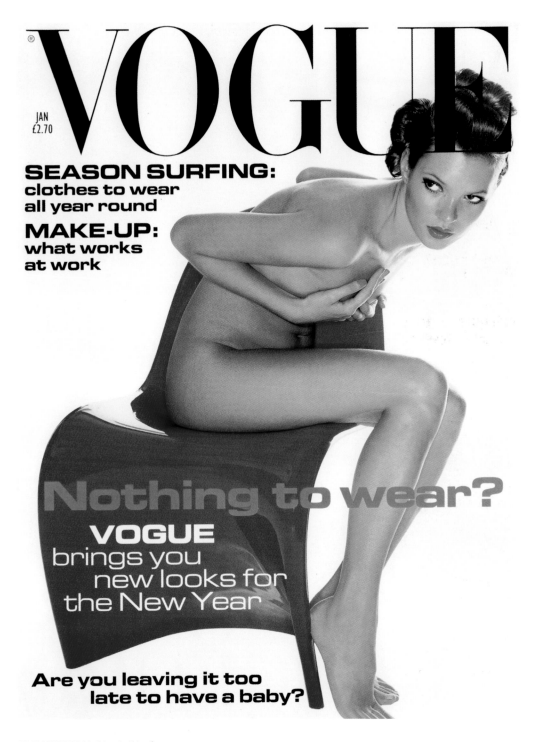

VOGUE

JAN
£2.70

SEASON SURFING:
clothes to wear
all year round

MAKE-UP:
what works
at work

Nothing to wear?

VOGUE
brings you
new looks for
the New Year

**Are you leaving it too
late to have a baby?**

JANUARY 1995 Nothing to Wear?

The 'Nothing to Wear?' issue started the New Year and the new looks to accompany it (or lack of them, if you agreed with *Vogue*'s prognosis). For her fourth appearance on the cover, Kate Moss wears 'nothing but Max Factor International Orchid Mist', as the magazine put it. The shot entirely dictated the coverlines, since the nude scenario was unforeseen. Between takes — and between changes of clothes — Moss sat on a red

Verner Panton chair. The opportunity was too beguiling to miss and this unplanned shot, known as an 'in between', became the cover.

Photograph by Nick Knight. Model: Kate Moss.
Fashion editor: Lucinda Chambers.
Hair: Juilen D'Ys. Make-up: Linda Cantello

213

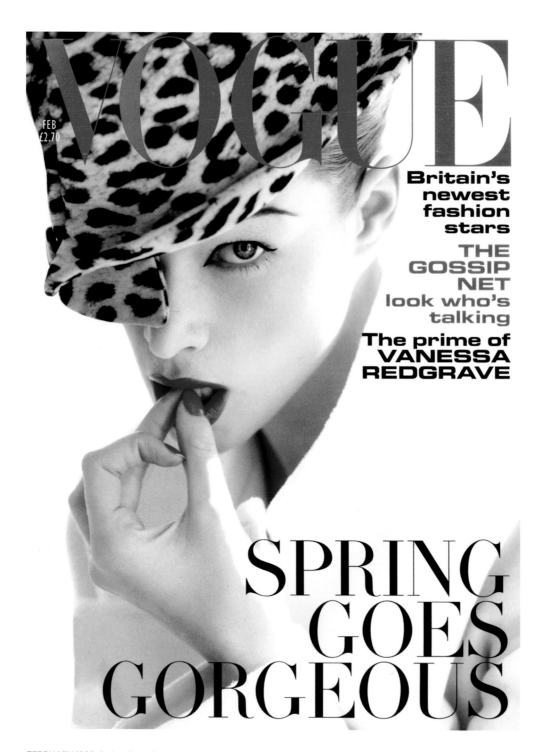

VOGUE

FEB
£2.70

Britain's newest fashion stars

THE GOSSIP NET look who's talking

The prime of VANESSA REDGRAVE

SPRING GOES GORGEOUS

FEBRUARY 1995 Spring Goes Gorgeous

The public's idea of how a fashion photographer behaves is drawn from cinematic history and contemporary parody. He (and it is always a 'he') is ineffably polite and carefully groomed, gesticulatory, theatrical and perhaps a little overdramatic. And unapologetically enthusiastic for opulence and artifice. Testino is a pared-down version of the above and it is little wonder that the British public has taken him to its collective heart. His museum retrospective at the National Portrait Gallery in 2002 remains by far the most successful show the NPG has ever mounted.

Photograph by Mario Testino. Model: Meghan Douglas. Fashion: Salvatore Ferragamo and Stephen Jones. Fashion editor: Lucinda Chambers. Hair: Laurent Philippon. Make-up: Tom Pecheux

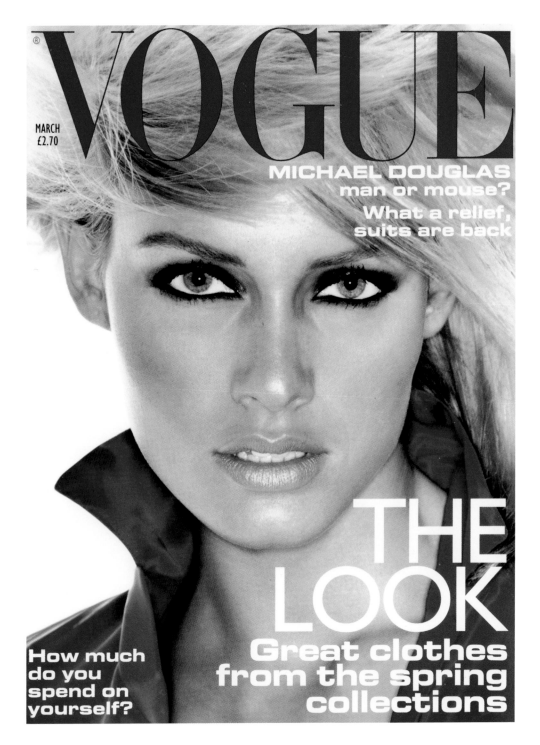

VOGUE

MARCH
£2.70

MICHAEL DOUGLAS
man or mouse?

**What a relief,
suits are back**

THE
LOOK
Great clothes
from the spring
collections

**How much
do you
spend on
yourself?**

MARCH 1995 The Look

Like his Victorian predecessors, Nick Knight treats photography as the science it is; very little is left to accident and he relies to a great extent on digital post-production. He finds it inconvenient to shoot outside because of 'sensory overload — my head starts swirling', but conversely, is not in thrall to the technology he employs. 'That's about as interesting to me as asking, what pen are you writing with? . . . I'd happily use a photo-booth to do pictures, as I would high-speed video cameras, as I would a mobile phone . . . It all depends on what you're trying to say.'

*Photograph by Nick Knight. Model: Amber Valletta.
Fashion: Jil Sander. Fashion editor: Lucinda Chambers.
Hair: Julien D'Ys. Make-up: Linda Cantello*

215

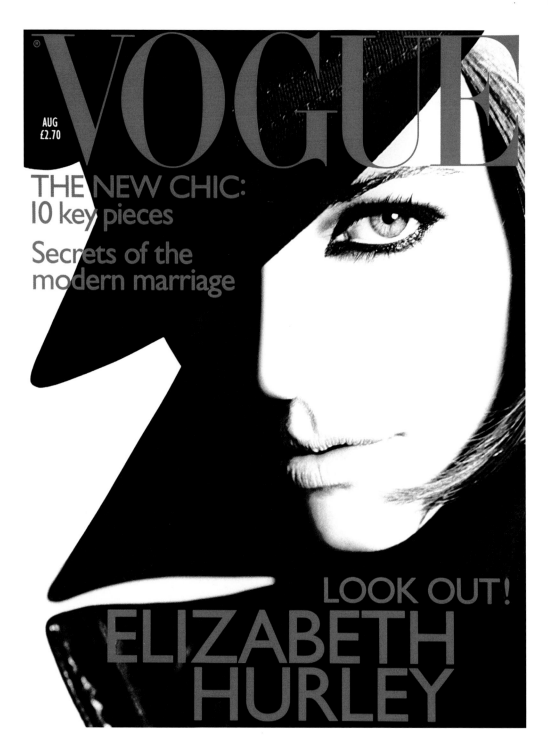

VOGUE

AUG
£2.70

THE NEW CHIC:
10 key pieces

Secrets of the
modern marriage

LOOK OUT!
ELIZABETH
HURLEY

AUGUST 1995 Look Out! Elizabeth Hurley

It all started with 'that dress', a black Versace number slit up the side and tentatively safety-pinned in 24 places, worn to the premier of her then boyfriend Hugh Grant's film *Four Weddings and a Funeral*. 'The same significance in tabloid folklore,' remarked *Vogue*, 'that the Nativity has to Christians; the moment a star was born.' It helped launch Hurley's career as a fashion model, and a lucrative contract as the face of Estée Lauder.

Photograph by Nick Knight. Fashion: Jil Sander and The Hat Shop.
Fashion editor: Lucinda Chambers.
Hair: Jimmy Paul. Make-up: Pat McGrath

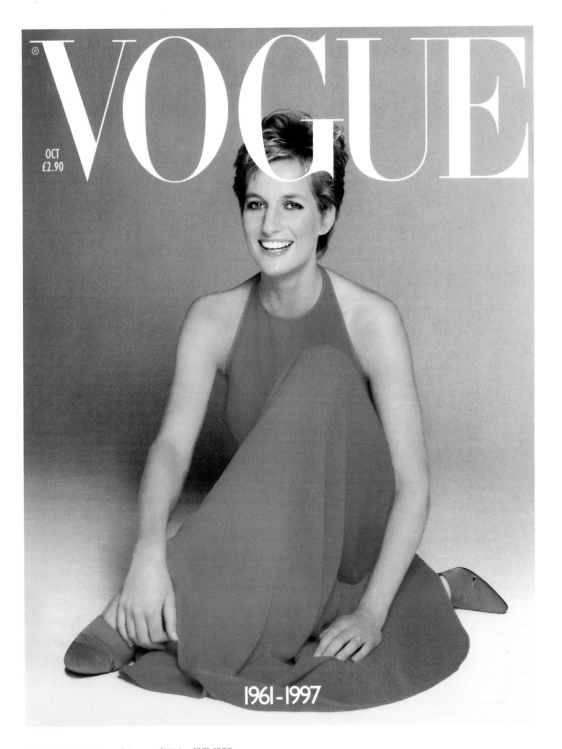

OCTOBER 1997 Diana, Princess of Wales, 1961–1997

This previously unpublished informal portrait, taken in 1994, was used to mark Diana's untimely death in the late summer of 1997. *Vogue*'s deadline had passed for the October issue, and the suddenness of her death meant that there was no cover ready. Patrick Demarchelier, who had photographed the princess many times for the magazine, was the obvious source. Except he was on location somewhere remote and would not be back for a week.

The day before the funeral, he arrived back at his office in New York, grabbed the only picture he had in mind and stepped on the plane to London. At Westminster Abbey, *Vogue* had a motorcycle courier ready to take the print from him, and minutes later the magazine had its cover.

Photograph by Patrick Demarchelier

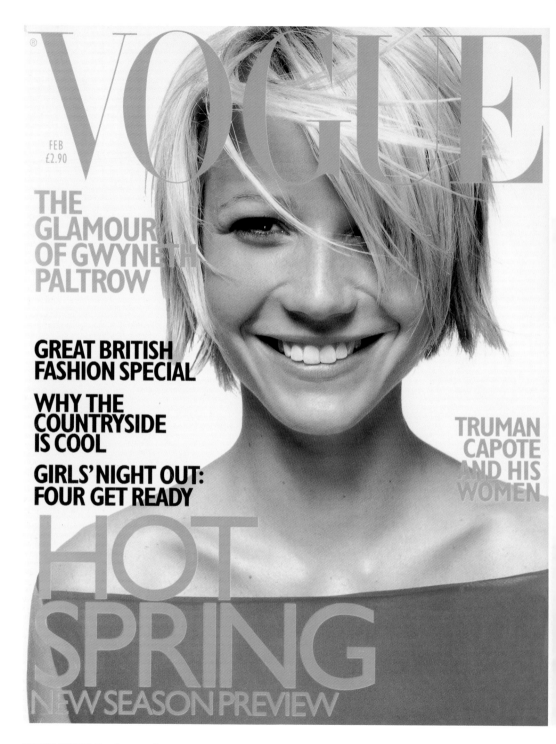

VOGUE

FEB
£2.90

THE
GLAMOUR
OF GWYNETH
PALTROW

**GREAT BRITISH
FASHION SPECIAL**

**WHY THE
COUNTRYSIDE
IS COOL**

**GIRLS' NIGHT OUT:
FOUR GET READY**

TRUMAN
CAPOTE
AND HIS
WOMEN

HOT
SPRING
NEW SEASON PREVIEW

FEBRUARY 1998 The Glamour of Gwyneth Paltrow

That Mario Testino and celebrity like each other enormously is clear. But anyone ranged before his camera can, because of his peculiar alchemy, come out looking like a star. He has skilfully married the fashion picture to the portrait, so that, a portrait of, say, Gwyneth Paltrow becomes, through styling (a feathered headdress loomed large in this issue), grooming and composition, something approaching an iconic fashion shot. Even those ideas that become increasingly unappetising the more you consider them turn out, in Testino's hands, to be oddly alluring: the entire family of the Rolling Stones' Ronnie Wood, for example, naked but for their underwear, posed around a tin bath.

Photograph by Mario Testino. Fashion: Clements Ribeiro.
Fashion editor: Lucinda Chambers. Hair: Orlando Pita. Make-up: Tom Pecheux

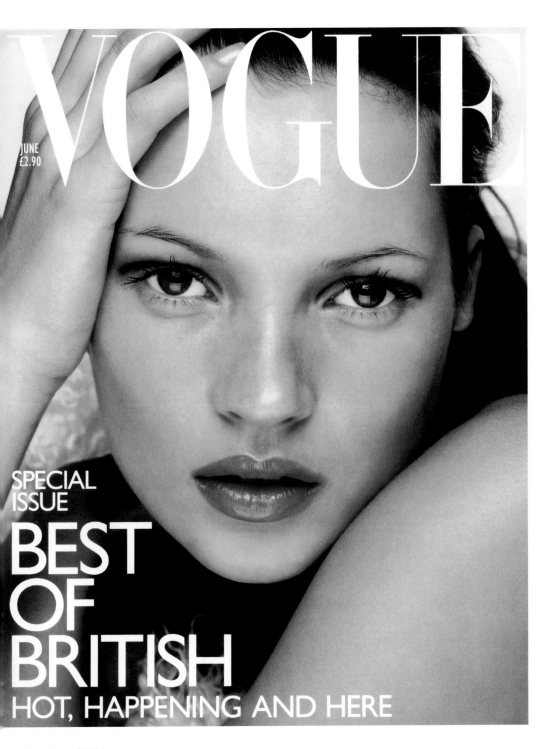

VOGUE

JUNE
£2.90

SPECIAL
ISSUE

BEST
OF
BRITISH
HOT, HAPPENING AND HERE

JUNE 1998 Best of British

As London swung again, *Vogue* celebrated with a special issue devoted to British cultural life. The 'Blair effect', the residue of Cool Britannia, the fin-de-siècle boom in British arts, from Britpop to Britart — all metamorphosed into a continuing enthusiasm for British creativity. Though the lure of Hollywood continued to pull readers transatlantically, as it has done for nearly a century, traditional British virtues of inventiveness and ingenuity remained vividly in the pages of *Vogue*. In this issue, Peter Mandelson rubbed shoulders with Julie Christie, Jay Jopling and Sam Taylor-Wood with members of the England football team.

Photograph by Nick Knight. Model: Kate Moss. Hair: Sam McKnight. Make-up: Sharon Dowsett

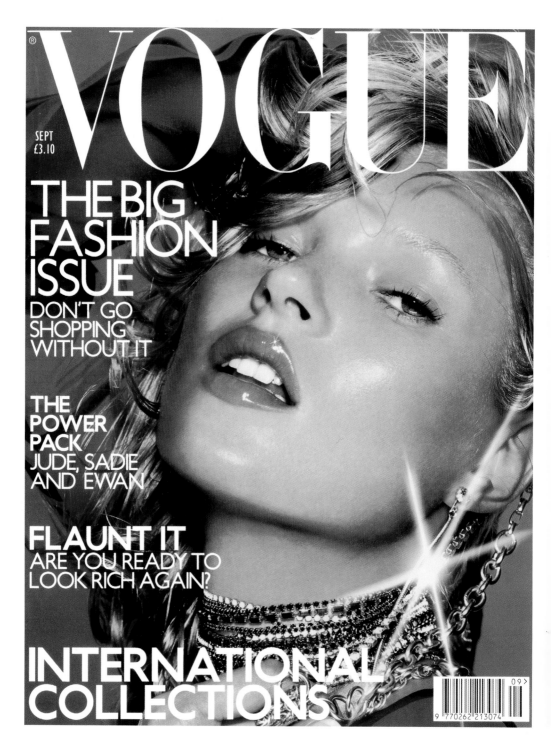

VOGUE

SEPT
£3.10

THE BIG FASHION ISSUE
DON'T GO SHOPPING WITHOUT IT

THE POWER PACK
JUDE, SADIE AND EWAN

FLAUNT IT
ARE YOU READY TO LOOK RICH AGAIN?

INTERNATIONAL COLLECTIONS

SEPTEMBER 2000 Flaunt It: Are You Ready to Look Rich Again?

The most anticipated *Vogue* covers are the International Collections issues of March and September. They hit the newsstands as the season's new looks reach the shops. They are, for the most part, 'high concept' covers — the ones that can be pre-arranged well in advance and art-directed so tightly that nothing is left to chance. For autumn/winter 2000, *Vogue* detected a return to unapologetic high glamour.

Photograph by Nick Knight. Model: Kate Moss. Fashion: Versace. Fashion editor: Kate Phelan. Hair: Sam McKnight. Make-up: Val Garland

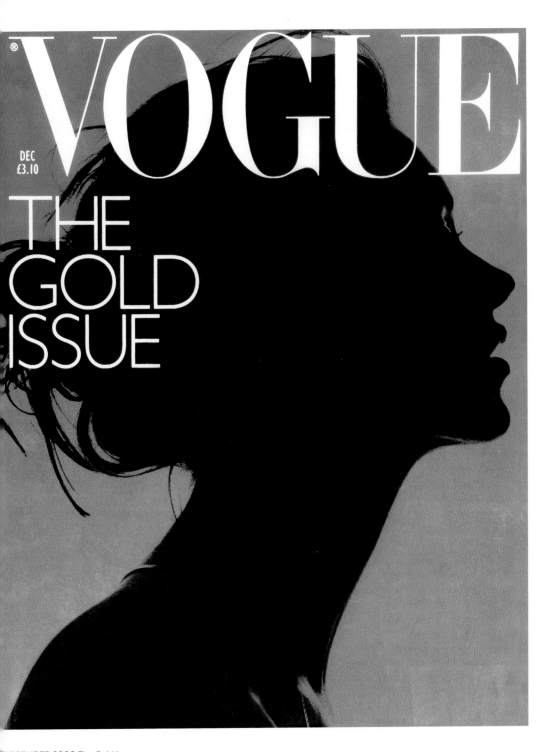

VOGUE

DEC
£3.10

THE GOLD ISSUE

DECEMBER 2000 The Gold Issue

The theme for the end of the first year of the new millennium was gold and all
t suggested, loosely or otherwise. Testino shot a portfolio of 'gilded youth',
Nigella Lawson created golden food, and the most inventive British designers
produced gold outfits. 'I doubt,' wrote *Vogue*'s editor, Alexandra Shulman,
that there's a piece of gold clothing in the country that hasn't been called in.'
The swan-necked profile in silhouette was, by now, instantly recognisable.

Photograph by Nick Knight. Model: Kate Moss.
Fashion editor: Kate Phelan. Hair: Sam McKnight. Make-up: Val Garland

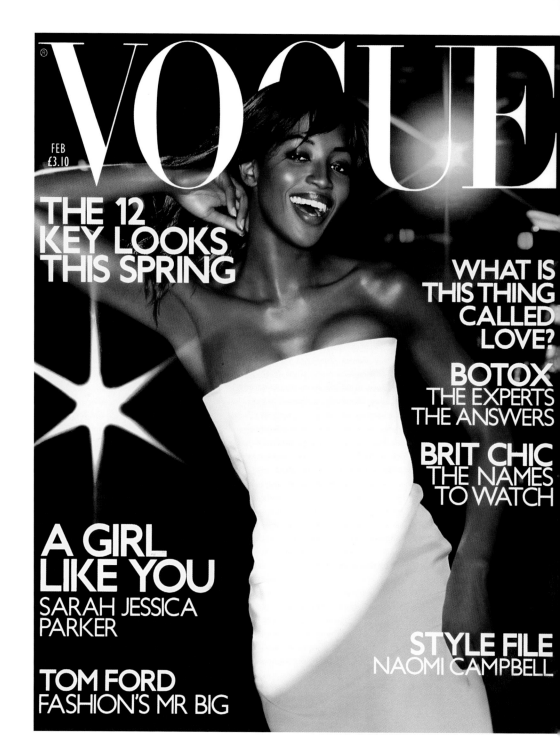

VOGUE

FEB
£3.10

THE 12 KEY LOOKS THIS SPRING

WHAT IS THIS THING CALLED LOVE?

BOTOX
THE EXPERTS THE ANSWERS

BRIT CHIC
THE NAMES TO WATCH

A GIRL LIKE YOU
SARAH JESSICA PARKER

TOM FORD
FASHION'S MR BIG

STYLE FILE
NAOMI CAMPBELL

FEBRUARY 2001 The 12 Key Looks This Spring

By the beginning of 2001, Naomi Campbell had been a star for some 16 years and (just occasionally, before she tightened them up again) things had started to unravel a little bit. As *Vogue* put it: 'The fashion industry — not one of the most generous — appears aware of her foibles and weaknesses but indulgent of them and prepared, endlessly, to excuse her — which after 16 years is some achievement. A monster she might be, but a lovable one . . . '

Photograph by Mario Testino. Model: Naomi Campbell.
Fashion: Tom Ford for Yves Saint Laurent Rive Gauche.
Fashion editor: Lucinda Chambers. Hair: Marc Lopez. Make-up: Val Garland.

222

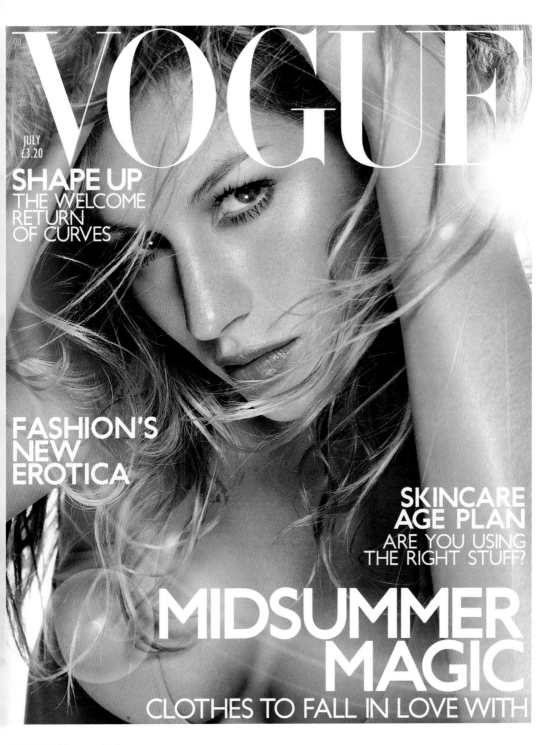

VOGUE

JULY
£3.20

SHAPE UP
THE WELCOME
RETURN
OF CURVES

**FASHION'S
NEW
EROTICA**

**SKINCARE
AGE PLAN**
ARE YOU USING
THE RIGHT STUFF?

MIDSUMMER
MAGIC
CLOTHES TO FALL IN LOVE WITH

JULY 2001 Midsummer Magic

Gisele Bündchen was shooting in New York when *Vogue*'s creative director showed her this picture on a finished magazine. A silence greeted it, which he hoped was reverential. Gisele's then boyfriend, actor Leonardo DiCaprio, cut the long pause with four carefully chosen words. 'This cover,' he said, 'is *dog*.' The creative director was visibly dispirited until it was gently explained to him that, among young people, there could be no greater words of approval.

*Photograph by Nick Knight. Model: Gisele Bündchen.
Fashion: Versace. Fashion editor: Kate Phelan.
Hair: Sam McKnight. Make-up: Sharon Dowsett.*

223

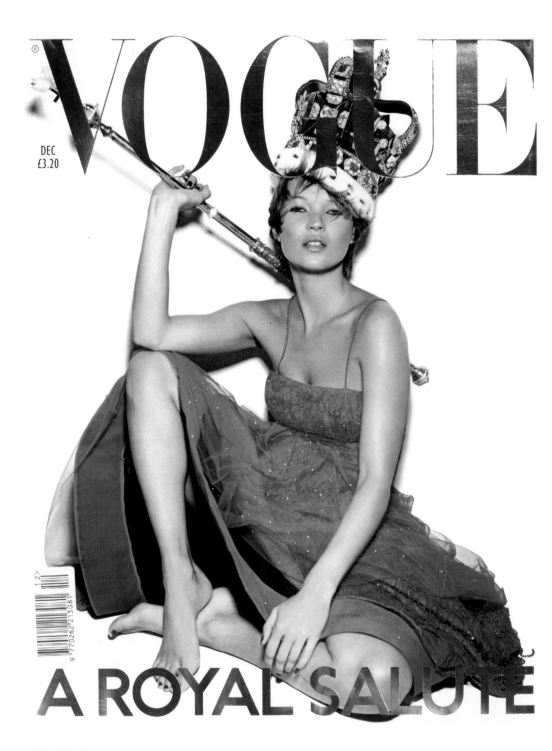

VOGUE

DEC
£3.20

A ROYAL SALUTE

DECEMBER 2001 A Royal Salute

Vogue's theme for Christmas was one that had preoccupied it for the best part of 85 years. Since its launch, the magazine had chronicled the reigns of four monarchs, two coronations, two silver jubilees, the funerals of two kings and one abdication. This issue was conceived before the terrorist atrocity of 11 September, but published after; *Vogue* remarked that 'as the days pass in a climate of uncertainty and speculation, what we increasingly treasure is the recognisable, the predictable, the familiar. And . . . what could embody those attributes more clearly than our royal family?' Wielding a sceptre, fashion's own approximation of royalty wears a replica crown.

Photograph by Nick Knight. Model: Kate Moss. Fashion: Giorgio Armani. Fashion editor: Kate Phelan. Hair: Sam McKnight. Make-up: Val Garland

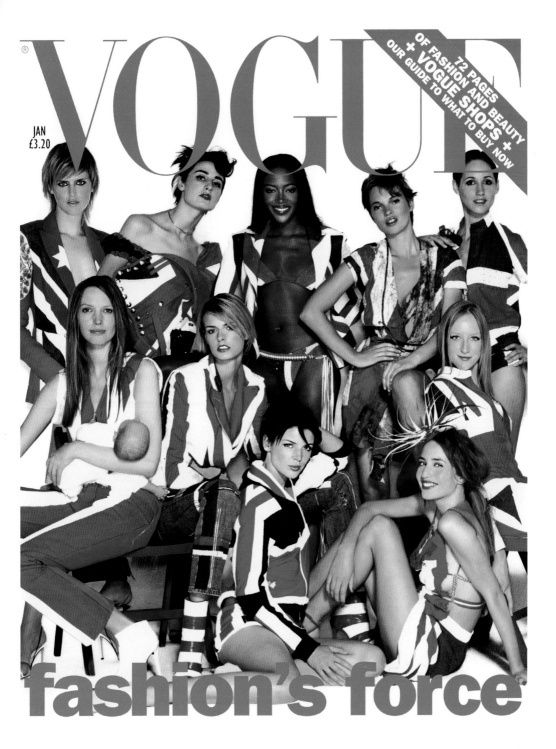

VOGUE

JAN
£3.20

fashion's force

JANUARY 2002 Fashion's Force

In a patriotic reaction to the events of 11 September 2001, *Vogue* rounded up the most recognisable British models and dressed them in Union Flag outfits specially customised by leading British designers. Mario Testino photographed them for a gatefold cover. 'What better way,' the magazine asked, 'for patriotism to run wild?' Though Peruvian-born, Testino has been accorded honorary Brit status, not least because he has lived in London for nearly 30 years. And London was, for him, where it started to happen: 'I liked it', he says, 'this mixture of cosmopolitan city and anarchy was just what I'd always seemed to be looking for . . . '

Photograph by Mario Testino. Fashion editor: Lucinda Chambers.
Hair: Marc Lopez. Make-up: Tom Pecheux.

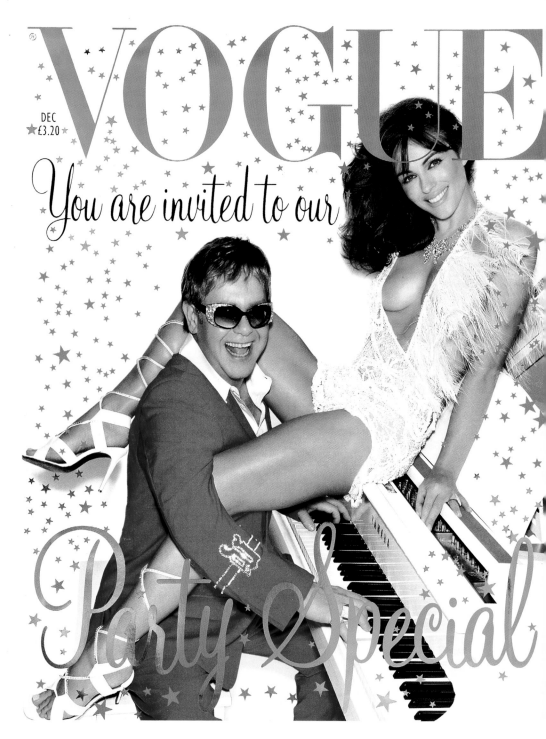

VOGUE

DEC
£3.20

You are invited to our

Party Special

DECEMBER 2002 Party Special

The Christmas cover session was attended by *Vogue*'s editor. 'Uncomfortable and ungainly as Elton's position is — sprawled over the Yamaha with his mouth wide open and Elizabeth's hand in his trousers — he's giving it his all,' wrote Alexandra Shulman. 'There's the kind of amazed silence in the huge studio that occurs when no-one can quite believe how well everything's going. In particular, we are all astonished at how incredibly compliant Elton has been,

considering he *hates* having his photograph taken — according to his boyfriend, David Furnish, who is hovering around reassuringly . . .'

*Photograph by Mario Testino. Cover stars: Elton John and Elizabeth Hurley.
Fashion: Givenchy and Versace. Fashion editor: Lucinda Chambers.
Hair: Guido and Paul Davies. Make-up: Charlotte Tilbury*

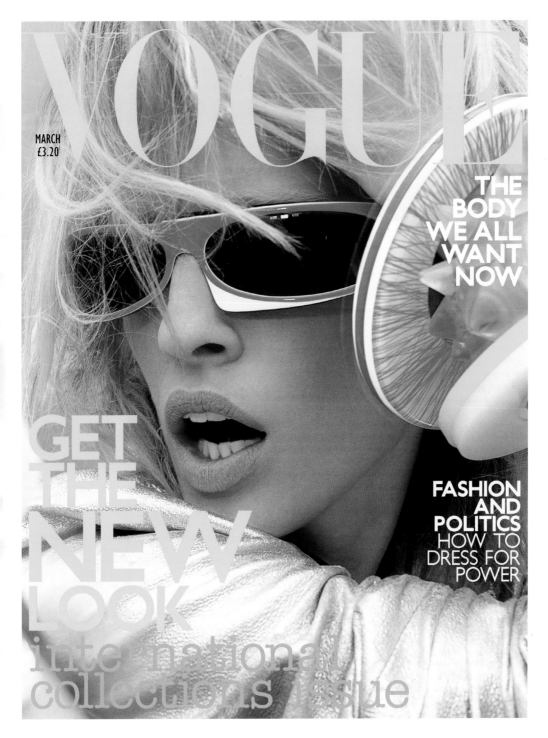

VOGUE

MARCH
£3.20

THE BODY WE ALL WANT NOW

GET THE NEW LOOK

international collections issue

FASHION AND POLITICS HOW TO DRESS FOR POWER

MARCH 2003 Get the New Look

This cover, a six-colour separation, was something of a technical departure for *Vogue* (the norm was the standard four-colour, first introduced to the magazine some 70 years previously). The two new colours are fluorescent pink and yellow, most effective on the *Vogue* logo and Miss Vojnovic's oversize bangles. They don't quite glow in the dark but readers were entranced, like moths to a flame, by this startling and vivid cover.

Photograph by Nick Knight. Model: Natasha Vojnovic.
Fashion: Christian Lacroix. Fashion editor: Lucinda Chambers.
Hair: Sam McKnight. Make-up: Val Garland

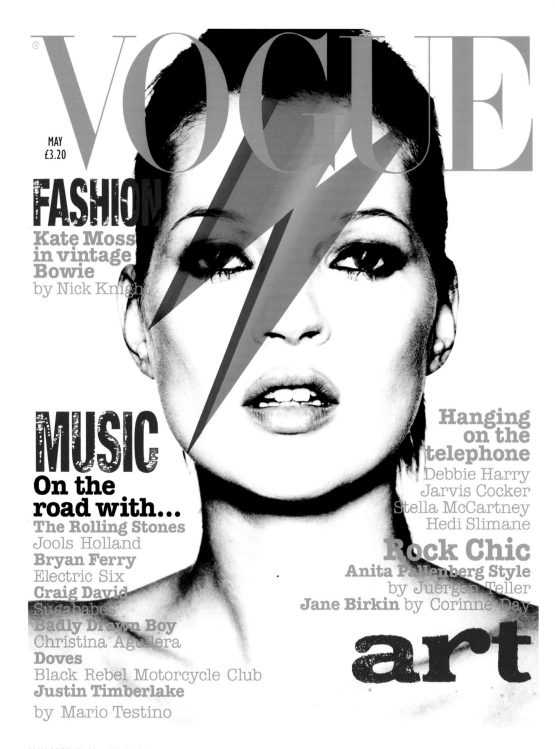

VOGUE

MAY
£3.20

FASHION
**Kate Moss
in vintage
Bowie**
by Nick Knight

MUSIC

On the
road with...
The Rolling Stones
Jools Holland
Bryan Ferry
Electric Six
Craig David
Sugababes
Badly Drawn Boy
Christina Aguilera
Doves
Black Rebel Motorcycle Club
Justin Timberlake
by Mario Testino

**Hanging
on the
telephone**
Debbie Harry
Jarvis Cocker
Stella McCartney
Hedi Slimane

Rock Chic
Anita Pallenberg Style
by Juergen Teller
Jane Birkin by Corinne Day

art

MAY 2003 Fashion, Music, Art

Kate Moss in monochrome slashed with a bolt of lightning. The reference was clear and instant: David Bowie's cover image for *Aladdin Sane* (1973). Inside, Nick Knight photographed Moss in several of the Thin White Duke's original stage outfits: the red patent-leather boots of his Ziggy Stardust stage persona, his waistcoat and trousers from the film *The Man Who Fell to Earth* (1976) and the androgynous knitted jumpsuits made for him by Kansai Yamamoto. Bowie himself was shot for a *Vogue* cover with Twiggy in 1973, but it was vetoed by the editor. Instead, Justin de Villeneuve's double-headshot became the cover of Bowie's album *Pinups*.

*Photograph by Nick Knight. Model: Kate Moss.
Fashion editor: Kate Phelan. Hair: Sam McKnight. Make-up: Val Garland*

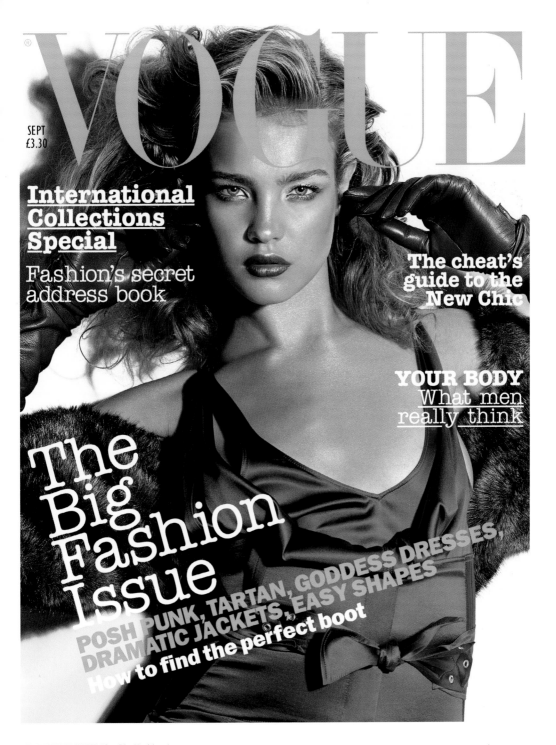

VOGUE

SEPT
£3.30

**International
Collections
Special**

Fashion's secret
address book

**The cheat's
guide to the
New Chic**

YOUR BODY
What men
really think

The
Big
Fashion
Issue

POSH PUNK, TARTAN, GODDESS DRESSES,
DRAMATIC JACKETS, EASY SHAPES
How to find the perfect boot

SEPTEMBER 2003 The Big Fashion Issue

Natalia Vodianova's life story comes over as rags-to-riches romance. She was born in sprawling Nizhny Novgorod in bleak, industrial Russia, and helped the family survive by selling fruit with her mother. She came into contact with a modelling agency and, aged 17 and in Paris, erupted onto a larger stage. Her trajectory swept higher with marriage to the Hon Justin Portman, whose family owns and maintains large parts of central London. 'I loved my life. I even miss it sometimes,' she says of those days, not so long ago, spent haggling with Chechen fruit wholesalers.

*Photograph by Mario Testino. Model: Natalia Vodianova.
Fashion: Gucci. Fashion editor: Lucinda Chambers.
Hair: Samantha. Make-up: Charlotte Tilbury*

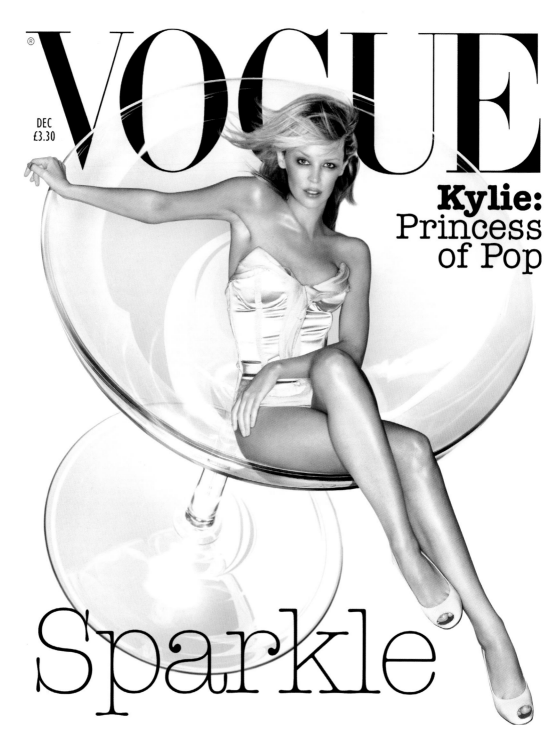

VOGUE

DEC
£3.30

Kylie:
Princess
of Pop

Sparkle

DECEMBER 2003 Kylie: Princess of Pop

Vogue wondered whether the 'pop pixie', with her taste for high fashion and a steady love interest, had 'hung up her hotpants for a more serious way of life'. The taste for high fashion outlived the love interest, and by then her way of life had changed seriously with a much-documented battle with cancer. Before this, she was the Christmas cover for 2003, shot by Nick Knight. 'Nick's team gathers in the kitchen, Kylie's team in the canteen, the *Vogue* fashion team hovers by a rail of clothes the length of a small street,' reported *Vogue*'s Fiona Golfar. 'All teams are discussing today's look for the Princess of Pop.'

Photograph by Nick Knight. Fashion: Stella McCartney.
Fashion editor: Kate Phelan. Hair: Sam McKnight.
Make-up: Val Garland. Set design: Simon Costin

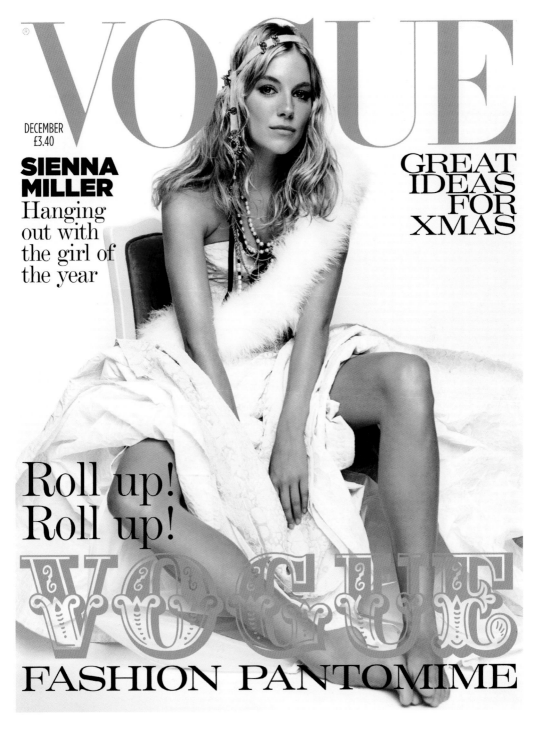

VOGUE

DECEMBER
£3.40

**SIENNA
MILLER**
Hanging
out with
the girl of
the year

GREAT
IDEAS
FOR
XMAS

Roll up!
Roll up!

VOGUE

FASHION PANTOMIME

DECEMBER 2004 Sienna Miller

For its Christmas cover, *Vogue* secured the girl of the moment. She had had something of an *annus mirabilis*, in which she had sprung up as if from nowhere. 'Sienna Miller admits to having a lovely life,' *Vogue* observed. 'She's gorgeous, stylish and has a superstar boyfriend, so no-one's going to disagree.' Luckily in the months to come, she could rely on her unfailing good humour and courtesy in the face of almost constant media scrutiny. It was *Vogue*'s perceptive guess that her fashion-icon status would grow in tandem with her acting career.

Photograph by Mario Testino. Fashion: Rochas.
Fashion editor: Lucinda Chambers.
Hair: Marc Lopez. Make-up: Miranda Joyce

231

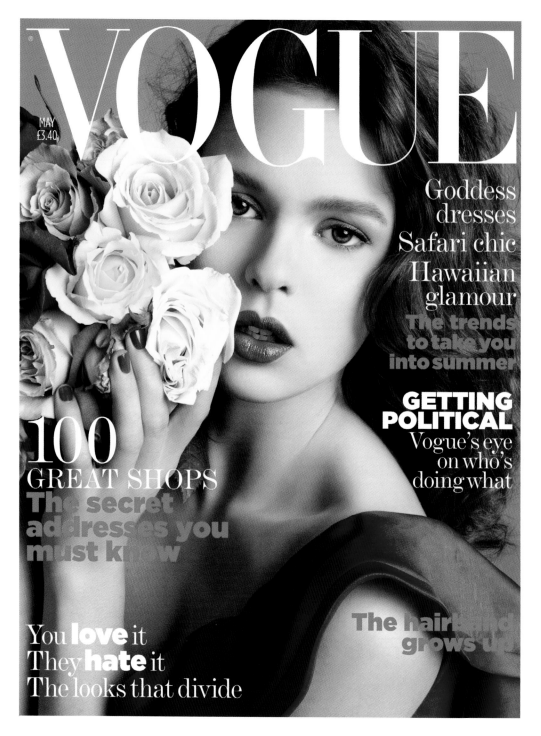

VOGUE

MAY
£3.40

Goddess
dresses
Safari chic
Hawaiian
glamour
The trends
to take you
into summer

**GETTING
POLITICAL**
Vogue's eye
on who's
doing what

100
GREAT SHOPS
The secret
addresses you
must know

The hairband
grows up

You **love** it
They **hate** it
The looks that divide

MAY 2005 The Trends to Take You into Summer

The team of Inez van Lamsweerde and Vinoodh Matadin met over 20 years ago, at fashion college in Amsterdam, and though they came late to fashion photography it has been with a rigour that betrays their perfectionism. 'In the early period,' van Lamsweerde once remarked, 'we did the picture as well as the layout and text, so were completely involved with the whole concept.'

Photograph by Inez van Lamsweerde and Vinoodh Matadin.
Model: Elise Crombez. Fashion: Yves Saint Laurent.
Fashion editor: Kate Phelan. Hair: Kevin Ryan. Make-up: Dick Page.

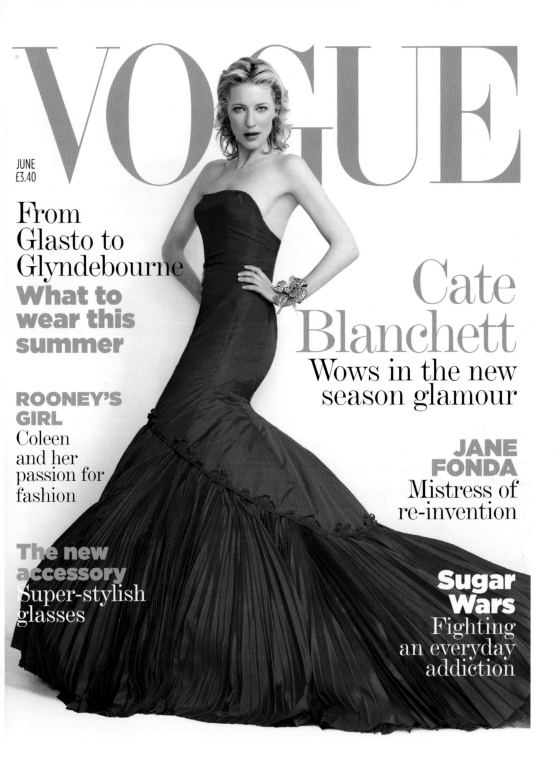

VOGUE

JUNE
£3.40

From Glasto to Glyndebourne
What to wear this summer

ROONEY'S GIRL
Coleen and her passion for fashion

The new accessory
Super-stylish glasses

Cate Blanchett
Wows in the new season glamour

JANE FONDA
Mistress of re-invention

Sugar Wars
Fighting an everyday addiction

JUNE 2005 Cate Blanchett Wows in the New Season Glamour

Vogue's Emily Sheffield sat in on a cover shoot with the holder (of only one week's standing) of the Oscar for Best Supporting Actress: 'She appears to grow into the dress, a red silk-taffeta wonder by Alexander McQueen . . . Her camera technique is surprisingly adept for someone who has never been a model.' Regan Cameron was similarly impressed: 'I explained that I wanted to bring some classic *Vogue* into the shoot, a bit of Norman Parkinson and Erwin Blumenfeld. I felt she went straight into it, referenced it in her mind.' Cate Blanchett herself was more hesitant in her self-appraisal: 'I'm not a natural exhibitionist, but I think to myself: "This is just what's happening today."'

Photograph by Regan Cameron. Fashion: Alexander McQueen. Fashion editor: Miranda Robson. Hair: Sam McKnight. Make-up: Mary Greenwell.

233

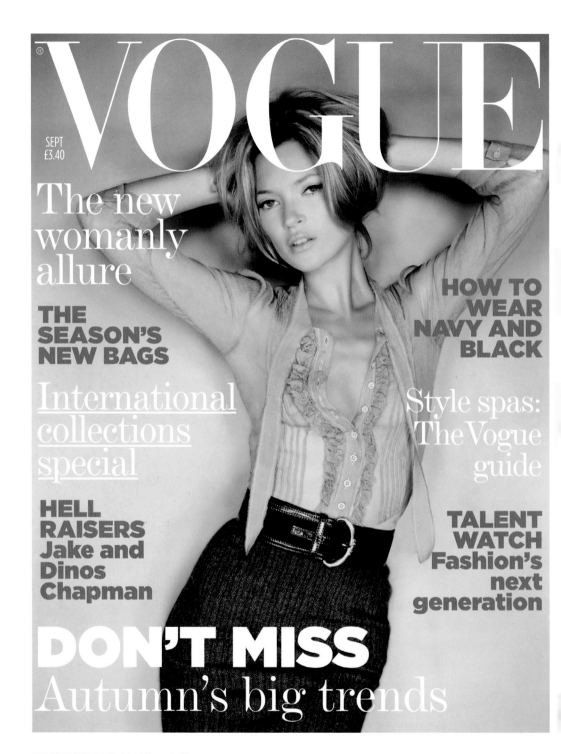

VOGUE

SEPT
£3.40

The new womanly allure

THE SEASON'S NEW BAGS

International collections special

HELL RAISERS Jake and Dinos Chapman

HOW TO WEAR NAVY AND BLACK

Style spas: The Vogue guide

TALENT WATCH Fashion's next generation

DON'T MISS
Autumn's big trends

SEPTEMBER 2005 The New Womanly Allure

This issue marks the tenth cover from one of fashion's closest collaborations: that of Nick Knight and Kate Moss. He has photographed her in various roles: vamp, girl-next-door, party queen and, unusually, monarch, complete with crown and sceptre (see page 224). 'We understand each other very well,' says Knight. 'What's more we have a laugh.' This cover was, according to Alexandra Shulman, 'probably the bestselling cover we have ever done with

her. It captures her attainable perfection — she looks very sexy but it's not impossible for people to think that they could, conceivably, look like her.'

Photograph by Nick Knight. Model: Kate Moss.
Fashion: Alberta Ferretti and Celine. Fashion editor: Kate Phelan.
Hair: Sam McKnight. Make-up: Val Garland.

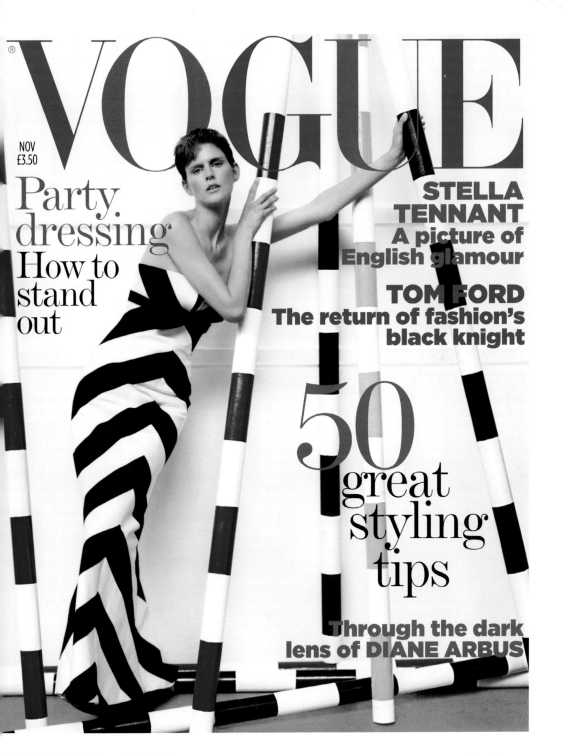

VOGUE

NOV
£3.50

Party dressing
How to stand out

STELLA TENNANT
A picture of English glamour

TOM FORD
The return of fashion's black knight

50
great styling tips

Through the dark lens of DIANE ARBUS

NOVEMBER 2005 A Picture of English Glamour

The digitally enhanced images of much contemporary fashion photography occasionally demand a corrective. Tim Walker's approach to fashion is rooted in a rigorous regard for good taste. His pictures always reveal their deeply felt roots in a quirky, individualistic English eccentricity. His set pieces owe much to his *Vogue* predecessors, Parkinson and Beaton especially, and he possesses that emotional attachment to rural elegance that attracted Gainsborough,

Zoffany and his inspiration for this issue, Alfred Munnings. For the cover: coloured showjumping poles and the aristocratic bearing of Stella Tennant.

Photograph by Tim Walker. Model: Stella Tennant.
Fashion: Neil Cunningham. Fashion editor: Kate Phelan.
Hair: Gianni Scumaci. Make-up: Samantha Bryant. Set design: Andy Hillman.

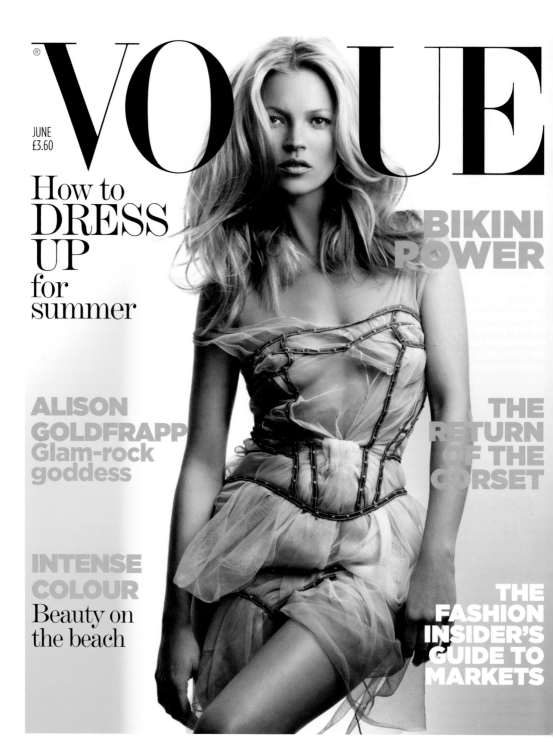

VOGUE

JUNE
£3.60

How to
DRESS
UP
for
summer

ALISON
GOLDFRAPP
Glam-rock
goddess

INTENSE
COLOUR
Beauty on
the beach

BIKINI
POWER

THE
RETURN
OF THE
CORSET

THE
FASHION
INSIDER'S
GUIDE TO
MARKETS

JUNE 2006 How to Dress up for Summer

Another cover with Moss, another bestseller. This was the first cover by Craig McDean, one of the great names of modern fashion photography. 'It's hard to say what hasn't been done before,' he says. 'I think that if you touch people, that's more important. It's not about being first; it's not a race. It's about how you use photography to express your vision in a commercial medium.' McDean's polished images are more considered than those of his New Realism contemporaries, so much so that one commentator put him at the vanguard of a movement-in-waiting: 'Hyper-Realism'.

Photograph by Craig McDean. Model: Kate Moss.
Fashion: John Galliano for Dior. Fashion editor: Kate Phelan.
Hair: Sam McKnight. Make-up: Val Garland.

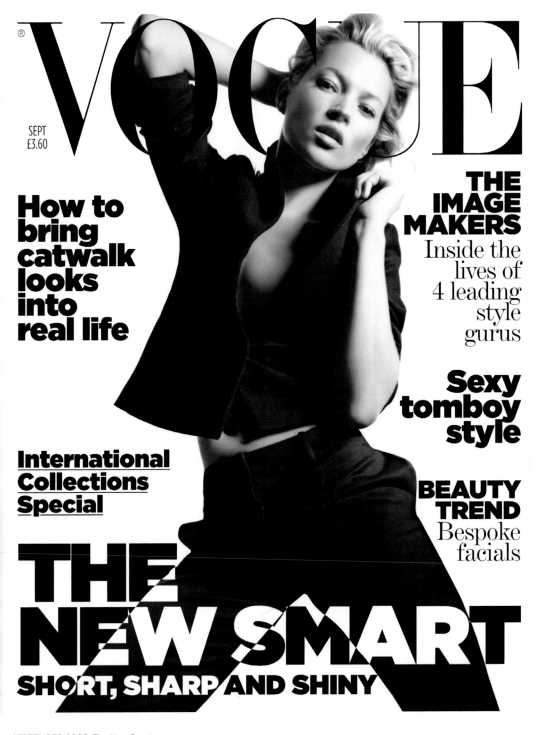

VOGUE

SEPT
£3.60

How to
bring
catwalk
looks
into
real life

THE
IMAGE
MAKERS
Inside the
lives of
4 leading
style
gurus

International
Collections
Special

Sexy
tomboy
style

BEAUTY
TREND
Bespoke
facials

THE
NEW SMART
SHORT, SHARP AND SHINY

SEPTEMBER 2006 The New Smart

Another cover for Kate Moss, the twenty-third in a series that shows no signs of finishing, though surely one day it will. 'If ever a person deserved the appellation of icon,' wrote Alexandra Shulman, 'it is Kate, whose image has graced more magazine and newspaper pages than anybody else of her generation, but who has chosen to stay silent in the face of a multitude of negative projections of that image.' She continued: 'Icons — well, in the days before they were handbags — are images onto which a collective consciousness is projected, offering meaning way beyond the simple image.' This icon has now appeared on more *Vogue* covers than anyone else.

Photograph by Nick Knight. Model: Kate Moss. Fashion: Jil Sander.
Fashion editor: Kate Phelan. Hair: Sam McKnight. Make-up: Val Garland

INDEX

Page numbers in **bold** indicate photographs (including captions when they are on the same page); numbers in normal type refer to captions only

ACKNOWLEDGEMENTS

The authors would like to thank the staff of the Condé Nast Library in London (Brett Croft, Jooney Woodward, Jeb Crowell, Bonnie Robinson and Paul Dyer) for their tireless research and assistance. They would also like to thank Alexandra Shulman, editor of *Vogue,* for her encouragement and also Jonathan Newhouse, Nicholas Coleridge and Stephen Quinn, all of The Condé Nast Publications Ltd, for their encouragement too.

This book would not have reached publication without the unstinting efforts of Jaime Perlman, art director of *Vogue,* and Jennifer Cargey, art co-ordinator, who worked on the project with unfailing good humour. It certainly would not have reached that stage without the skills, both administrative and diplomatic, of Harriet Wilson who played a crucial part in the book's genesis and development and for which the authors are very grateful. They would also like to thank Julian Alexander

of Lucas Alexander Whitley. For help with specific images, they would like to thank Tim Walker and his London office, Annabel Thomas of the Fine Art Society and James Glennie of Bonhams, who secured permission from a private collection to reproduce the portrait on page 7. Thanks are also due to Steve Fisher, Steve Jackson of Hungry Tiger Studio and Epilogue.

A special debt of gratitude is owed to Stephen Patience for editing the text, for his painstaking corrections and for his encyclopedic knowledge of world events and fashion history. A similar role was undertaken by Tracey Brett and thanks are due to her for her pertinent amendments.

The authors are delighted to have continued their association with Little, Brown and would like to thank Ursula MacKenzie, Vivien Redman and Nick Ross for the third in a series that follows *Unseen Vogue* (2002) and *People in Vogue* (2003). Thanks, also, to Chanel for their support.

Robin Muir would like to pay tribute to the authors of several previous books on *Vogue*'s history, most significantly William Packer and his two volumes on the magazine's graphic heritage: *The Art of Vogue Covers 1909-1940* (Octopus, 1980) and *Fashion Drawing in Vogue* (Thames & Hudson, 1983); *The Art of Vogue Photographic Covers* (Octopus, 1986) by the late Valerie Lloyd was similarly indispensable. He is also indebted to three pioneering studies of *Vogue*'s heritage: *In Vogue* by Georgina Howell (Allen Lane, 1975), *The Man Who Was Vogue: The Life and Times of Condé Nast* by Caroline Seebohm (Viking, 1982) and Polly Devlin's text to *The Vogue Book of Fashion Photography* (Thames & Hudson, 1979).

Finally, both authors would like to record their gratitude to all the illustrators and photographers whose work is included in this book, and the editors and art directors who commissioned them.